100 JAPANESE GARDENS

STEPHEN MANSFIELD

TUTTLE Publishing

Tokyo │ Rutland, Vermont │ Singapore

Contents

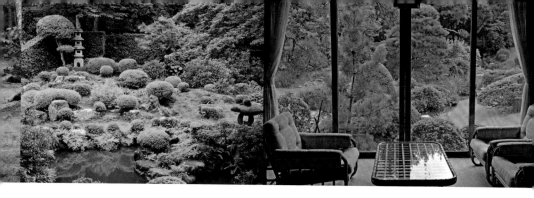

Preface

The title for this book was inspired by a fondness among Japanese artists, writers and the general public for compendiums of one hundred, celebrated examples being the twelfth century anthology *One Hundred Poems by One Hundred Poets*, Utagawa Hiroshige's *One Hundred Famous Views of Edo*, Hokusai's *One Hundred Ghost Stories* and, more recently, Fukada Kyuya's *One Hundred Mountains of Japan*. The Japan Environment Agency even went to the trouble of registering one hundred quintessentially Japanese sounds, from the tolling of a bronze bell in a fire tower to the cracking of ice floes in sub-Arctic Hokkaido and the flapping of crane wings in southern Kyushu, all in the hope that they could be preserved when the substance no longer exists.

The inaccuracy of ranking gardens according to their assumed merits, a method that is subjective at best, is obvious. While I have selected Japanese gardens as celebrated as the landscapes of Capability Brown or Humphry Repton, designs as imprinted on the collective mind as the geometric formalism of Vaux-le-Vicomte, there are also little visited gardens, works deserving of more attention.

The criteria for selecting these landscapes was how well they represented the various Japanese garden forms. Inevitably, these include stroll, stone, tea and courtyard gardens as well as works created for the early noble families of Edo (present-day Tokyo), imperial gardens, and later designs commissioned by wealthy entrepreneurs. There are a number of experimental, contemporary gardens that defy easy classification. The book also includes a small sampling of herbal and medicinal gardens and flower

ABOVE A garden perspective from the second floor of the Kiun-kaku residence.

RIGHT The rock groupings at Kongobun-ji Temple on Mount Koya represent authority rather than subtlety.

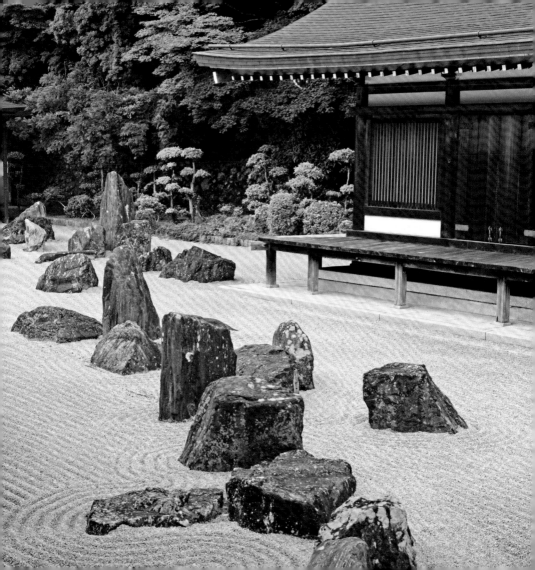

viewing sites. The book concludes with a set of images from Okinawa, where the Chinese influence on its private and royal gardens is strongly felt.

Not intended as a guide book per se, it can, nonetheless, be used as a selective guide to the gardens of Japan and as a sight companion to visiting well-known locations. For obvious space reasons, some very fine gardens are not included here. Readers are encouraged to explore Japanese gardens beyond the confines of this numerically extensive but not finite book.

The gardens have been placed in cardinal clusters, the Kyoto and Tokyo groupings in an approximate north, south, east and west order, regional gardens starting in the sub-Arctic northern island of Hokkaido and terminating in the southernmost, sub-tropical region of Okinawa. Residents of large cities such as Osaka, Kobe or Kagoshima might not appreciate the term "regional," with its implications of provinciality, but for my purposes this simply refers to gardens in places other than Kyoto and Tokyo.

As with all nature photography, a degree of patience is required to capture the right light, changing hues and climatic conditions. At other times, images almost seem to compose themselves. All the photographs in this book were taken on digital cameras. When processing and editing images, rather than attempting to super-enhance them I have tried to reproduce the same colors, tones and textural qualities seen with the eye. None of the compositions are cropped.

Entrance fees for the gardens have been ranked according to yen symbols:

¥ = ¥600 or less
¥¥ = ¥600–¥1000
¥¥¥ = Over ¥1000

Historical Periods
Nara 710–795
Heian 794–1185
Kamakura 1185–1333
Muromachi 1333–1568
Momoyama 1568–1600
Edo 1600–1868
Meiji 1868–1912
Taisho 1912–1926
Showa 1926–1989
Heisei 1989–2019

RIGHT The pond garden of Tenryu-ji,
a living manifestation of Buddhist tenets.

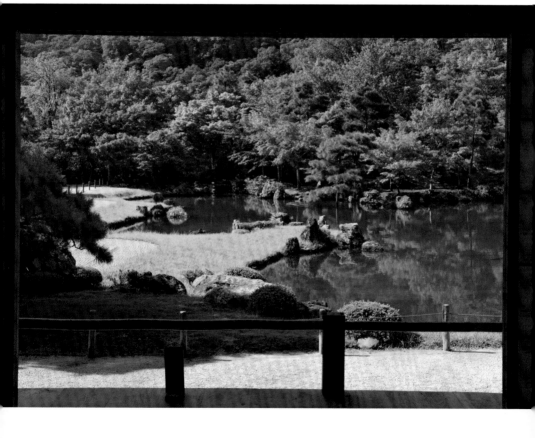

Japan's Incomparable Gardens

If Westerners occasionally see the hand of God in the slants of light piercing the tall, cathedral-like trees of their forests, the early Japanese, making clearings in their woodland glades, created actual places of worship.

Pre-Shinto and Buddhist natives of Japan, without shrines, temples or religious reliquaries, sought out features of the natural world as manifestations of divinity. Large rocks, known as *iwakura*, were placed in forest clearings, beside waterfalls and along stretches of pebbly beach. Conductors through which the gods could be petitioned, these natural altars and ritual spaces, characterized by a deliberate and aesthetically pleasing sculptural arrangement of stones, were not gardens in the strictest sense but they did prefigure the later centrality of rocks in Japanese landscape design.

When it became known that Chinese Taoists visualized paradise as a land mass known as the Islands of the Immortals, Japanese garden designers began to place rock arrangements symbolizing aspects of this mythology in their gardens, just as the Chinese had. When a Japanese emissary returned home in 607 with a detailed account of Chinese garden methods, Empress Suiko had a garden designed that was inspired by Mount Sumeru, the Buddhist center of the universe. The turtle and crane, Chinese symbols of longevity, were also incorporated into Japanese landscapes. One of

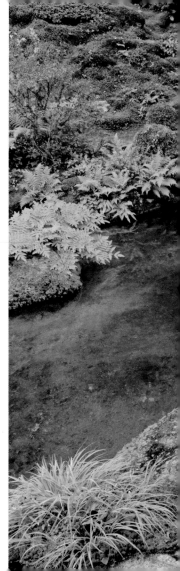

RIGHT The fringes of a pond skillfully planted with ferns, moss, grasses and other plants to soften the rocks and frame the pond.

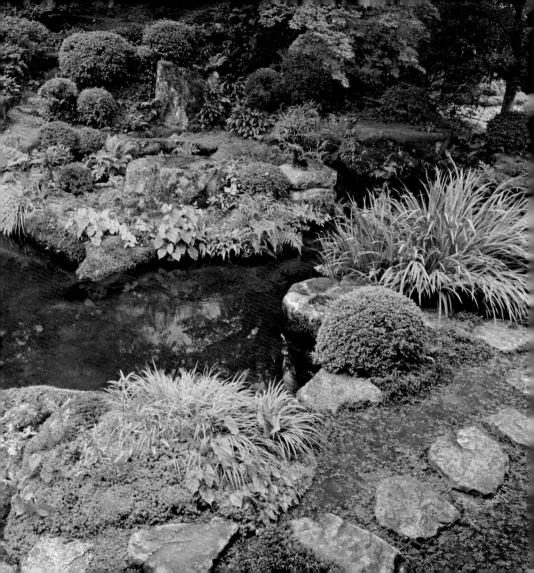

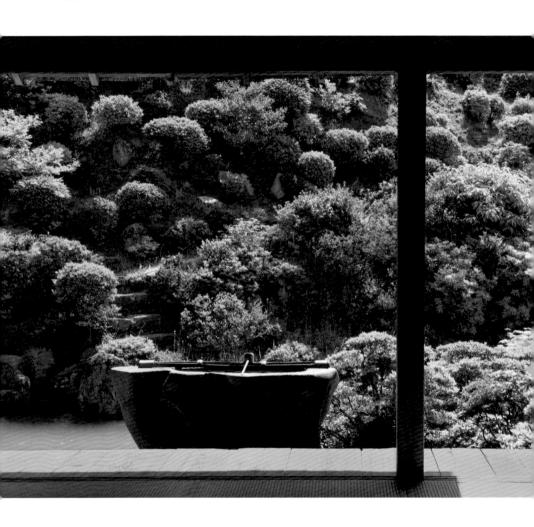

the delights of visiting these gardens is trying to spot these forms, which are not always immediately visible.

By the Heian period, gardens had already begun to incorporate rock groupings, plant arrangements and islands understood by the literate as references to subjects found in both Chinese and Japanese literature. Symbolism came to be used not only to add depth and erudition to gardens but, through an unfolding of associations, to expand the spatial aspects of the mind.

Integral to the building process itself, it was entirely natural that gardeners should begin to integrate meanings into the design. A singular stone might be named

Fudo-myoo, after the Buddhist divinity of fire; other groupings were set to evoke desolate mountain ranges and shorelines, or through their colors, tones and cardinal alignments to satisfy the demands of Chinese geomancy. In this way, primordial sculptural forms were imbued with sophisticated concepts whose provenance was both cultural and spiritual.

The induction of Chinese geomantic principals and land patterns into Heian period garden designs, with their cognitive notions of interdependence, intuitive natural science and rational cosmology, are not easily grasped. But there was also a lighter, playful element in the early aristocratic and imperial gardens. Banquets,

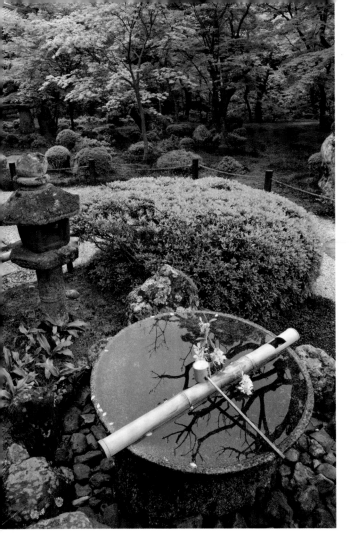

boating and poetry competitions took place within the precincts of these generously proportioned gardens. Stages set on small islands provided platforms for dance performances. Poetry competitions called *kyokusui-no-en*, the "banquet beside the winding stream," were held.

The medieval era was characterized by the martial disciplines of the samurai class and the emerging practices of Zen. In the gardens of this time, particularly the Muromachi period, regarded by many as the apex of Japanese stone garden design, sand or white gravel was placed around rocks to mark the border between the sacred and human realms. The legacy stemming from a spiritual interpretation

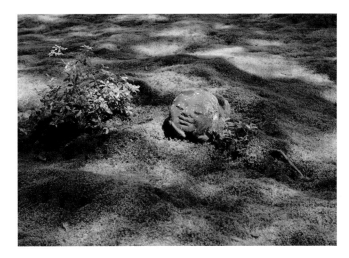

of rocks as primary garden elements is seen in the use of stones for religious imagery in this period of more urbane landscape design. In gardens attached to Zen temples, rocks were infused with meanings that would place them firmly within a religious context, turning landscapes into representations of a Buddhist worldview.

During the Edo period, designers freed up space for extra ornamentation, resulting in the inclusion of miniature bridges, carved bodhisattvas, half-buried sections of roof pediments and finials, water basins and lavers, stone lanterns, granite bridge piers, dry stream beds and waterfalls, stone pagodas, and exotic plants like cycads. *Karikomi* (topiary)

appeared at this time, the meticulously clipped bushes and evergreens representing everything from lucky treasure ships to billowing clouds.

These landscapes, known as *kayushiki teien*, stroll or circuit gardens, provided the setting for guests to wander at their leisure through scenes representing a cultural digest of famous Japanese and Chinese sites, both real and imaginary. Stroll gardens, in common with landscape painting, paid tribute to natural forms. Popular

garden recreations included the islands of the Inland Sea, the coast at Sumiyoshi, and Tamatsushima in Kii province. Visitors followed a route that featured *meisho*, or "famous sights." These landscape compendiums obviated the need to undertake long and arduous journeys on foot over mountain passes, on horseback or by boat that often involved months away from home. Despite injunctions to modesty, some of these gardens were enormous and costly undertakings.

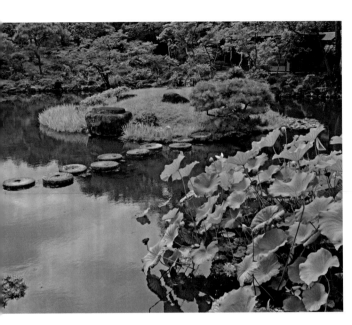

Garden design, like other art forms, needs to evolve. This was something landscape designer and scholar Shigemori Mirei (1896–1975) instinctively understood. Shigemori's gardens were destined to divide the gardening establishment in much the same way that the works of the more radical French artists he admired did in Europe. Shigemori believed that the Japanese garden had degenerated into mannerism and over-decorativeness during the Edo period, that there was a need to revitalize the form. This he did brilliantly and seditiously. Several of his contentious gardens appear in this book. At a relatively young age, Shigemori recognized that "the old is new." He would later

The new elite class that commissioned the building of gardens in the final years of the nineteenth century and early decades of the twentieth, numbered business leaders, politicians and plutocrats, an empowered elite intrigued by Western gardens but with a lingering nostalgia for fondly recalled late Edo period landscapes. The period in which these designs were made is notable for its poor level of garden scholarship. Japanese garden design was no longer regarded as an art. Gifted garden designers were liberated from the models of the past, the less talented free to create substandard works. In this aesthetic and conceptual hiatus, themes, symbolism and abstraction receded as gardens reverted to extensions of aristocratic homes.

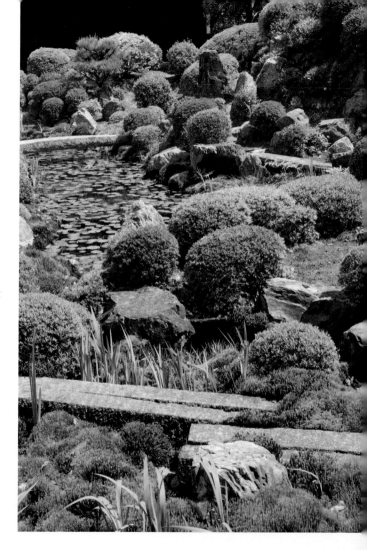

RIGHT Granite bridges and stones contrast with softer plantings like water lilies at Fumon-in, part of the "Garden of Eight Phases" at Tofuku-ji.

coin the expression "eternal modern" to describe the melding of the classical and contemporary in gardens, the notion that the traditional contains an exuberance that can invigorate the new.

In his *Song of Meditation*, the Zen monk and poet Hakuin Ekaku wrote of the joys of "unobstructed repose." For urban dwellers, the temporary sanctuary of Japanese gardens provides just the right counterbalance to the more negative forces generated by cities. Some may even find that the state of suspended thrall created by such gardens, the contact with nature transmuted into art, turns out to be less escapism than connection.

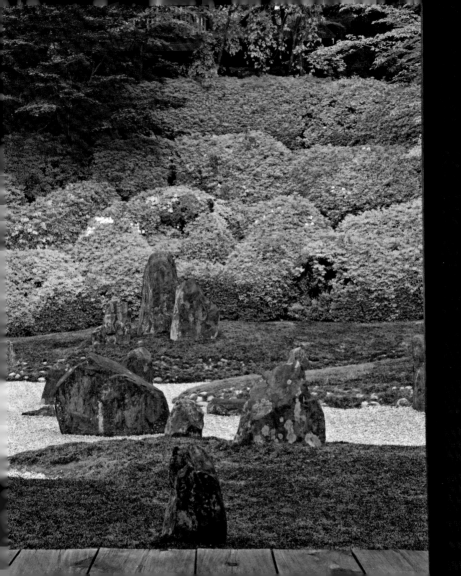

Part One
Kyoto & Nara

Electing the twenty-second day of the tenth month of 794, an auspicious choice according to astrological charts, Emperor Kammu declared Heian-kyo the new imperial capital. Over seventy emperors would preside over the city until 1869 when the center of power shifted to Tokyo and Heian-kyo was renamed Kyoto.

The presence of countless temples, aristocratic estates, artists and literati, and the popularity of refined pastimes like the tea ceremony, prefigured the creation of a culture comparable in its depth and beauty to the achievements of Florence, Xi'an or Isfahan.

From a garden perspective, Kyoto, with over 200 listed formal landscapes, must surely rank as the world's foremost garden city. The sheer diversity of garden forms constitutes an important element in the rich and textured culture of a city whose surrounding hills and forests, ready supply of rock, sand and gravel, plentiful water sources and humid, growth-inducing summers make it ideal for cultivating gardens.

If Japan's passion for the modern coexists with aesthetic proclivities that favor antiquity and refinement, nowhere is this more apparent than in this city's ancient religious architecture and gardens. The better-known Kyoto gardens, however, have become some of the most photographed landscapes in the world, hosting a crush of people vying for space, a mayhem of ringing cell phones and tour guides raising their voices

in order to be heard. These scenes are a long way from the original purpose of gardens as sanctuaries, places designed for contemplation. The good news is that there still remain a considerable number of quiet, little visited but exquisite landscape designs in a city that was recently ranked the country's number one destination for both Japanese and overseas tourists. Seeking out the smaller gardens of subtemples, you can discover fine landscapes, many located in settings of genuine rusticity.

What you see and what you know are often quite different. How many of us, for example, have walked through temple complexes in Kyoto without realizing that the staircases ascending to these compounds terminate in structures symbolic of Mount Sumeru, the center in the Hindu and Buddhist cosmologies? I have often wondered whether the white stripes

LEFT Spring at Komyo-in, also known as "The Garden of Hashin."

running along the surfaces of light yellow temple walls, were purely decorative or contained meanings beyond the ocular. The patterns, it turns out, signify high status, one version of the design indicating that a member of the imperial family once served there. When applied to gardens, meanings are often hidden in plain sight. Kyoto, with its bewildering mass of formal gardens, offers a prime example of concealed meaning. On first acquaintance, Japanese aesthetics can seem impossibly complex.

Concepts such as *koko* (precious simplicity), *seijaku* (absolute stillness) and *yugen* (unfathomable depth), vital to the principals of Japanese garden design, may baffle the uninitiated. Kyoto gardens may be just the right place to study such things.

Bedeviled by a failure at urban planning, the ability to co-ordinate the old with the shabby new, no one would say that Kyoto, despite its cultural pre-eminence, is a beautiful city. Aldous Huxley likened it to a shambolic American mining town. In its specifics, however, particularly, and for the purposes of this book, the detail and minutiae of its exquisite gardens, we encounter a city suffused with beauty and meaning.

BELOW LEFT Billowing bushes and stone lantern at Shisendo.
BELOW CENTER Iconic rocks at Ryoan-ji.
BELOW The majestic pavilion of Kinkaku-ji.

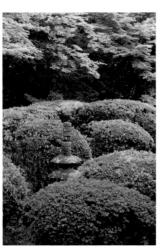

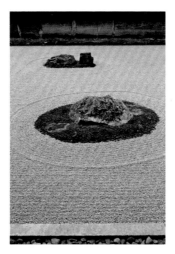

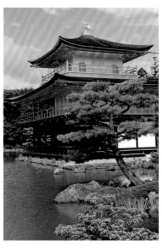

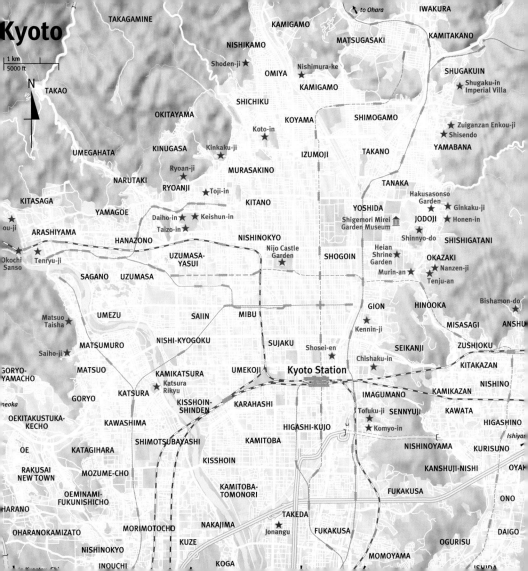

KENNIN-JI
建仁寺

Location: 584 Komatsu-cho, Higashiyama-ku. **Hours:** 10.00 a.m.–4.00 p.m. **Fee:** ¥

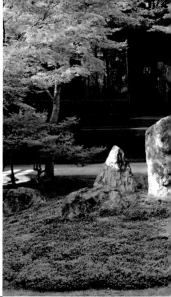

In the midst of a congested downtown area, Kennin-ji, the former imperial capital's oldest Zen temple, appears to have a separate existence, its compounds and gardens sealing off the activity of the city from its sanctified precincts. Two gardens stand out, the first one a dry landscape creation dating from the Momoyama era. A period notable for its extravagant, almost baroque ornamentation, the Daiyu-en or "Garden of Grandeur" facing the Hojo or Superior's Quarters, is sobriety itself, consisting of little more than a rectangle of raked sand confined within tile-capped earth walls. Fifteen rocks, a

ABOVE A powerful rock grouping creates a strong central focus.

LEFT Rich green borders contrast with the temple's dry landscape garden.

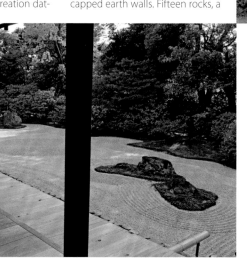

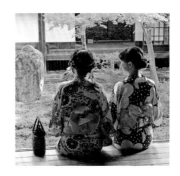

RIGHT Visitors take a moment out for quiet contemplation.

BELOW An "island" in a swirl of raked gravel.

blend of horizontals and verticals, harmonize perfectly with carefully trimmed bushes and shrubs at the rear of the garden. Fronted by the abbot's, monk's and priest's quarters, the even more minimalist square garden is based on a calligraphic work by Gibon Sengai, which represents a circle, square and triangle, the three essential forms of the universe. Contrasting with the stark simplicity of this arrangement is an inner courtyard garden known as the Choun-tei or "Garden of Tidal Sound." Visible from four sides, a lush carpet of moss appears to surge towards a hillock, where a *sanzon-seki*, a triad of three large rocks representing the Buddha and two attendant Bodhisattvas, and a flat *zazen-seki*, or meditation stone, dominate the center of this serenity-inducing garden.

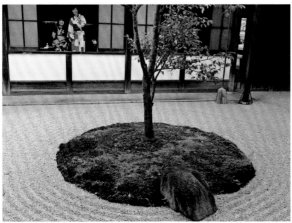

HEIAN SHRINE GARDEN
平安神宮

Location: 97 Nishitenno-cho, Okazaki, Sakyo-ku.
Hours: 8.30 a.m.–5.00 p.m. **Fee:** ¥¥

LEFT In resplendent
bloom, a spring peony.

If the axial symmetry of the shrine buildings pay tribute to Heian era architecture, its garden, designed by Ogawa Jihei in 1895, is an authentic recreation of the era's distinctive tastes and aesthetics. Heian predilections, though, are augmented with the use of con-temporary plants and trees, including some new species that were appearing in Japan during the Meiji era. The visual centerpiece of the pond, Taihei-kaku, is an elegant wooden bridge in the Chinese style but also references the Heian love of cantilevering pavilions over water. Ogawa drew water from the nearby Lake Biwa Canal. He also used the brick aqueduct to transport rocks from Moriyama, a peak on the west coast of the lake. Another interesting feature of this rather ingenious garden is the use Ogawa put to a set of bridge pillar

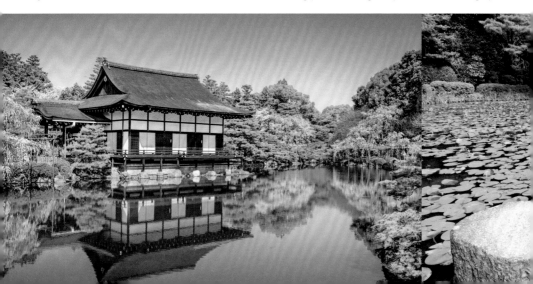

supports, which he used to create a highly original line of stepping stones across a section of the pond. The vermilion-colored shrine, built to commemorate the city's eleven hundred years of existence, is a well-known landmark in this northeast district of the quarter, its religious, cultural and garden events well-attended. In the spring, the garden heaves with crowds flocking to see the delicate, highly transient blossoms of its cherry trees. This season also sees the flowering of azaleas and iris.

RIGHT Meandering paths induce a pleasant sense of serendipity.

BELOW Requisitioned bridge foundation piers used to form stepping stones.

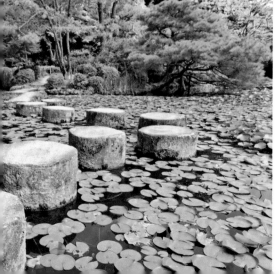

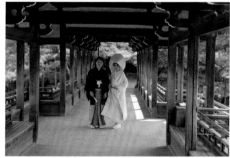

FAR LEFT On fine days, the pond acts as a mirror, doubling the effect of the cherry blossoms.

ABOVE The garden's elegant wooden bridge is a popular photo spot for newlyweds.

NANZEN-JI
南禅寺

Location: 86 Nanzen-ji Fukuchi-cho, Sakyoku. **Hours:** 8.40 a.m.–5.00 p.m. **Fee:** ¥

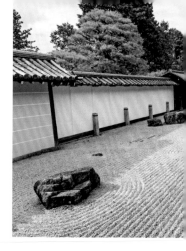

Regarded by many as Kyoto's foremost Zen temple, Nanzen-ji consists of a number of smaller courtyard and inner gardens to the rear that support its main landscape, a design known as the "Leaping Tiger Garden." This consists of a minimum number of carefully selected rocks, moss, trees and hedges at the rear of a plain of raked gravel. The greater massing of rocks to the left of the arrangement replicates a concentration of garden walls, conspicuous temple roofs and a densely wooded hillside whose outline is reflected in the form of the garden's most imposing rock. The complementary colors and hues on both sides of the garden wall create a wonderfully harmonized and integrated composition. If the sand foreground represents the sea, a typical interpretation for such expanses, and the raked surface, ripples, the curving boundary

ABOVE A side portion of the temple set aside as a dry landscape garden.

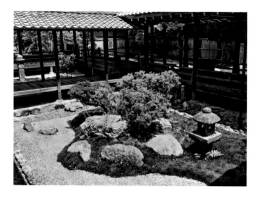

LEFT This small courtyard garden can be viewed from open-sided corridors.

between this zone and the mossy area supporting rocks and greenery might be considered a shoreline. Commenting on this design concept in her 1940 book, *The Art of Japanese Gardens*, Loraine E. Kuck interpreted the dominant rock in the left-hand corner of the garden as a promontory, noting in the motion of symbolic water lapping at its feet, "a feeling of directional flow."

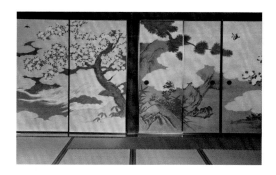

RIGHT Plum trees skillfully depicted on interior *fusuma*, sliding paper doors.

BELOW Located at the foot of the Higashiyama Hills, Nanzen-ji benefits from the bluff's stunning autumn leaves.

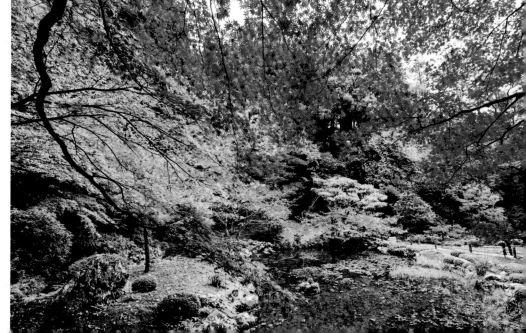

TENJU-AN
天授庵

Location: 86-8 Fukuchi-cho, Nanzen-ji, Sakyo-ku. **Hours:** 9.00 a.m.–5.00 p.m. **Fee:** ¥

An easily overlooked subtemple of the great Nanzen-ji, Tenju-an is a very venerable temple, positively saturated in time. Built during the reign of Emperor Kogon as a dedication to Daimin Kokushi Osho, the founder of Nanzen-ji, a path leads from a dry landscape garden into a wooded area where autumn maples draw a rare crowd of visitors. This lower garden is organized into the shape of two peninsulas that merge to form a curling clasp dividing two carp-filled ponds, one of which resembles the Chinese character for heart. A green sanctuary, sutras are chanted and bells rung at ordained times, advancing the impression of a Buddhist Camelot. Rock forms and placements are breathtaking. Some stone outlines are only just visible beneath mottled lichen, moss and plants that have gained a deep purchase in crevices. An L-shaped granite path in front of the main hall appears to be a modernist design playing off diamond and square forms but turns out to have been made in 1337. Along with the garden's rocks, it is the only element to have survived the devastating Onin War of 1447 and the fires that raised its original structures to the ground.

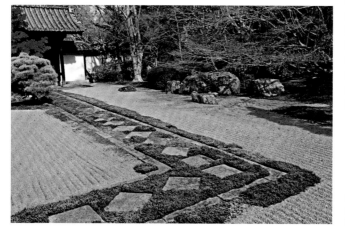

LEFT Framed stepping stones dating from the fourteenth century.

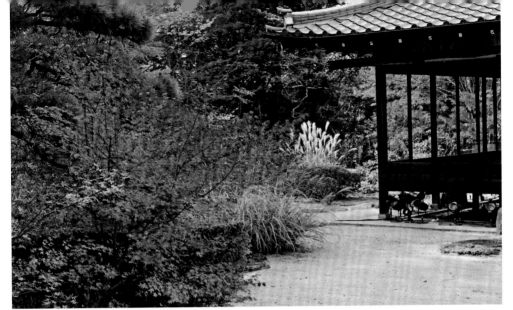

ABOVE Autumn leaves and grasses flare into color in the rear garden.

LEFT The handrails for these cube-shaped stepping stones are of recent placement.

RIGHT Adding a touch of rusticity, this traditional wooden gate divides the front and rear gardens.

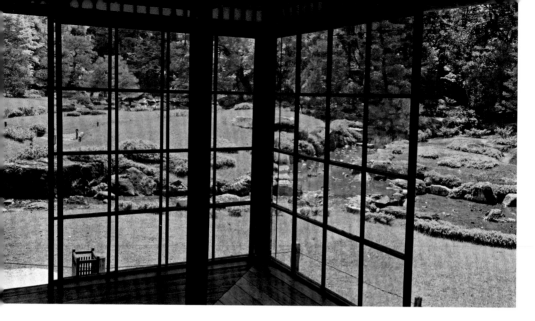

MURIN-AN
無鄰菴

Location: Sakyo-ku, Nanzen-ji, Kusagawa-cho. **Hours:** 8.30 a.m.–5.00 p.m.
Minor variations according to seasons. Closed December 29–31. **Fee:** ¥

With the advent of the Meiji era, the new patrons of gardens were no longer shoguns, court aristocracy and feudal lords but government officials, wealthy landowners and businessmen. At Murin-an, commissioned by political and military leader Arimoto Yamagata, prominent garden designer Jihei Ogawa (1860–1933) created a naturalistic space co-opting the Higashiyama Hills as backdrop. Diverting water from the nearby Biwa Aqueduct, Ogawa built a small filtering cascade, a shallow pond and brook to form a fluid,

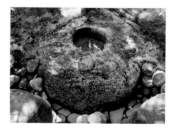

ABOVE A moss-covered water basin adds age and a hint of wisdom to the garden.

TOP Fine views of the garden layout can be appreciated from the tearoom.

liquid tracery over the garden's gently sloping terrain. There is skillful illusion here: the streams seem to flow down from distant hillsides rather than a man-made canal. An ode to the beauty of water, the surfaces of the pond move slowly, reflecting slightly distorted images of the overhead tree canopy. Although located next to a busy road, miraculously all is silent within. Murin-an produces an audio effect where quieter sounds—summer cicadas, autumn crickets, purling brooks—dominate. At Murin-an, water, unsullied and luminous, is another means of expressing the ultimate purpose of all Japanese gardens—the search for the essence of landscape.

ABOVE LEFT Clearing teatrays from a room that provides fine views of the garden.

ABOVE Gravel paths meander through a scene created to resemble a woodland.

BELOW This simple courtyard garden also acts as a light vent.

BISHAMON-DO
毘沙門堂

Location: 18 Inariyama-cho, Anshu, Yamashina-ku. **Hours:** 8.30 a.m.–5.00 p.m. **Fee:** ¥

Named after one of the seven gods of good fortune, Bishamon-do really is a lucky find. Perhaps the 20-minute walk up a gentle incline from Yamashina Station into this tranquil Kyoto suburb explains the relatively low visitor rate at the temple, but the minimal effort is worth it. Founded in 703, Bishamon-do, with strong connections to the imperial family, has experienced several reconstructions. Relocated to its present site in 1665, a stone footbridge known as the "Bridge to Paradise" spans a small pond beside a brilliant orange and red shrine built into the declivity of a cliff. In the garden's main pond, with its perspective defining stone pagoda, the astute will identify tortoise- and plover-shaped rocks. An all-seasons garden, autumn is notable for the surrounding canopy of trees bursting into red and orange, the crimson tints surpassing many better known changing leaves viewing sites. This well laid out garden is also known as Bansuien because of the dense greenery and the dark pools of shadow trapped in its foliage, the effect suggestive of jade glimpsed at night.

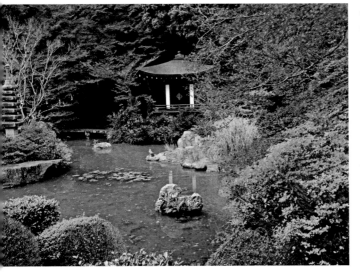

LEFT The temple's main water course, known as Shinji Pond, induces calm and the sense of being in a hermitage setting.

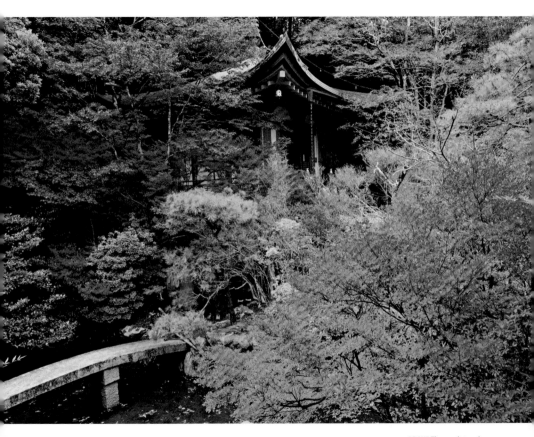

ABOVE The scarlet and orange leaves of autumn are further enhanced with a red and green-roofed shrine.

SHINNYO-DO
真如堂

Location: 82 Shinnyo-cho, Jodo-ji, Sakyo-ku.
Hours: 9.00 a.m.–4.00 p.m. **Fee:** ¥

This Tendai sect temple, with its important standing figure of Amida Nyorai, has two distinctly different main gardens. A contemporary landscape design representing a Japanese family crest, Zuien-no-niwa is divided into four perfectly equal squares that express a deference towards geometrical precision. The garden, designed by Chisao Shigemori, was completed in 2010. The Nehan-no-niwa (Nirvana Garden) is a good example of how a little knowledge on the part of the visitor can illuminate a design and enhance appreciation. Based on a painting known as the Nehan-zu or "Painting of Great Nirvana," large stones at the center of the garden represent the Buddha in the reclining form taken before entering Nirvana. The smaller rocks symbolize his disciples and animals, while the trees in the garden stand for sal trees, which are native

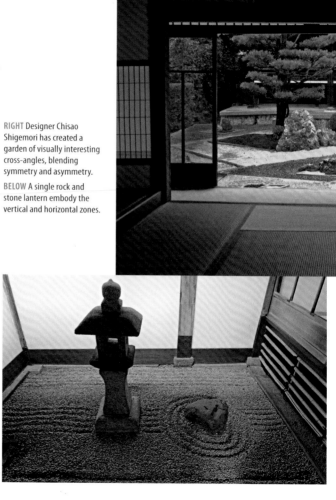

RIGHT Designer Chisao Shigemori has created a garden of visually interesting cross-angles, blending symmetry and asymmetry.

BELOW A single rock and stone lantern embody the vertical and horizontal zones.

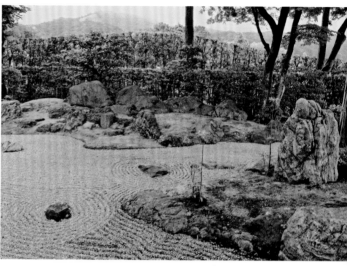

to the Indian subcontinent. The Hindu god Vishnu is said to have favored the tree. Buddhist tradition holds that the Buddha's mother gave birth while holding firmly to a branch of the tree, and that it was under a sal tree in Lumbini in southern Nepal that he expired. The light gravel in front of the symbolic sal trees represents the River Ganges. In this way, an entire universe of meaning is embodied in this apparently simple garden.

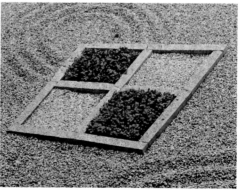

ABOVE Rocks and graduated hedges control depth of field and skillfully blend with a background of hills as "borrowed scenery."

LEFT The rigid form of a miniaturized pattern contrasts with the sea-like flow of gravel.

SHIGEMORI MIREI GARDEN MUSEUM
重森三玲庭園美術館

Location: 34 Kamioji-cho, Yoshida Sakyoku. **Hours:** Three viewings per day.
Special Features: By reservation only. Before viewing, a 10-minute talk is given
in Japanese. **Tel:** (0)75-761-8776/e-mail shima753@hotmail.com. **Fee:** ¥¥¥

One of the most original garden designers in the history of the art, Shigemori Mirei's landscapes, which included the use of unorthodox materials like cement and tile, are, according to devotees or detractors, either iconoclastic masterpieces or affronts to tradition. The house, located close to Yoshida Shrine, was the former residence of priests. In Shigemori's home garden, four rocks placed next to a large, flat worship stone represent the Sennin Islands,

RIGHT Many of Shigemori Mirei's trademark design features are compressed into this home garden.

LEFT A small inner garden with an adjoining building in the teahouse style.

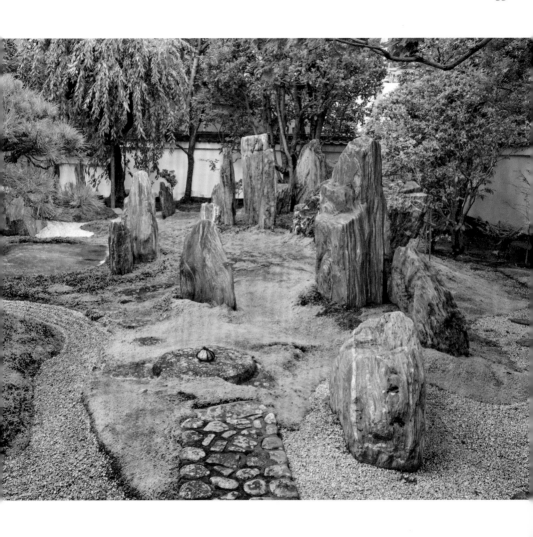

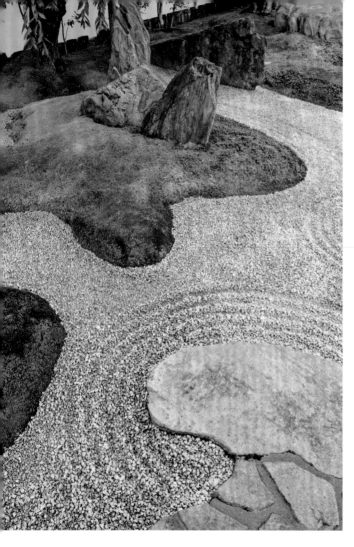

believed in Chinese thinking to have been occupied by monks in possession of the elixir of life. This is the garden's central stone ensemble. Shigemori's gardens are notable for their generous use of vertical stones, some of which are slightly tilted. Conventional wisdom and the strong admonitions found in ancient garden manuals warn against creating clusters of upright rocks in close proximity. Shigemori's skillfully positioned arrangements flaunt this traditional advise but to great effect, with the stone groupings lending a muscular, soaring quality to the garden. The timeless modernity of Shigemori's private garden embodies the notion that Japanese landscape designs are not imitations of the natural world but coexisting forms that harmonize art and nature.

LEFT Curvaceous lines and contrasting hard and soft elements are characteristic of Shigemori Mirei's work.

ABOVE The custom of placing a small *sekimori ishi* stone, denoting no entry, began in tea gardens.

LEFT A small shrine adds a touch of divinity without overburdening the garden with too many objects and items of interest.

LEFT This stone pedestal, once used to support a temple pillar, is a fine example of *mitate mono* or "found objects," items requisitioned to enhance gardens.

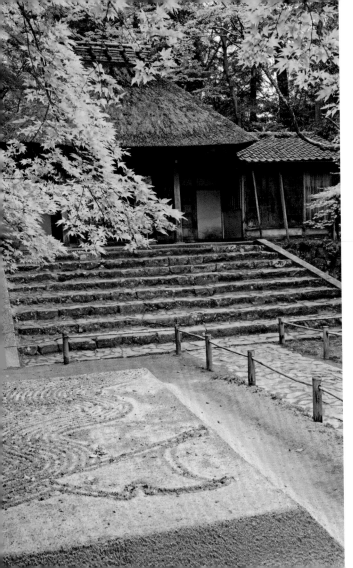

HONEN-IN
法然院

Location: Sakyo-ku, Shishigatani, Goshonodan-cho. **Hours:** 9.00 a.m.– 4.00 p.m. **Fee:** None

Named after Honen, the twelfth century founder of the Jodo sect of Buddhism, this Edo period stroll garden with a small pond and two highly distinctive sand mounds incorporates elements of the dry landscape garden in its design. A secluded temple at the foot of the densely wooded Higashiyama Hills, a broad set of stone steps end in a wooden gate. Turn left and a gentle incline passes through maple trees planted in beds of moss. A worn stone staircase leads to an elegant thatched-roof gate, the Sanmon. Chinese characters inscribed on a stone marker to the left of the gate warn visitors that alcohol, meat and garlic are not permitted inside the Sanmon. Descending steps place you between the two white platforms of sand, known as the Byakusadan. Each mound is identical in form

and size. Only the patterns raked every few days by priests into the sand differ, though one complimentary motif comprises leaf shapes floating in sinuous lines of sand. Seasonal themes surface in the patterns, maple leaves being a common depiction in the autumn. The designs of the mounds are said to symbolize water that purifies body and mind. Religious statuary, a moss-covered fountain, a wooden belfry and a *bussoku-seki*, a flat stone with the indented feet of the Buddha carved into it, add further interest and detail to the grounds of this peaceful retreat.

OPPOSITE One of a pair of rectangular sand mounds beneath ancient stone stairs and a thatched gate.

ABOVE The main hall at Honen-in takes visitors beyond the outer gardens into the inner recesses of the sacred.

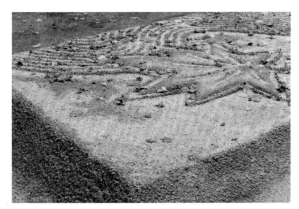

LEFT Priests have created maple patterns in this sand pile, covered with actual maple leaves in autumn, in an interesting synergy of art and nature.

RIGHT A summer hibiscus adds color to the gray edge of a stone water laver.

GINKAKU-JI
銀閣寺

Location: 2 Ginkakuji-cho, Sakyo-ku.
Hours: 8.30 a.m.–5.00 p.m. **Fee:** ¥

Spare a moment before entering the garden to take in the corridor of greenery leading to the entrance of Ginkaku-ji, a magnificent hedge-wall of towering camellia. The garden was built on the grounds of the former retirement residence of the shogun Yoshimasa Ashikaga, who planned to cover parts of his two-story wooden pavilion with silver leaf. The project never materialized but the idea persisted in the name "Silver Pavilion." Upon Yoshimasa's death, his splendid home was converted as a memorial to a Zen temple by the name of Jisho-ji. The grounds are divided into two quite different parts, the juxtapositioning of dry and verdant areas unusual in Japanese gardens but brilliantly complementary in this instance. The first section consists of an area of rocks, trees, plants, dense moss

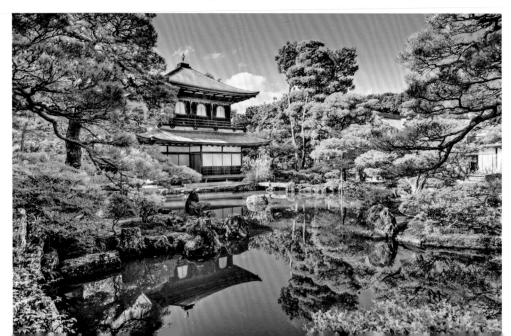

and a small pond, representing scenes inspired by descriptions from Chinese and Japanese literature. Paths run through this part of the garden, providing different perspectives. The second, most visually arresting section, begins with a sand cone known as the Moon-Viewing Height that is vaguely suggestive of Mount Fuji, and a beautifully raked sand plateau, both likely to have been created in the Edo era. The plateau, called the "Sea of Silver Sand," is named after its appearance in moonlight. There is something inexpressibly romantic about this garden.

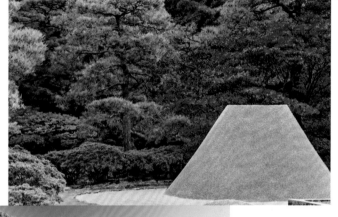

RIGHT The garden's imposing sand "sea" and cone are carefully maintained each day before visitors are admitted.

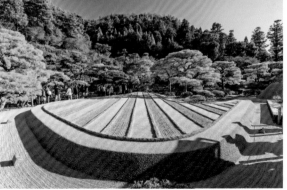

ABOVE Some have compared the cone and its scarlet backdrop of leaves to an erupting Mount Fuji.

LEFT Probably a later addition to the original garden, its sea of gravel adds another dimension.

LEFT Though not actually silver, there is a silven quality to Ginkaku-ji.

HAKUSASONSO GARDEN
白沙村荘

Location: 606-8406 Jodoji Ishibashi-cho 37. **Hours:** 10.00 a.m.–5.00 p.m. **Fee:** ¥¥¥

The garden, museum and residence that comprise Hakusasonso ("White Sand Villa") were designed by the Nihonga artist Hashimoto Kansetsu (1883–1945) and reflect his painterly tastes in layout and composition. The stroll garden, designed around a carp pond with a borrowed view of nearby Mount Daimonji and Mount Hiei, was constructed over a thirty-two year period in an area that was previously set aside for ricefields. The 108,000 square foot (10,000 square meter) site is said to be the largest artist residence in Kyoto. The spacious grounds are replete with three tea ceremony houses and a thatched arbor cantilevered over the pond, adding rustic charm and refinement to the garden. Its numerous works of stone art include Buddha and Rakan statues, stone pillars, lanterns and pagodas. Some

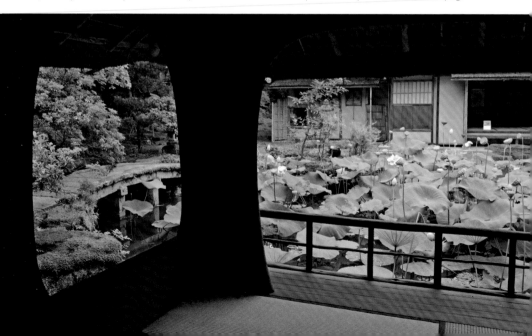

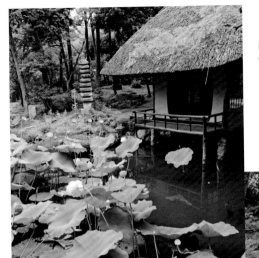

of these, dating from the Heian and Kamakura periods, were obtained from the Kunisaki region of Kyushu. An all-seasons garden, the grounds of Hakusasonso are planted with plum, cherry, pine and maple trees. Beds of luxuriant moss, protected from harsh sunlit, thrive beneath the tree cover and help to muffle outside sounds.

RIGHT Retaining the configuration of a water basin, this container is actually sunk into the earth.

OPPOSITE The view from a cantilevered tea pavilion provides an excellent panorama of the garden's summer lotuses.

SHISENDO
詩仙堂

Location: Ichijoji-Monguchi-cho, Sakyo-ku.
Hours: 9.00 a.m.–5.00 p.m. Fee: ¥

Constructed by Jozan Ishikawa in 1636, the fore garden of this old hermitage, with its raked white sand, appears as an almost seamless, spatial continuum of the broad *tatami* mat *shoin*, a traditional Japanese tea pavilion. The focal point of this section of the garden abutting the Higashiyama Hills is a row of meticulously clipped azalea shrubs, shaped to resemble a mountain range. A maple grove forms the backdrop to this imagined landscape. A single persimmon tree, pendant in autumn with orange fruit, stands in a corner of the sand quadrangle, suggesting the existence of a rural orchard. A student of philosophy, garden construction, the arts and tea ceremony, Ishikawa's scholarship and sensitivity are evident in a design that combines elements of both stroll and dry landscape gardens. Ishikawa lived in Shisendo for the last thirty years of his life, enjoying a deliberate seclusion. A lower section of the grounds, with a small pond, pergola and stone

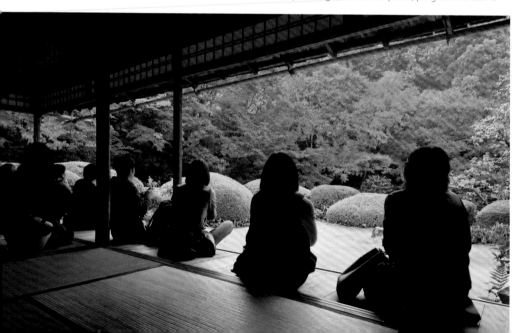

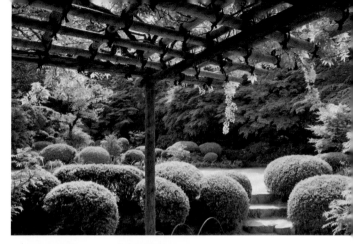

ornamentation, though engaging, is a later addition. The clear, woody clack of a *shishi-odoshi*, a bamboo pole that fills with water from a stream running along the edge of the site, dropping down to strike a stone, can be heard from a quiet corner of Shisendo, a garden, where good taste prevails over the ostentatious.

ABOVE White wisteria hanging from a pergola in the lower garden.

ABOVE Maple leaves turning into spiky red forms.

RIGHT Water makes its way into the garden through a series of bamboo pipes.

LEFT Visitors assume a contemplative pose before the garden's sea of gravel.

ABOVE The garden can become quite busy during the autumn changing of colors.

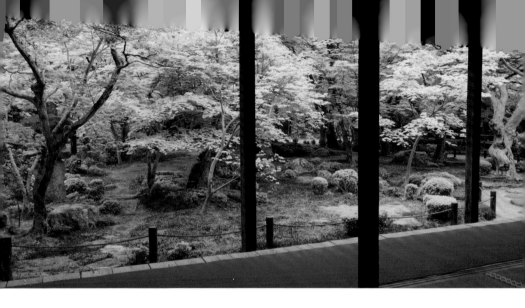

ZUIGANZAN ENKOU-JI
瑞巌山圓光寺

Location: 13 Kotanicho, Ichijoji, Sakyo-ku. **Hours:** 9.00 a.m.–4.30 p.m. **Fee:** ¥

A Rinzai Zen sect temple founded in 1601, Enkou-ji's grounds, relocated to the present site in 1667, erupt into the colors of fallen leaves during autumn. This seasonal highlight is centered on the Jugyu no Niwa, a mossy woodland viewed from a circular path. The word "Jugyu" in this instance is analogous with the Buddhist path to enlightenment.

Immediately engaging the eye on entering the grounds, the Honryu-tei, a modernist dry landscape garden, was completed in 2013. The design combines the primitive and abstract in striking sculptural forms. Stone clusters represent a dragon aspiring towards the heavens. The work was created by Tsubo Keikan and his brother, both Buddhist

priests. Keikan disclaims any knowledge of Japanese gardens or garden design, professing that it was created purely in the spirit of Buddhism. Formal training or not, Keikan and his sibling might be compared to the stone-setting Zen priests of the medieval era known as *ishi-tate-so*. Only a handful of such dedicated people exist today.

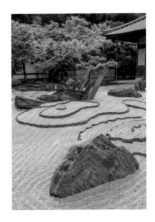

LEFT A fine view of the Jugyu no Niwa, an intensely green glade.

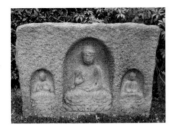

ABOVE A well-crafted Buddhist triad at the entrance to the temple.

ABOVE CENTER A seasonal theme represented by maple leaves floating on the surface of a water laver.

ABOVE RIGHT Priest Tsubo Keikan's inspired garden is an exercise in modernism.

RIGHT Carpeting the ground, autumn leaves at their visual peak.

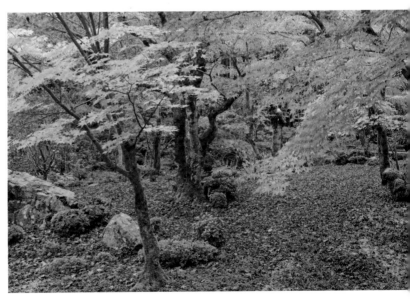

SHUGAKU-IN IMPERIAL VILLA
修学院離宮

Location: 1-3 Shugaku-in-yabusoe, Sakyo-ku.
Hours: Tours are held five times a day, except Monday.
Fee: None. **Special Features:** Permission is required from the
Imperial Household Agency to visit. This can be made by
contacting their official website or visiting their office located
in the northwestern part of the Kyoto Imperial Park.

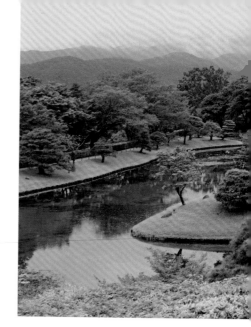

LEFT In the midst of
greenery, a stone lantern
and steps.

Created as a retreat for the retired
Emperor Gomizuno after his abdi-
cation in 1629, the villa and garden
occupy a site beneath the deeply
forested northeastern hills of the
city. Widely regarded as a master-
piece of Japanese landscape art,
the extensive grounds, believed to

have been designed by Gomizuno
himself, are divided into the Lower,
Middle and Upper Villa zones. The
exquisitely maintained Lower Villa
garden is accessed after passing
through several gates. Here, a
stream flows into a pond in front
of the restored Jugetsu-kan villa,
a structure fronted by a patch of
sand and three stone lanterns,
the most impressive known as
the "Sleeve-shaped Lantern." At
a slightly higher elevation, the
Middle Villa garden boasts a well-

preserved pond and the elegantly
conceived Rakushi-ken, a residence
built for Gomizuno's eighth daugh-
ter, Princess Ake. A pine tree,
trained in the manner of bonsai
cultivation to grow horizontally,
stands on a lawn, its name, fittingly,
kasamatsu, the "umbrella tree."
A sharp uphill turn leads to the
Upper Villa area where a long, pine
tree-lined path reveals views of
tiered ricefields and vegetable
plots. The path leads to the Impe-
rial Gate and the most stunning

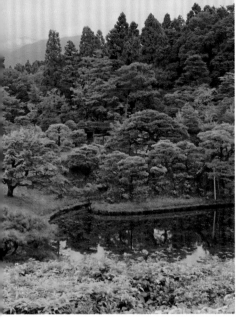

LEFT This view from the Upper Villa area can have changed little since the garden was created.

RIGHT Droplets of rain collect on the leaves of lotus plants.

CENTER RIGHT Lotuses represented on the doors of an inner chamber.

BELOW Parts of the grounds of Shugaku-in incorporate farmland.

garden of the trio. After climbing through a passage enclosed by hedges, one arrives at the Rinun-tei, the "Pavilion in the Clouds," with its heart-stopping vista of distant hills and expansive pond with a complex layout of islets, small peninsulas, coves and cleverly contrived bridges and paths. The scale of the borrowed scenery is unprecedented, the art involved in sequential revelation of perfectly framed perspectives unparalleled in Japanese garden art.

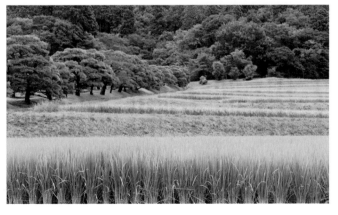

SHOSEI-EN
渉成園

Location: Aidanocho-higashi,
Shimogyo-ku, Higashitamamizu-cho 300.
Hours: March–October: 9.00 a.m.–5.00 p.m.
November–February: 9.00 a.m–4.00 p.m.
Fee: ¥

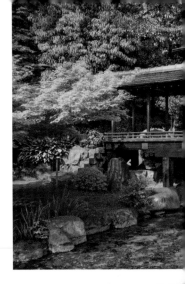

A well-integrated and creatively managed ensemble of ponds, stone and wooden bridges, Japanese style reception halls, teahouses and pavilions, Shosei-en's compound of design themes are prefigured even before entering its main grounds. The Taka-ishigaki or "High Stone Wall," immediately visible on passing through the west gate, is composed of a glorious jumble of stone materials ranging from granite slabs and millstones to uncut mountain rocks and cornerstones. Shosei-en was purportedly designed in the mid-seventeenth century by Ishikawa Jozan, a Confucian scholar, poet and calligrapher. The object of much transformation, restoration and reconstruction, today's garden, an annex of the great Higashi-Hongan-ji temple,

is a surprisingly expansive site. The seasonal flowering of wisteria, camellia, azalea, water lily, iris, gardenia, spirea and bush clover form a colorful counterpoint to the

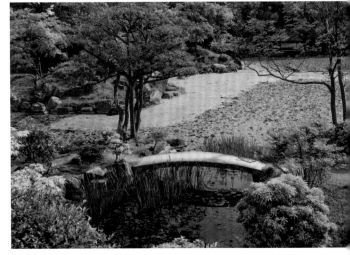

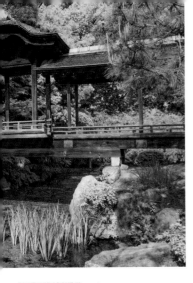

OPPOSITE ABOVE The outer walls of the garden blend rock forms, and even include a circular millstone.

LEFT Water lilies and algae gather in dense profusion at the edge of the main pond.

overwhelming dominance of greenery provided by masses of trees placed along the periphery of the garden. A Buddhist temple garden with a parkland character, it is easy to linger in the generous grounds of Shosei-en, which, though a mere 10-minute walk from Kyoto Station, remain serenely peaceful.

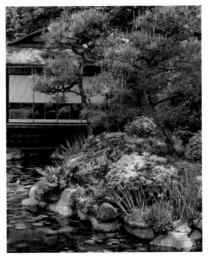

ABOVE CENTER A symmetrically poised covered bridge spans an inlet of the garden's main pond.

ABOVE Visitors dressed in summer kimono (*yukata*) pose for a shot on the bridge.

LEFT A teahouse on the bank of the pond is rarely open to the public.

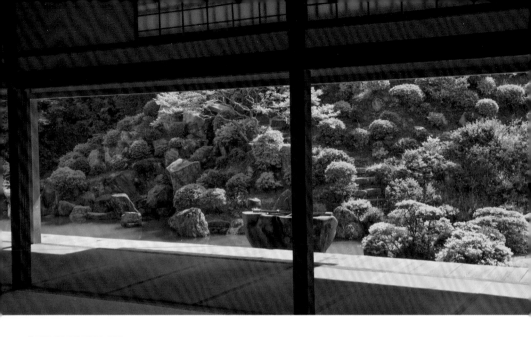

CHISHAKU-IN
智積院

Location: 964 Higashiyama-ku, Higashikawara-cho, 605-0951.
Hours: 9.00 a.m.–4.00 p.m. **Fee:** ¥

Dating from the Momoyama era, this garden was rebuilt in 1674 and again after a 1947 fire. Visitors enter the south garden along a broad veranda. This portion of the garden is an exercise in graduated topiary, with a broad, flat expanse of shrub-bery tilted at forty-five degrees, above which there are countless azaleas, tightly clipped into forms resembling balls of mercury. Inspired by the mountain of Lu-shan in China, a narrow waterfall carves a passage through the maze of shrub-bery and rocks that cover the steep hillside of the main eastern garden, providing the focal point in front of the *shoin*, a spacious viewing pavil-ion. The problem of how to counter what might appear to be an over-abundance of rocks piled up against

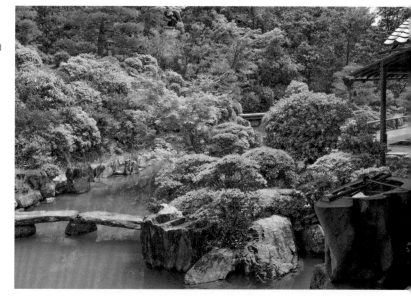

the hill facing the *shoin*, is skillfully resolved by introducing stones into the pond itself and placing other rocks under the veranda at angles visible from the deck. The unusual manner in which the veranda is placed recalls a *tsuridono* or fishing pavilion. Chushaku-in is a fine example of the synthesis of architecture and landscape, a feature of many Japanese gardens that is often only noted unconsciously. This is as it should be, the effect so seamless that one hardly notices.

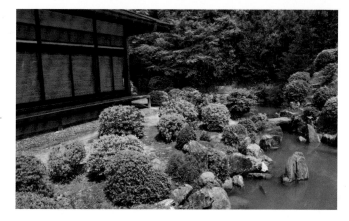

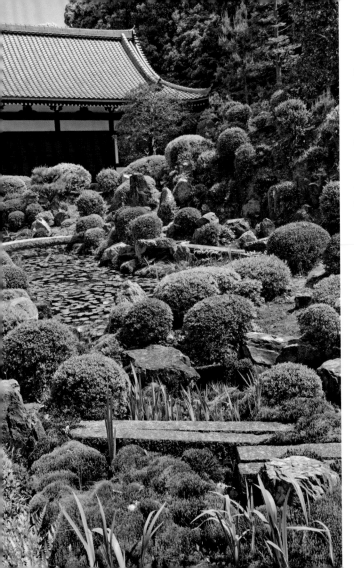

TOFUKU-JI
東福寺

Location: 15-778 Honmachi, Higashiyama-ku. **Hours:** 9.00 a.m.–4.30 p.m. **Fee:** ¥

When Shigemori Mirei was invited to create the Abbot's Hall garden in 1938, Tofuku-ji was deeply in debt, unable to offer any remuneration. Confident in his untested skills, Shigemori extracted a single condition from the head abbot: if the work was to be pro bono, he was to have a completely free hand in its design and execution. The temple environs demanded a division into stylistically diverse areas. The work that Mirei created was called the "Garden of Eight Phases," a reference to the eight stages in the life of the Buddha. A seemingly infinite expanse of gravel representing the sea occupies the south side of the Abbot's Hall, the dry landscape arrangement, muscular horizontal and upright stones set in the east corner of the garden, symbolizing the Chinese Islands of the Immortals. A startling

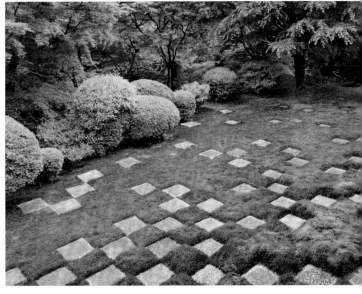

ABOVE LEFT Set amidst swirls of gravel, these temple foundation stones represent the constellation's Great Bear.

LEFT *Mitate mono*, or "found objects," like these stone bases, are common features of gardens.

ABOVE A checkerboard of stones sunk in moss represents traditional Chinese land divisions.

OPPOSITE Divided into east and west sections, Fumon-in is a splendid jumble of rocks, granite bridges, water plants and bushes.

checkerboard pattern occupies the north garden. A bank of azaleas adds mass to the background, suggesting distant, undulating hills. As you continue to circle the main hall, you will come to the small but cosmologically infinite eastern "Garden of the Big Dipper," representing the constellations. What makes Tofuku-ji so rewarding is that it consists not of a single garden but a complex of numerous subtemples, each with their own uniquely styled landscapes.

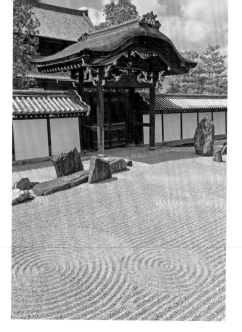

ABOVE An imposing gate and sharply vertical stone representing Shinsen Mountain are central features of the south garden.

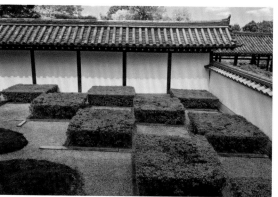

LEFT A grid pattern made from azalea bushes in the west garden represents a matrix design that is both tradition and modern.

LEFT An elevated pavilion is cantilevered above a deep valley full of maple trees.

RIGHT A soaring triad of stones in the park-like outer gardens of the temple. The stones are set against flowering azaleas.

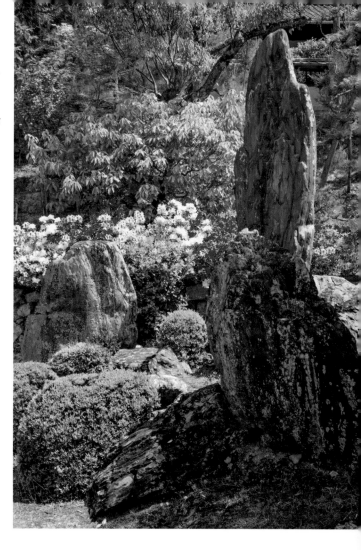

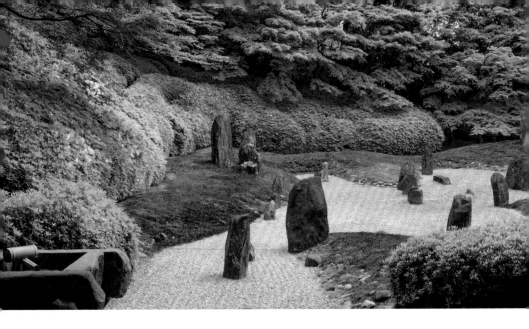

KOMYO-IN
光明院

Location: 15–809 Hommachi, Higashiyama-ku. Hours: 8.00 a.m. to sunset. Fee: ¥

The Hashin-tei garden at Komyo-in, a subtemple of the large Tofuku-ji compound, was laid out as a dry landscape garden in 1939. One of Shigemori Mirei's first projects, his mastery of space and perspective is already apparent in this early work. The swirling topiary and the garden's moss-covered hillocks create the impression of an undulating ocean surface. A teahouse named Ragetsu ("Mossy Moon") overlooks the garden. A glance at Shigemori's original drawings for the garden reveal a complex nest of diagonal lines connecting stones in what appears to be a power grid, with a *shaka sanzon*,

ABOVE The complex site lines of this garden connect stones in a dynamic grid of interdependency.

a triad of three Buddhist Shaka stones, also referred to in generic terms as a *sanzon ishigumi*, as its focal point. The name of the temple, Komyo, is made up of two Chinese characters, the *ko* signifying "light from the sun" and *myo* standing for moonlight and stars, both used in Buddhist terminology. When combined, the two characters represent rays emitting from the central Buddha stone. It is yet another instance of how a little knowledge of the principals and concepts underpinning design can add immensely to the appreciation of Japanese gardens.

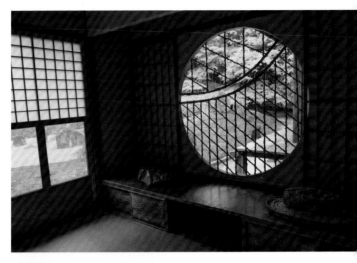

ABOVE Subdued light in a study room overlooking Komyo-in, also known as the "Garden of Hashin."

LEFT Azaleas in full bloom at the entrance to the garden.

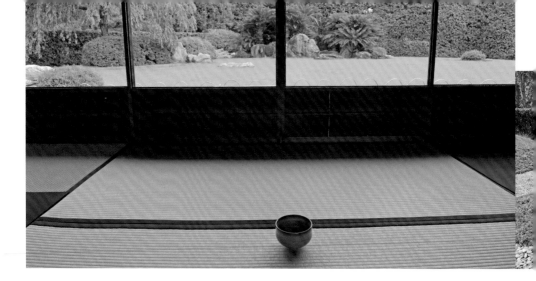

JONANGU
城南宮

Location: 7 Nakajima Tobarikyu-cho, Fushimi-ku.
Hours: 9.00 a.m.–4.30 p.m. **Fee:** ¥

The 20-minute walk from Takeda Station to Jonangu passes through an unpromising urban mash of raised expressways, love hotels, electrical installations and a cement factory, which makes the green and orderly environs of Jonangu all that more of a sanctuary, a wondrous anomaly. At Jonangu, the prominent twentieth century landscape designer Nakane Kinsaku created a gallery of historical styles in interconnecting gardens representing the Heian, Muromachi, Momoyama and contemporary periods. In these ambitious, boldly conceived works, the design allusions are simple and clear. The Heian garden, consisting of plants believed to have been used at the time, achieves a sinuousness from the placement of two streams flowing from a pond with an island at center. The Muromachi and Momoyama sections of the grounds are notable for another pond, a well-appointed teahouse and a generous lawn, its grassy expanse a substitute for the raked sand or gravel of a dry landscape garden. It is a contemporary reinterpretation that confirms how Jonangu illustrates the possibilities of Japanese gardening in the modern age.

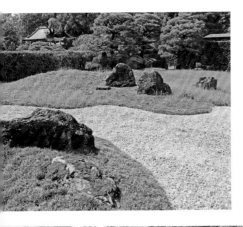

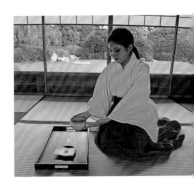

FAR LEFT A single bowl placed in a tearoom overlooking a generous expanse of lawn.

LEFT Grassy borders suggestive of clouds are a feature of the dry landscape garden.

BELOW Purling brooks add an air of refreshment to the gardens.

ABOVE Green tea served by a young woman in garments similar to those worn by shrine maidens.

BELOW A typical *tsukubai* or water basin.

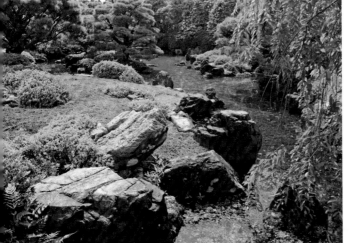

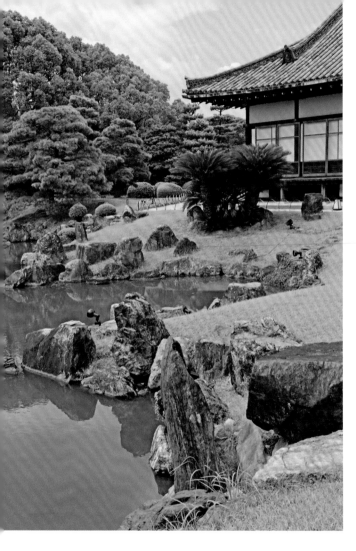

NIJO CASTLE GARDEN
二条城 二の丸庭園

Location: 541 Nijo-cho, Nakagyo-ku.
Hours: 8.45 a.m.–5.00 p.m. **Fee:** ¥¥

The shogun Tokugawa Ieyasu ordered the construction of this garden shortly after assuming power in 1600. A symbol of political authority in the imperial capital, the garden occupying the Ninomaru, or secondary enclosure of the castle grounds, was completed in 1626, the year Kobori Enshu was commissioned to restore parts of the design. Enshu cleverly rearranged some of the rocks so that it was possible to view the garden from all of the rooms surrounding the central pond. The absence of ancient stumps and shrubs suggests that the original pond may have been devoid of water, a view corroborated by old photographs showing a garden resembling a dry landscape. Gigantism characterizes the design, with a massive stone bridge leading to a Horai Island and an ensemble of huge, irregularly shaped rocks. Traces of the

simplicity that characterized the former Muromachi era are visible in some of the flat-topped stones deployed in the garden, but for the most part understatement has been replaced with an impressive individualism of style embodied in large, forceful rocks, an assertion of the authority of Ieyasu himself. The garden has a durable quality, as if it might challenge the erosions of time. Dense greenery masses beside the water margins, but there are said to have been no trees in the original design. Falling leaves, it was thought, would remind the shogun of the impermanence of existence.

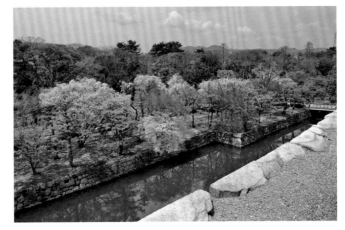

OPPOSITE Rocks create a bold, almost fortified shoreline around the pond.

ABOVE The cherry blossom season attracts even more visitors than usual.

BELOW A fine bridge topped by *giboshi*, bronze finials.

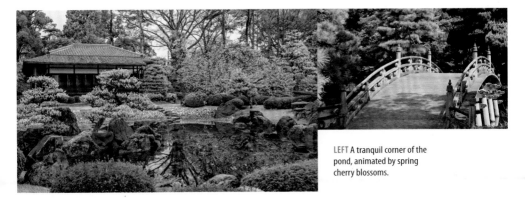

LEFT A tranquil corner of the pond, animated by spring cherry blossoms.

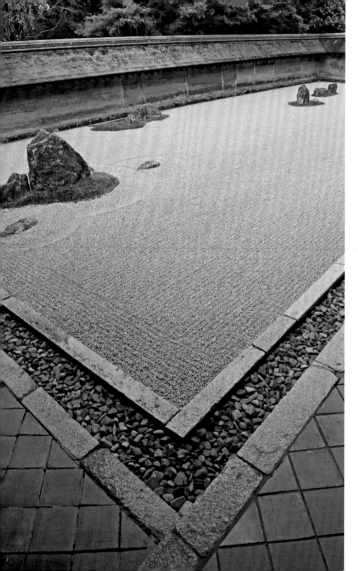

RYOAN-JI
龍安寺

Location: 13 Ryoanji Goryonoshita-cho, Ukyo-ku. **Hours:** 8.00 a.m.–5.00 p.m. **Fee:** ¥

Ryoan-ji must surely be one of the most photographed gardens in the world. Its rectilinear lines and enigmatic rock formations, inspiring the British painter David Hockney to create photomontages of its form, which has been interpreted as both garden composition and art installation. The pared down nature of the design, based around fifteen stones inserted into a bed of raked gravel, seems very contemporary but is believed to date from around 1500, a number of years after a Zen temple was established there. Besides a few touches of moss growing on the rocks, there are no plants in the garden, making it one of the purest, most reductive examples of the dry landscape form. Such is the almost talismanic power of the garden that some Zen priests hold that the mind, subjected to intense

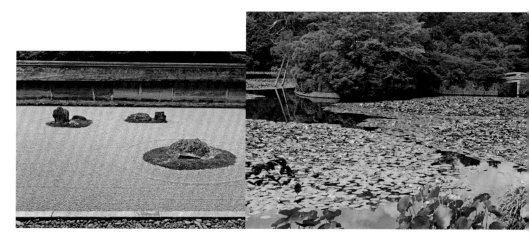

contemplation of the landscape, will teleport the viewer into the garden, expanding the limited dimensions of time and space into the infinite. Visitors should also note the garden's earthen walls. Made from rammed clay kneaded in oil, the retaining walls are a feature in their own right. With the passage of time, the oil has seeped out, creating a surface of mottled yellows, ochre and browns that give it an organic, aged aspect. Designated a National Treasure, it is as if the picture frame were almost as precious as the painting.

ABOVE In half a millennium, the garden at Ryoan-ji has changed little.

OPPOSITE The simple rectangle of Ryoan-ji conceals a depth of meaning and interpretation that continues to intrigue onlookers.

ABOVE The outer grounds of the site, with a water lily covered pond.

BELOW This water basin is unusual in being hollowed out with a perfect square in the middle.

KINKAKU-JI
金閣寺

Location: 1 Kinkaku-ji-cho, Kita-ku.
Hours: 9.00 a.m.–5.00 p.m. **Fee:** ¥

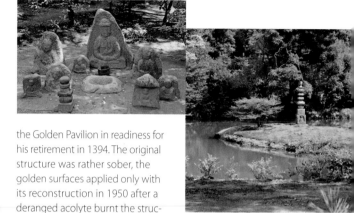

Drawing inspiration from the design concepts originating in the Heian era and influences from China's Song dynasty, the third Ashikaga shogun, Yoshimitsu, spared no expense in constructing the Golden Pavilion in readiness for his retirement in 1394. The original structure was rather sober, the golden surfaces applied only with its reconstruction in 1950 after a deranged acolyte burnt the struc-

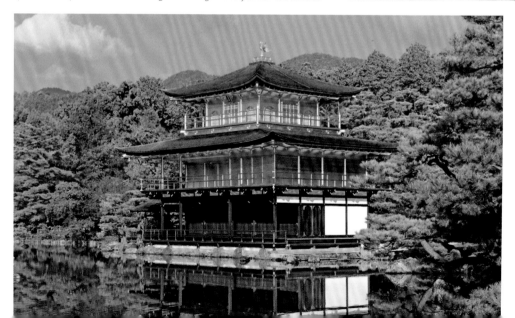

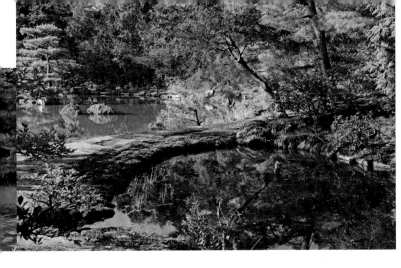

FAR LEFT A group of Buddha figures appear to be sitting in deliberation.

CENTER LEFT A stone pagoda graces a small island, conferring it with the sacred.

LEFT Hints and tints of autumn arrive in late October.

ture to the ground, an incident explored in Mishima Yukio's novel, *The Temple of the Golden Pavilion*. It is natural to first pay tribute to the pavilion, located on the edge of a pond known as Kyoko-chi ("Mirror Pond"), but then to turn our attention to the outline of Mount Kinugasa at the rear, forming a perfect borrowed view. Although the moss-saturated grounds cover a mere four and a half acres, the skillful control of foreground, middle and background create the illusion of extra space. Undulating pond embankments, immaculately pruned pine trees, small islets, miniature peninsulas and rocks

placed in the waters, suggest a painterly shoreline. A row of four rocks near the perimeter represent vessels anchored at night before making their journey to the Islands of the Immortals, much alluded to in Chinese mythology. A fine

model of the synergy of buildings and landscape, the temple's grounds appear to have been created in accord with descriptions of the Western Paradise of the Buddha Amida, elevating a pleasure garden into a divine vision.

RIGHT The horizontal white lines indicate the high status of a temple and possible connections with the imperial family.

OPPOSITE The garden's unsurpassed pavilion appears to float on the pond.

TAIZO-IN
退蔵院

Location: 35 Hanazono Myoshinji-cho, Ukyo-ku. **Hours:** 9.00 a.m.–5.00 p.m. **Fee:** ¥

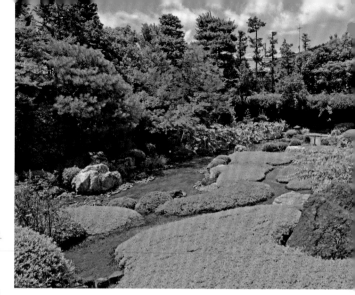

The temple of Taizo-in hosts two quite different gardens with no apparent interconnecting concepts. Nakane Kinsaku's contemporary landscape, located in the lower reaches of the temple grounds, is a stroll garden with a stream tapering downhill into a small pond. The narrowing watercourse creates the sensation of depth, the technique highlighting Nakane's skillful control of design and placement. The stream is bordered by well-trimmed shrubbery, its headwaters distinguished by a three-tiered waterfall. Vertical rocks in the depths of the garden contrast with flat stones in the foreground, another perspective expanding method. The painter Kano Motonobu (1476–1559) is credited with designing the Muromachi era dry landscape garden to the west of the Hojo, the Superior's Quarters. This claim is lent credence by the design similiarity of the garden to the Kano School of painting. This recreation of a three dimensional landscape combines Chinese Song dynasty techniques with Japan's prevailing *yamato-e* painting methods. The central focal point of the garden is its Mount Horai rock cluster, but there is also a visually dominating dry waterfall placed against deep foliage suggestive of a forest, a turtle island and a symbolic lake which flows beneath a bridge. This important garden is often overlooked by visitors.

ABOVE The upwardly curving lip of this stone lantern adds lineal flow to the garden.

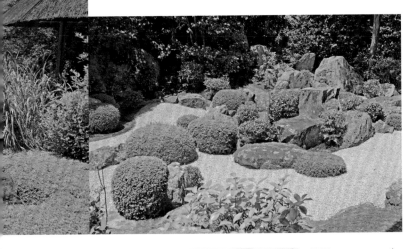

FAR LEFT Watercourses through the main section of the garden, a welcome presence in high summer.

LEFT Taizo-in's much older Muromachi era garden is of great historical import.

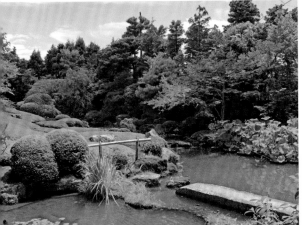

LEFT Late summer sees the blossoming of lotus but also the first traces of autumn.

BELOW A shady pergola is the perfect place to relax and contemplate the garden.

KEISHUN-IN
桂春院

Location: 11 Hanazono, Teranonaka-cho, Ukyo-ku. **Hours:** 9.00 a.m.–5.00 p.m. **Fee:** ¥

Keishun-in, a subtemple of the imposing Myoshin-ji complex, was founded in 1598. A wonderfully serene environment, the deployment of limited space is impressive. The temple has four small gardens, beginning as you enter with the Shojo, a tiny inner garden. Visitors proceed to the Wabi Garden, a *roji* or tea garden with stepping stones leading to the Kihaku-an, a tearoom, and the Shinyo Garden. The Baike-

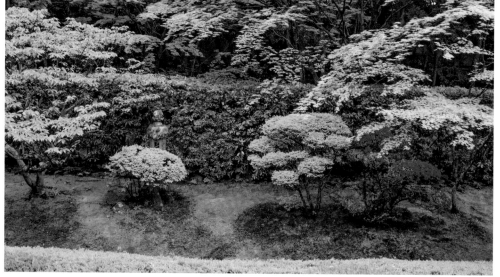

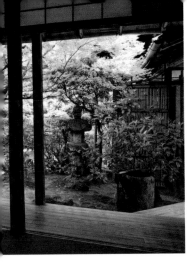

LEFT The rusticity of the view from this open-sided room aligns the design with the style of the *cha-niwa*, the tea garden.

RIGHT In the most accomplished temple gardens there is an almost seamless line between landscape and architecture.

OPPOSITE A mottled stone lantern provides the focal point for the dry landscape garden.

BELOW A fluid depiction of pine trees cover *fusuma* sliding doors.

mon gate divides the site into separate but conjoined zones. Largest is the Seijo, the "Garden of Purity," located in front of the main hall. Its alternative name is the Meditation Garden. Where the land slopes, there is Soryu-chi ("Pond of the Azure Dragon") and an old well. A huge Japanese andromeda tree adds interest to the garden. To the east of the abbot's residence, sixteen rocks represent *arhat*, the followers of the Buddha. A central rock has been placed nearby for the purpose of Zen meditation (*zazen*). Listed as a dry landscape creation, Keishun-in feels like it was created in the spirit of the tea garden.

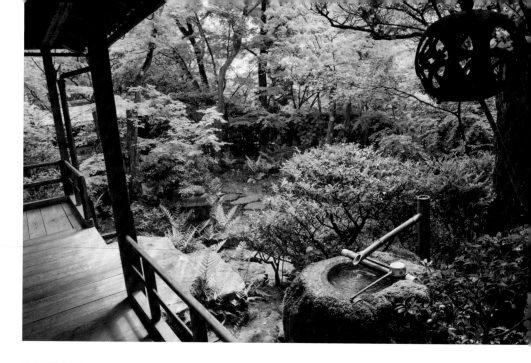

DAIHO-IN
大法院

Location: Ukyo-ku, Hanazono, Oyabu-cho, 20. **Hours:** Visiting times are limited to mid-April to mid-May and November 1–30: 9.00 a.m.–4.00 p.m. **Fee:** ¥¥. Includes green tea and a sweet.

Created in the spirit of the tea garden, Daiho-in, founded in 1625 and tucked into a corner of the great Myoshin-ji temple complex, emits the atmosphere of a hermitage. The *roji* or "dewy path" of this Edo era design leads to a teahouse, emphasizing an affinity with the *chaniwa* or tea garden. Despite the lush, mossy grounds and canopy of trees, designed to create a forest setting, Daiho-in is also categorized as a dry landscape garden. Created to evoke the Buddhist *seijo sekai* or "pure world" ideal, an imposing stone lantern, modest but well-formed rocks and a *tsukubai* (wash basin) are among the only additional features to this wonderfully understated garden. Powdered green tea and a Japanese sweet are served in a room

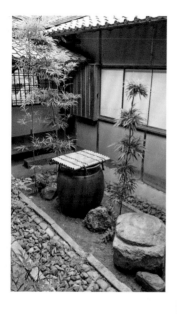

LEFT Stone, clay and bamboo objects add interest to an inner garden.

OPPOSITE Despite numerous elements, the garden never feels congested.

with a perfect view of the main garden. Daiho-ji is only open to the public in the spring when the fresh maple leaves are at their best, and in autumn when visitors come to see the changing leaves. The head priest opines that the moss is at its best during the early summer rainy season when the grounds are soaked and the garden stones, wet and glossy, are dark and luminous.

ABOVE The first fallen leaves of autumn begin to carpet the ground.

LEFT Ferns and low bush growth have been placed around the lantern to soften the effect of stone.

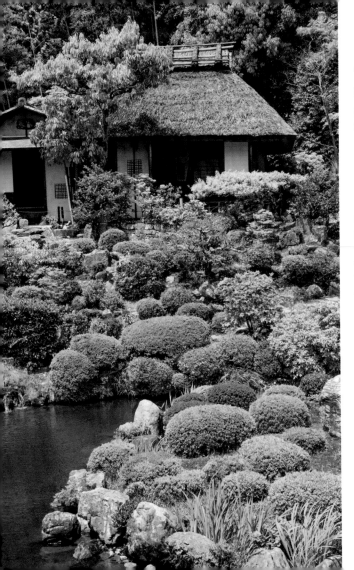

TOJI-IN
等持院

Location: Kitamachi 63, Kita-ku.
Hours: 8.00 a.m.–5.00 p.m. **Fee:** ¥

Founded in 1341, Toji-in hill and pond garden is characterized by the beauty and precision of its design and a refining tea aesthetic that lends the composition a quiet dignity. Located in a tranquil residential area at a safe remove from the city's increasingly busy tourist routes, the main feature of the eastern garden is a pond shaped in the form of the character *kokoro*, standing for "heart" or "spirit." An intense compression of rocks and azalea bushes creates the impression of a weightless act of levitation as our eyes climb the slope that rises from the pond to rest on Seiren-tei, a classic teahouse. Stone paths, concealed amidst the dense greenery, connect the upper and lower levels of the garden. A stone bridge leads to a small island built

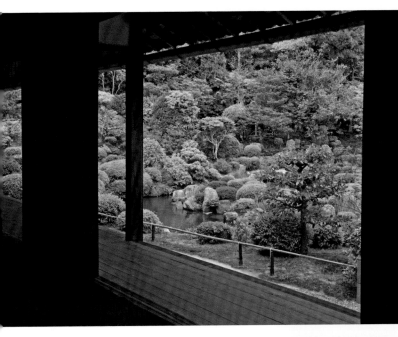

LEFT The main viewing room, the Hojo, overlooks a pond with a Horai island replete with rocks and azalea bushes.

BELOW Cool water gurgles into a stone basin, a welcome touch in Kyoto's humid summer months.

to recall the island of Horai in Chinese mythology. Japanese maples, camellias and fragrant olive add color and texture to the landscape. A dry landscape garden, entirely flat and with a minimal amount of stone and moss, forms an independent southern garden. Routinely attributed to Muso Soseki, there is, in common with many similar assertions for other gardens, no evidence to support this claim.

OPPOSITE An intensely cultivated hill ascends to Seiren-tei, a teahouse originally erected by the eighth shogun, Yoshimasa.

KOTO-IN
高桐院

Location: 73 Murasakino-Daitokuji-cho, Kita-ku.
Hours: 9.00 a.m.–4.30 p.m. **Fee:** ¥

Passing through the gate of Koto-in, a subtemple garden of the important Daitoku-ji Zen monastic complex, a fine stone walkway conveys you beneath a canopy of trees to the main building. A bed of moss occupies the main space of the south garden. In autumn, the delicate beauty of the spot is covered with fallen leaves, giving Koto-in its alternative name, the "Garden of Maples." In winter, a dusting of snow performs another transformation. A dry landscape garden without rocks, gravel or sand, the south garden acts as a mirror of the changing seasons. A single stone lantern, a focal point of the garden, stands in silent sentinel year round. A stone path connects two teahouses that are the main features of a tea garden to the west of the main build-

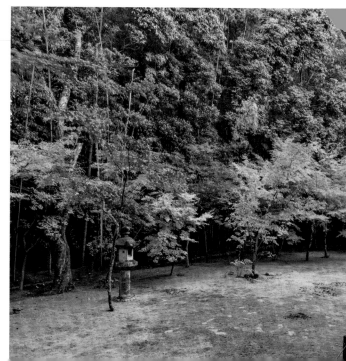

LEFT An interesting confluence of stone, granite, tile and pebbles.

BELOW South of the Hojo, the moss garden is shaded by maple trees and tall stands of bamboo.

LEFT This leafy, meandering path conforms to the tea aesthetic of rusticity.

BELOW One of the pleasures of the garden at Koto-in is that it is not over-maintained.

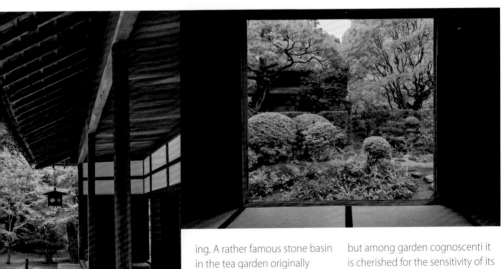

ing. A rather famous stone basin in the tea garden originally served as a foundation stone at the imperial palace in Korea. Koto-in receives relatively few visitors from the general public but among garden cognoscenti it is cherished for the sensitivity of its design and as a place where the beauty of nature and the passing of time can be contemplated in the most serene of settings.

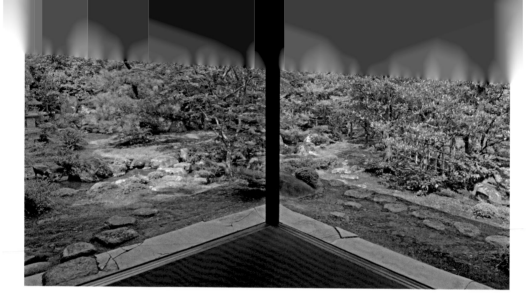

NISHIMURA-KE
西村家庭園

Location: 1 Kamigamo Nakaoji-cho, Kita-ku. **Hours:** March 15–December 8: 9.30 a.m.–4.30 p.m. **Fee:** ¥

Located in an area known as Shake-machi, close to Kamigamo Shrine, a short stone bridge is crossed to enter the grounds of the Nishimura residence, a home originally built for Shinto priests serving at the shrine. Of the forty homes remaining in the district, this is the only one open to the public. Visitors are requested to ring the bell at the entrance to summon the keeper of the house, who will guide you into a *tatami* room facing the garden before disappearing into the recesses of the building. In an already quiet residential district, the earth walls and dense trees at the edges of the garden act as a further sound barrier, creating a space that is one of the most tranquil in the city. A little frequented spot, it is quite possible you will have the view of this relatively small garden, incorporating elements from a number of landscape forms, to yourself. A shallow pond surrounded by trees

LEFT It is not clear if this sunken feature is the remains of a well or a water basin.

RIGHT After crossing a stone bridge, visitors approach the house along this quiet path.

BELOW The formal quality of the garden is softened by water and greenery.

and stone paths at the side of the house is easy to miss. The timeless quality of this subgarden recalls a Zen-inspired poem by the *haiku* master Basho Matsuo:

> *An ancient pond*
> *a frog jumps in*
> *water's sound.*

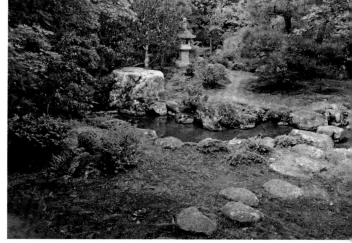

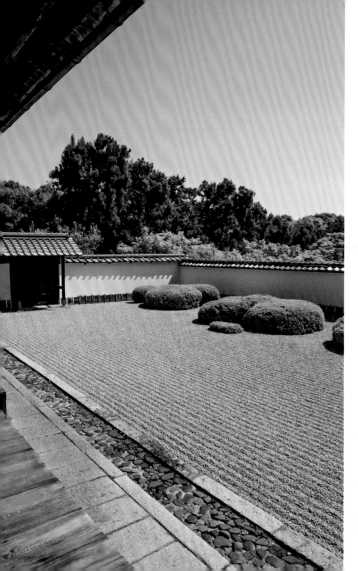

SHODEN-JI
正伝寺

Location: 72 Nishigamo-Kitachinjuan-cho, Kita-ku. **Hours:** 9.00 a.m.–5.00 p.m. **Fee:** ¥

At a welcome remove from Kyoto's well-established garden viewing routes, the dry landscape design at Shoden-ji temple may be part of the city but feels a world apart. As you climb towards the temple through a cedar wood, the first thing you note is the fragrant air. One is reminded that the word *sorin*, meaning "dense forest," is also used in a literary sense to signify a Zen temple. Like many stone gardens, Shoden-ji, an early Edo period *karesansui*, depends on a strong sense of enclosure for its effects. The second blessing is that rarest of things in contemporary Kyoto— a view of distant Mount Hie from the wooden veranda, one completely devoid of wires, buildings and other urban trappings. In place of stones, the auspicious number-

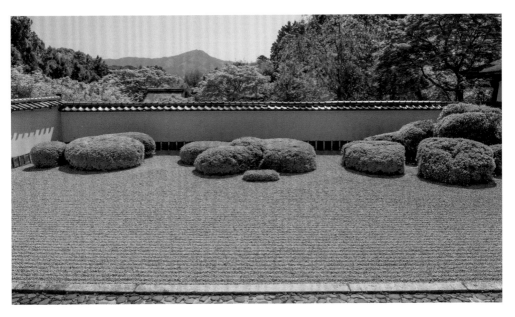

ing 7-5-3 is achieved with a row of tightly clipped azalea bushes. Odd numbers are favored over even ones, irregular lines over the straight in the Japanese garden, which strives for asymmetric balance. At secluded gardens like Shoden-ji, conducive to contemplation and reflection, we experience both the suspension and teleporting of time.

ABOVE Unimpeded by urban clutter, a perfect view of Mount Hiei, providing "borrowed scenery" for the rock garden.

LEFT Stones, some with speckles of gold leaf, at the bottom of a water basin.

OPPOSITE Without using stones, the garden achieves a decorative but minimalist character.

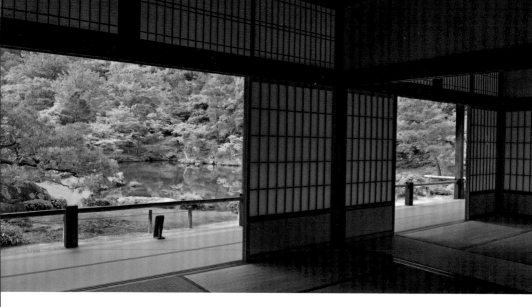

TENRYU-JI
天龍寺

Location: 68 Susukinobaba-cho, Saga-Tenryuji, Ukyo-ku.
Hours: 8.30 a.m.–5.30 p.m. **Fee:** ¥

ABOVE A large *tatami* matted room provides subtle framing for viewing the garden.

In the early morning, when Tenryu-ji and its magisterial circuit garden are opened to the public, its expansive grounds feel as fresh, natural and unsullied as the first day of the world. The Rinzai Zen temple was built in 1339 and is, with its great open-sided Main Hall,

Abbot's Quarters, covered walkways and vermilion balustrades and pillars, unquestionably the most imposing religious building in Arashiyama. As impressive as the complex is, it has become to some degree subservient to its landscaping, one of the oldest surviving

stroll gardens in Japan. Laid out by Kobori Enshu, one of Japan's most influential landscape designers, its central pond is shaped in the form of the ideographic character *kokoro* or "Enlightened Heart." A Chinese painting depicting Mount Horai, the center of the Buddhist Cosmos,

RIGHT A moss-covered mound adds ornamental interest to the secondary grounds of the garden.

BELOW One of the oldest examples of "borrowed scenery," Tenryu-ji represents one of the most dynamic examples of composition in Japanese garden history.

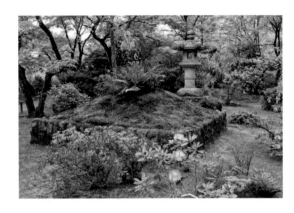

is said to have inspired the concept and there are visible Chinese touches, particularly the garden's Song period style seven rock arrangement. A complex cluster of rocks, arranged in mostly vertical patterns, form the impressive Ryu-mon-no-taki, the "Dragon Gate Waterfall." The Arashiyama and Kameyama hills have been requisitioned as "borrowed views," providing a lush green backdrop to the garden, expanding its already generous spatial peripheries.

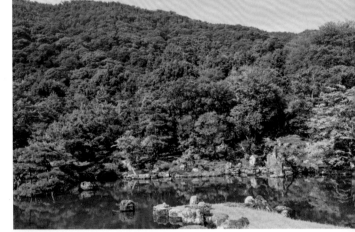

OKOCHI SANSO
大河内山荘

Location: 8 Tabushiyama-cho, Saga Ogurayama, Ukyo-ku.
Hours: 9.00 a.m.–5.00 p.m. **Fee:** ¥¥

Withdrawing from the jade colored Katsura River a few steps west of Tenryu-ji temple, visitors enter a narrow pedestrian lane buttressed by a towering bamboo forest. The sense of finally being immersed in a rural setting enriched with cultural assets is felt a little beyond the bamboo lane as the entrance to the Okochi Sanso Garden appears. Built in 1939, the garden occupies a swath of landscaped slope on the side of Ogura Mountain, with splendid views of Mount Arashi to the east, Hozukyo Gorge and distant Mount Hie. The garden was commissioned by Okouchi Denjiro, a renowned screen actor, who amassed a vast fortune playing, among other roles, the one-

BELOW Hillside, forest and winding paths are stacked above the Momoyama style main residence.

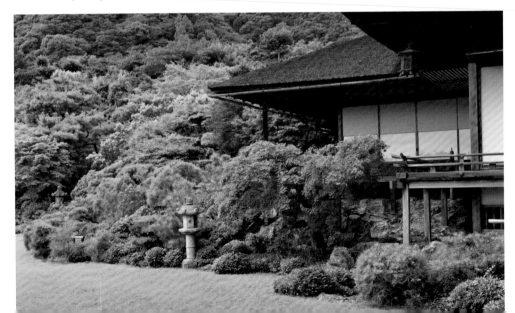

LEFT An old stone lantern with a Buddhist motif at its base.

RIGHT A small shrine building deep within the garden grounds.

BELOW The view from within the visitors' teahouse, where green *matcha* tea and a traditional sweet are served.

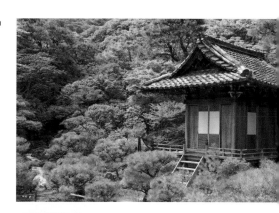

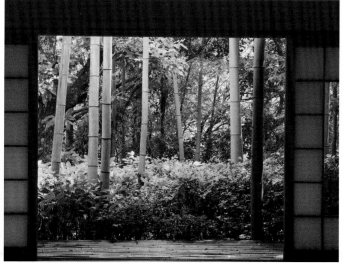

armed, one-eyed masterless samurai Tange Sazen. A devout Buddhist, he devoted three decades developing this stroll garden, which occupies a generous 215,000 square feet (20,000 square meters) of land build on the site where the renowned poet Fujiwara Teika collected verse that would appear in the literary classic *Ogura Hyakunin'isshu* (Ogura Anthology of One Hundred Poems by One Hundred Poets). There are seldom more than a handful of visitors at any given time in the grounds of the garden, with its elegant villa, teahouses, winding paths and suitably weathered Buddhist statuary.

GIOU-JI
祇王寺

Location: 32 Kozaka-cho, Saga Torimoto, Ukyo-ku.
Hours: 9.00 a.m.–5.00 p.m. **Fee:** ¥

BELOW The unusually low level of this lantern has the intended effect of being non intrusive.

The predominant color of Arashi-yama, on the outskirts of Kyoto, is jade. Though scrupulously maintained, the forest landscaping at Gio-ji temple is far removed from the formalisms of the Japanese garden. If you came upon this scene in a forest glade you would regard it as a perfectly naturalistic scene. The art of this garden lies in the hidden, non-invasive hand of its creators. Tucked into the foothills of Mount Ogura, the grounds are one of the loveliest locations in Arashiyama. Reminiscent of a farmhouse, the thatched structure of the temple faces a garden with deep beds of moss that are almost stereotypical in their perfection, conforming to many visitors preconceptions of what traditional Japan should look like. Where the exposed summer moss in other Kyoto gardens tends to wither to

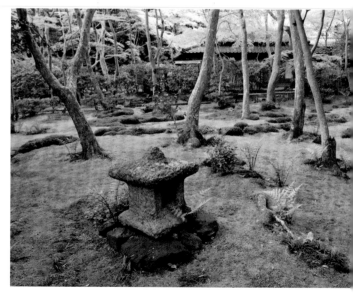

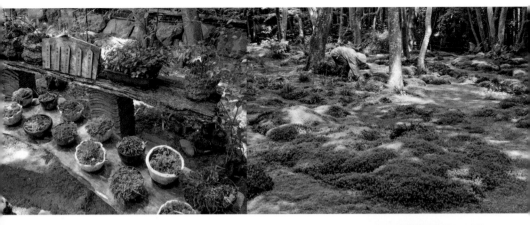

ABOVE LEFT The empty chamber at the center of this stone lantern can be used as a firebox when a candle is lit.

ABOVE CENTER Potted moss contrasts with the garden's naturalism.

ABOVE RIGHT Weeding the moss garden is a slow and time-consuming activity.

RIGHT A rather over-ornamentalized corner of the garden.

BELOW A face can just be made out in this ancient stone.

a russet brown, the moss that grows beneath the thick canopy of trees at Gio-ji thrives in all seasons. Here, the earth itself is hidden beneath the greenery. Serpentine tree roots are visible and small humps of moss indicate smothered rocks in a garden that has a subterranean ambience, like shafts of light penetrating the green shallows of an algae-rich pond.

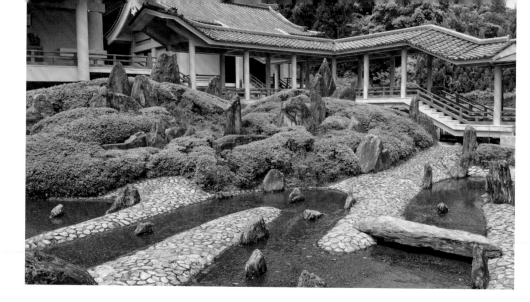

MATSUO TAISHA
松尾大社

Location: 3 Arashiyama-miyamachi, Nishikyo-ku. **Hours:** 9.00 a.m.–4.00 p.m. **Fee:** ¥

Shigemori Mirei frequently used the term "eternal modern" to represent his ideas and to define the aesthetic sense underpinning his work. Nowhere is the application of this term more evident than at Matsuo Taisha Shrine where Shigemori was able to synergize tradition and modernity. The Horai Garden, representing the ancient Chinese Realm of the Immortals, is the first landscape visitors encounter before moving to the Undulating Stream Garden to the east of the complex. Here, a water channel, reminiscent of Heian era gardens, flows. Courtiers enjoyed a literary pastime in which one would write the first line of a poem and then float it down a meander-

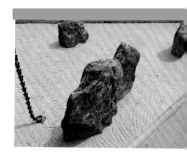

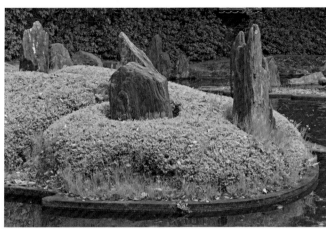

ing waterway to another guest, who would pick it up and add another line. The banks of the stream are embedded with flat blue stones, the bed with gravel. In the Garden of Ancient Times to the north, powerful rocks, tilted at exaggerated angles reminiscent of primitive stone circles, brim with a sense of vitality in what many consider to be Shigemori's finest stone setting. Aside from the highly assertive character of the arrangement, the garden has a transcendent quality, inspired perhaps by the local divinities resident at the shrine.

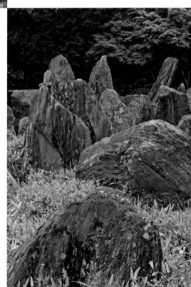

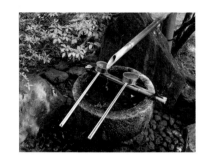

SAIHO-JI
西芳寺

Location: 56 Jingatani-cho, Matsuo, Nishikyo-ku. **Hours:** By appointment.
Fee: ¥¥¥. **Special Features:** Application to visit must be made by
sending a return postcard with desired visit day to the temple.

Created as a Pure Land Paradise
Garden in the twelfth century,
then redesigned by Muso Soseki
in 1339, Saiho-ji is also known as
Koke-dera, the Moss Garden. The
upper section of the grounds, with
an early dry landscape arrange-
ment, and the lower area domi-
nated by a pond, were integral to
Soseki's creation of an environ-
ment suitable for the gaining of
enlightenment. The garden we
see today owes much of its beauty
to an act of neglect. Abandoned
to the forces of nature, large trees
took root, providing shade and
moisture, perfect conditions for
the growth of moss. The garden
pond is formed in the shape of the
Japanese *kanji* for "heart" (*kokoro*),
which can also be understood to
signify "mind." Alex Kerr has written
of Saiho-ji, "The lake is one giant
kanji inscription, done in water and

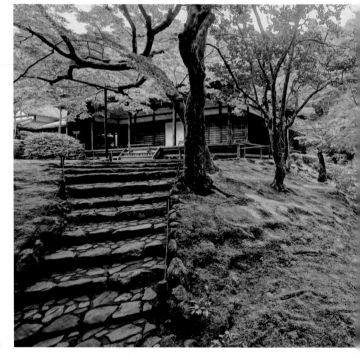

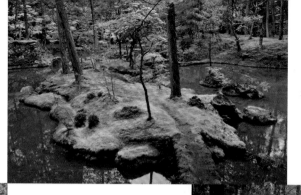

LEFT Probably a later addition, this stone basin is a traditional garden element.

LEFT One of a number of moss-covered islands at Saiho-ji.

LEFT Autumn foliage contrasts with the green tea hues of moss.

RIGHT Several gurgling brooks run through the garden.

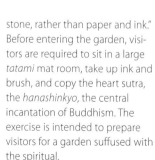

stone, rather than paper and ink." Before entering the garden, visitors are required to sit in a large *tatami* mat room, take up ink and brush, and copy the heart sutra, the *hanashinkyo*, the central incantation of Buddhism. The exercise is intended to prepare visitors for a garden suffused with the spiritual.

KATSURA RIKYU
桂離宮

Location: Katsura Misono, Nishikyo-ku.
Hours: 9.00 a.m.–3.30 p.m. Closed Mondays. **Fee:** ¥¥¥. **Special Features:** Application to visit must be made by sending a return postcard with desired visit day to the temple.

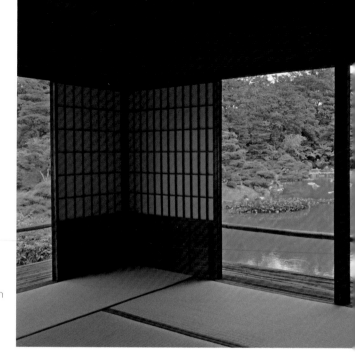

Visits to Katsura Rikyu Imperial Villa are devotional, undertaken in the knowledge that this is one of Japan's most important gardens. Originally the rural estate of Prince Toshihito (1579–1629), the addition of extensive refinements to the grounds required many years to complete. The main villa is considered a masterpiece of Japanese architecture, the structure employing the very finest craftsmen and rarest materials. Judiciously placed stepping stones, rock groupings, plants, teahouses and a central pond create a carefully conceived asymmetric landscape that served as a prototype for countless stroll gardens of the nobility during the Edo period. Arranged around a pond of complex contouring, a perambulation of the shoreline reveals countless fresh perspectives. Long attributed to the landscape designer Kobori Enshu, more recent research suggests that his role was more likely that of consultant. Immaculately tended, some visitors may find the garden on the cold and formal side. It is, after all, an imperial landscape, the closest a garden can get to visual protocol.

Not a stray leaf in sight, topiary razor sharp, paths immaculately swept, the thatched roofs of teahouses freshly cut, this is a garden fit for imperial gaze. A high point in the art, the renowned German architect Bruno Taut, recognizing its harmonic brilliance as the apotheosis of Japanese aesthetics, was responsible for introducing the garden to the West.

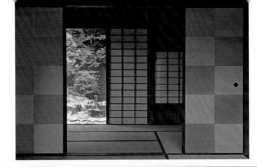

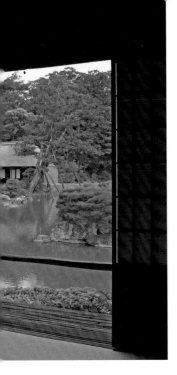

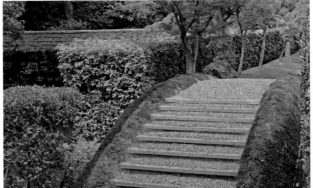

ABOVE For anyone wishing to know about the classic Japanese garden, Katsura Rikyu is considered a highly instructional model.

RIGHT Exquisitely balanced and maintained bamboo fences are an important feature of the garden.

TOP Rooms like this exemplify the *sukiya* style of design, defined as "structures of refined taste."

ABOVE Earthen bridges, known as *dobashi*, often use materials like logs, grass and cedar bark.

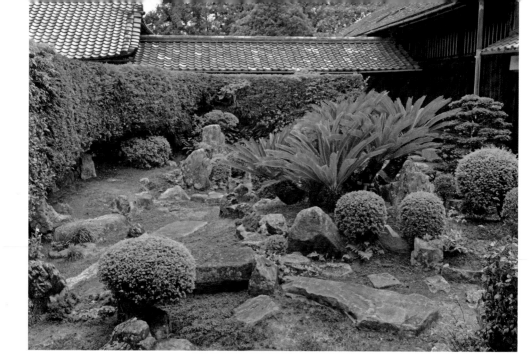

HIEZAN SAKAMOTO
SHOJURAIKO-JI
聖衆来迎寺

Location: Otsu-shi, Hieitsuji, 2-4-17.
Hours: 9.00 a.m.–5.00 p.m. **Fee:** ¥

There is something very special about gazing at a garden that was created hundreds of years ago by a stone-setting priest. Aside from the odd addition or replacement of bushes, hedges and other plantings, including an imposing clump of cycads, the original form of this Momoyama era design has remained remarkably intact since the sixteenth century. A temple settle-ment where structures were built to accommodate retired Buddhist monks, the district of Sakamoto in which this ancient garden nestles lies beneath mighty Mount Hiei and its eponymous temple, one of the most important Buddhist sites in Japan. Built in imitation of Lake Dotei in China's northern Hunan province, the garden, created by the monk Sensaiji Soshin, consists

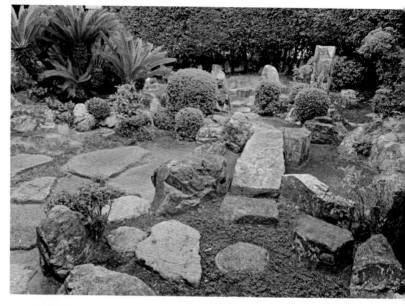

ABOVE Cycads or sago palms, known in Japanese as *sotetsu*.

LEFT Visitors feel a sense of reverence gazing at a garden that was created in the sixteenth century.

ABOVE The powerful structure of this garden is best appreciated from the slightly elevated viewing deck.

LEFT Cut from natural stone, this water basin seems as old as time itself.

of highly effective contrasts between large and small rocks in accordance with the design principals set out by the *Sakuteiki*, an influential Heian period gardening manual written by Tachibana Toshitsuna. A stone slab representing a bridge hints at the existence of water, absent in material form but pervasively present as a symbol in this dry landscape garden.

OHARA
SANZEN-IN
三千院

Location: Raikoin-cho, Sakyo-ku. **Hours:** 8.30 a.m.–4.30 p.m. **Fee:** ¥

LEFT An ancient, sage-like figure carved from stone.

BELOW A section of garden beside the Amida Hall, known as Ojo-gokuraku-in, is smothered in greenery from cryptomerias and moss.

Founded in 985, this Tendai Buddhist temple is rather grand, its history venerable. Located between two streams rippling down the slopes of Gyosan (Fish Mountain) in the village of Ohara, the temple was once considered remote and isolated. Even now, with easy bus access from Kyoto, its green and mossy environs can seem timeless. Its main garden viewing structure, the Hondo, is also known as the Temple of Rebirth in Paradise. Maples and towering cryptomeria trees grow from lush beds of moss, creating a canopied world that, despite the support of the temple's numerous visitors, creates the sense

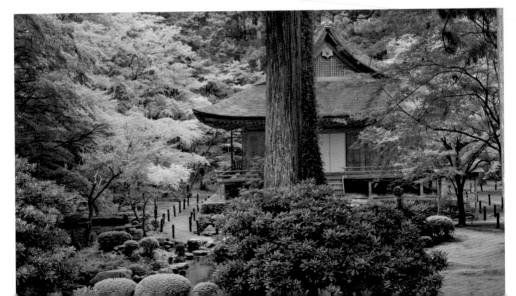

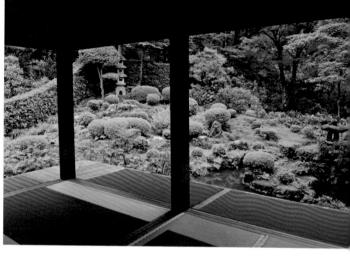

ABOVE LEFT Hard materials like stone are placed throughout Japanese gardens against the softer surfaces of leaf and water.

ABOVE The intricately composed Shuheki-en or "Garden That gathers Greenery," sits on the east and south side of the reception chamber.

LEFT The central focus of this tiny inner garden suggests the image of a verdant island surrounded by water currents.

of a private, concealed universe. Paths lead up from this area through a forested slope where clumps of hydrangea come into blossom during the June rainy season. Smaller, but no less exquisite gardens accessed from the Hondo surround a structure known as the Kyoku-den. These are veritable miracles of meticulously clipped topiary shrubs and hedges. These sights are at their greenest in the late spring and early summer months, but if you are lucky to visit Sanzen-in when the snow falls, the gardens are transformed into a white and silent wonderland.

OHARA
JIKKO-IN
実光院

Location: 187 Ohara, Shorinin-cho, Sakyo-ku. **Hours:** 9.00 a.m.–4.30 p.m.
Fee: ¥¥

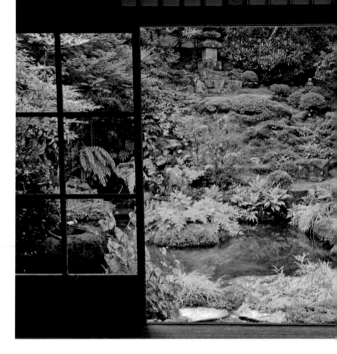

The Tendai sect temple of Jikko-in and its garden, Keishin-en, are often overlooked by visitors to nearby Sanzen-in. A subtemple of Shorin-in, this unassuming garden draws water from the Ritsusen River to feed its small, heart-shaped Shinji-ike Pond. This is best viewed from a seated position on the *tatami* mats of the Kyaku-den Guest Hall. The water in the pond is said to divide the garden into the foreground area, which represents our everyday life in an essentially material existence, while the area beyond the water symbolizes paradise, the world of the Buddha. A group of rocks near the waterfall stand in for Mount Horai, a legendary Chinese peak, while a pine tree on an artificial hill is understood to be emblematic of a crane, and the

ABOVE The pond viewing garden is best observed from its Guest Hall.

small island in the pond a tortoise. A brook runs from this water enclosure to a gourd-shaped pond encircled by rocks. A *chisen kansho teien* (pond and fountain viewing) garden designed in the late Edo era for strolling, Mount Koshio and Mount Konpira act as borrowed

BELOW The mossy rim of a water basin with water lilies.

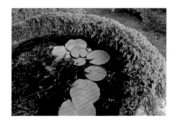

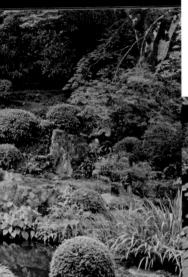

RIGHT Powdered green tea is served with *wagashi*, a Japanese sweet, in the main Guest Hall.

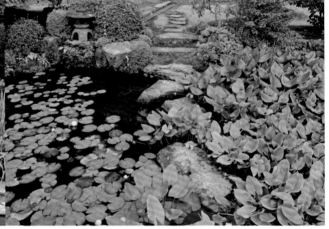

ABOVE A mass of water plants in one of the garden's smaller ponds.

LEFT A well-weathered Oribe stone lantern. The name comes from the celebrated tea master Oribe Furuta.

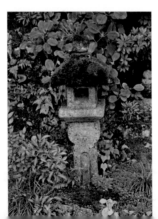

scenery, expanding the dimensions of a relatively confined space. The absence of large numbers of visitors, the restrained landscaping and the use of locally sourced wildflowers rather than cultivated types, add to the muted elegance of the garden.

OHARA
HOSEN-IN
宝泉院

Location: 187 Shorin-cho, Ohara, Sakyo-ku.
Hours: 9.00 a.m.–4.30 p.m. Fee: ¥¥

ABOVE A well-supported 700-year-old pine tree.

ABOVE CENTER A Japanese bellflower displayed in a bamboo flower vase at the entrance.

The garden of this Tendai sect temple is known for its 700-year-old pine tree, an assertive visual element in an otherwise highly understated layout. The modest lower garden consists largely of mounds of conical gravel, patches of moss and carefully trimmed hedges accessed from stepping stones. The main *tatami* mat room where powdered green tea is served, looks onto a mossy rock garden with a row of bamboo trees just beyond a perimeter that plunges into a deep valley. The view is framed by the wooden

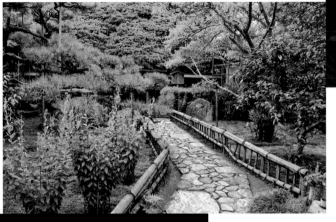

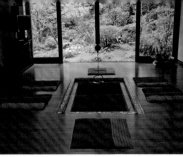

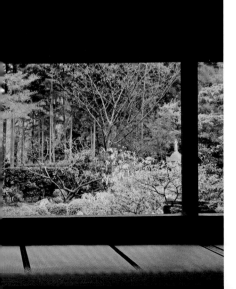

ABOVE The charming entrance to the temple is enhanced with seasonal flowers.

TOP RIGHT An *irori*, a sunken hearth, is the focal center of this garden-viewing chamber.

LEFT Listen carefully and, beyond the tranquility of this room with a view of the inner garden, you can hear a distant waterfall.

pillars of the room, creating a composition resembling a painting or horizontal scroll. Visitors can place their ears to two bamboo pipes piercing the wooden veranda of the inner garden to hear the calming ripple of its *suikinkutsu*, an inverted ceramic pot filled with stones. As water is filtered into the contraption, it emits a sound often compared to that of *shomyo* or Buddhist chanting, a form of devotion introduced into Japan after the priest Ennin's return from China in AD 847. An exquisite side garden contains a small pond whose outline replicates a crane stretching its wings. A small hill symbolizes the turtle, both symbols of longevity. Hosen-in's weathered stones, bamboo fencing and beds of emerald moss bear the features of an ancient, time-worn enclosure. Remarkably, the garden was built as recently as 2005.

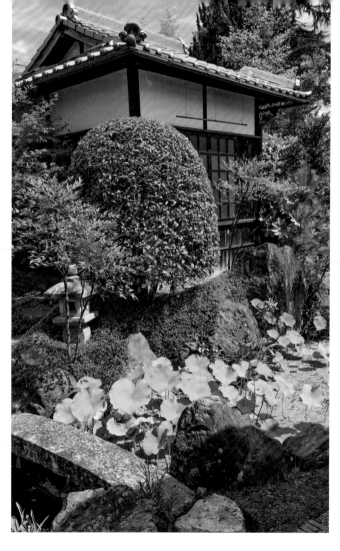

ZUIKO-IN
瑞光院

Location: Uji-shi, Gokasho, Sanbanwari.
Hours: 8.30 a.m.–5.00 p.m. **Fee:** ¥

There is an artificiality to the garden at Zuiko-in, a deliberate reminder that the divine may be present, but the landscape is firmly rooted in garden concepts, the design the result of human mediation. Rather too small to fit its definition as a

FAR LEFT Crossed by a granite bridge, this corner of the pond has the character of a channel.

LEFT An effective interplay between bridges, rocks and trimmed hedges.

ABOVE, LEFT TO RIGHT The sacred lotus at various stages in its summer evolution.

BELOW LEFT A water basin flanked by rocks and false *jalap*, a fragrant perennial plant.

chisen kaiyu, or stroll garden with pond, the design incorporates in its use of powerful boulders elements of the stone garden. A contemporary L-shaped garden, a carp-filled pond flows around this small temple's main room, its form complemented by a sinuous ridge of azalea bushes to the rear of the landscape. Pink lotuses, a Buddhist symbol of the evolution from mud and slime to the elevated heights

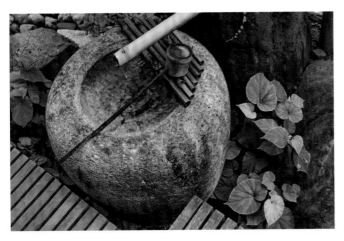

of enlightenment, bloom in the early mornings of summer. Other effective garden elements include a stone basin, a centrally aligned waterfall and a seven-story stone pagoda that, standing in the corner of the garden, adds stability and visual focus to the entire design. Half the fun of visiting Zuiko-in is in locating this little visited temple, a short distance from Uji. Tucked into a back lane among a scattering of other quasi-religious looking buildings, its most treasured offering to the visitor is serenity.

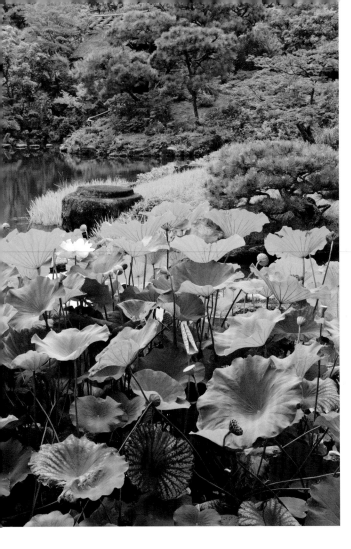

ISSUI-EN
依水園

Location: 74 Suimon-cho, Nara.
Hours: 9.30 a.m.–4.00 p.m. Closed Tuesdays.
Fee: ¥¥

Issui-en was purchased in the Enpo era (1673–81) by a wealthy bleacher and maker of fine quality Nara ramie textile, Kiyosumi Michikiyo. Stepping stones link the shore of the main garden pond to a small island. The stones were once used as mortars in the process of sizing ramie cloth and for grinding the pigments used in dyeing. Surrounded with miniature trees and carefully trimmed bushes, white lotuses bloom at the edges of the pond in the summer months. Typical of the Meiji era, azalea bushes substitute for rocks in providing mass and form. Rising above the green tiers of the garden's clipped and precise topiary, visitors can glimpse a segment of Todai-ji temple, the huge

LEFT It is best to be at the garden when it first opens as lotuses bloom early.

roof of its Great Buddha Hall. Girded with water, the inner pond at Issui-en is fed by winding streams similar to those placed in Heian period gardens. The Yoshiki River, reduced to a shallow, burbling brook, meanders through the garden beneath wooded glades. Combining privacy and openness, there is space enough, you would think, to attract attention and comment. The only stroll garden in Nara, the wonder of Issui-en is that it is so little known.

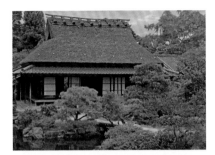

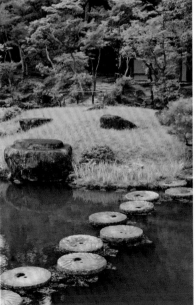

ABOVE LEFT The thatched roof of this teahouse is covered with shells, an old practice intended to confuse the fire god into thinking its surface is the sea.

ABOVE Diamond-shaped stone arrangements are occasionally used in gardens to break the monotony of gravel.

LEFT A clever contrast of land embedded and floating stones emphasizes two elemental zones.

FAR LEFT Water basins are sometimes matched with stone lanterns to create a miniature composition.

NARA
YOSHIKI·EN
吉城園

Location: 60-1, Noborioji-cho. **Hours:** 9.00 a.m.–5.00 p.m.
Fee: ¥. **Special Features:** Free admission for foreigners
on production of ID.

RIGHT Besides their
utilitarian use, stone steps
promote the connection
to untrammeled nature.

BELOW The incised stone
object also acts as an
indicator of elevation in
this multi-tiered section
of the garden.

Named after the Yoshikigawa, a
stream running beside the garden,
this site of a former temple resi-
dence passed into private owner-
ship in the Meiji era. The current
garden was built in 1919, after
which the city of Nara took over
both ownership and management
of the grounds. These were
opened to the public for viewing
and tea ceremony events in 1989.
Such cultural activities, and the
sensitive manipulation of the natu-
ral landscape, have saved the gar-
den from the fate of being merely
a sophisticated municipal park.
Open areas carpeted in hair moss
(*polytrichum*), are placed beside
wooded arbors, a medium-sized
pond garden, its banks intensely
planted, and a tea ceremony gar-
den where a variety of flowers
suitable for seasonal display are

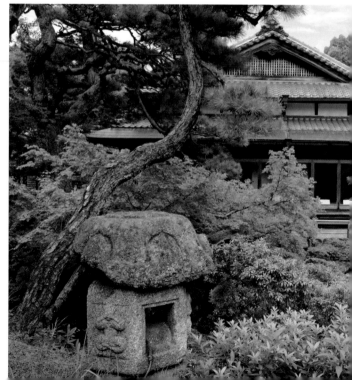

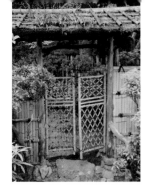

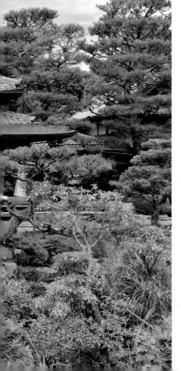

LEFT The shingle roof and unfinished timber of this gate express modesty and naturalness.

BELOW It was not until 1989 that the garden and its attached structures were opened to the public.

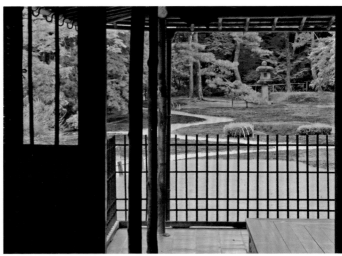

cultivated. Small thatch-roofed huts, wooden gazebos, moss-covered stone lanterns, stone pagodas and well-worn paths add a patina of age to a garden that is barely a century old. A popular spot during the autumn when its leaves, including scarlet maples, come into their own, this is an all-seasons garden.

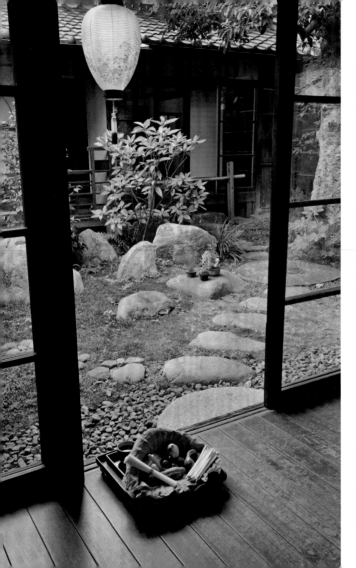

NARA
NIGIWAI-NO-IE
にぎわいの家

Location: Nakashinya-cho, 630-8333 Nara City. **Hours:** 9.00 a.m.–5.00 p.m. Closed Wednesdays. **Fee:** None

Built in 1917 but with the refined tastes of an earlier age, this tradesman's house is a fine example of the domestic architecture and garden design of a literate merchant class that had already acquired an advanced level of appreciation of culture in all its expressions and practices. In the manner of these merchant houses, with their narrow frontages with rooms stretching back into the plot, this narrow, L-shaped, north-facing garden is deeply recessed, enjoying great privacy. Outside and inside corridors and polished wood verandas offer varying perspectives on the garden and its elements, which include meandering stepping stones, water lavers, flat millstones, sleeve fences, ornamental lanterns, and a time-worn temple pillar

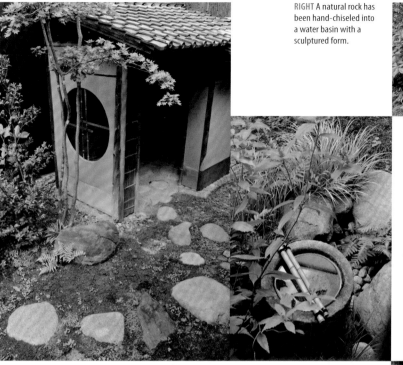

RIGHT A natural rock has been hand-chiseled into a water basin with a sculptured form.

LEFT Planting ferns and grasses beside stone ornaments creates a forest floor mood.

stone. Rooms are appointed in such a manner that an entire perspective of the garden is possible, but only in visual portions, an effect that forces the viewer to devote attention to each panel of the design. This emphasizes how the good taste evident in the house interior translates to the garden.

ABOVE A tea garden touch is achieved with this *koshikake machiai,* or roofed waiting bench.

OPPOSITE The display of vegetables is a reference to the original owner's trade in fresh foods.

RIGHT A large, disk-shaped millstone breaks up the monotony of the stone path.

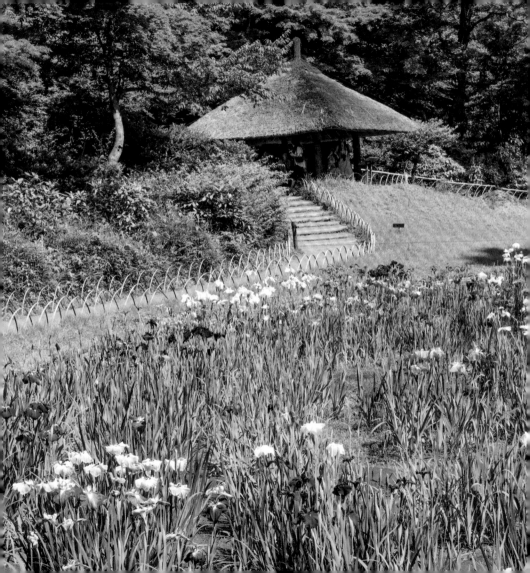

Part Two

Tokyo Gardens

Typically overshadowed by Kyoto, it comes as a surprise to realize that Tokyo may very well have the foremost concentration of formal gardens of any Asian capital.

Garden scholars have been unrelentingly snooty in comparing the refinements of Kyoto with the purportedly showier gardens of Edo (Tokyo), but as this book demonstrates the capital is home to an extraordinary number of accomplished gardens commissioned by the heads of noble families or, in a later period, wealthy entrepreneurs.

Now displayed in the Idemitsu Museum of Art collection, panels from a work known as the *Screens of Famous Sites in Edo*, show the city as it was around 1629–30, just three decades after its founding. The screen is careful to balance mercantile activity, crowded streets, bridges, aquaducts and waterfront teahouses with great swathes of greenery and landscaped gardens. As the urban features of the city expanded, so did its vegetation, with masses of natural trees and shrubs retained. This was the age of aristocratic gardens and those of elite samurai estates, but there were also green shrine and temple compounds, vegetable plots and riverbanks.

Under a powerful shogunate, the *daimyo*, forbidden from spending funds on enlarging their military arsenals, turned instead to amassing art collections and commissioning the erection of teahouses on their estates. Single teahouses, contrived as models of rustic simplicity but forming the setting for refined cultural practices, expanded in number and scale, providing outlines for the Edo era stroll garden. Here, guests could undertake a circuit of the grounds designed to reveal a series of partial perspectives resembling a *mise en scene*. Contrary to the trend in Japan and the West to view landscapes as objects of visual appreciation, their original function was to serve as venues for pleasure and hospitality. Gardens were also requisitioned as sites for outdoor banquets, poetry readings, duck hunting, falconry and fishing.

Western visitors to the city in the mid-nineteenth century, were struck by the green, semi-rural character of Edo, its natural features sustained by water, a nexus of rivers, ponds, moats and canals. Edo's moist air and fertile earth lent themselves to intense growth.

Consolidating his interest in the Japanese garden, the British architect Josiah Conder was the first to

LEFT Built in 1895, this iris pond flows into an adjoining pond where a profusion of water lilies grow.

write a book on the subject in English. His *Landscape Gardening in Japan*, published in 1893, contains a number of monochrome photographs of Tokyo *daimyo* gardens that no longer exist. Mercifully, some of the gardens in Conder's book have survived, albeit on a reduced scale.

Tokyo as we know it today is often characterized as an urban jungle, its dispensation of green spaces comparing unfavorably with Western cities. You may have to spend a little more time seeking out its gardens, but once found these precious spaces go a long way to ameliorating the more numbing aspects of the world's largest megalopolis. Here, it is still possible to smell the flower scents of spring, and in autumn to sense the decay of the organic, to inhale the leaf mold beneath your feet in the depths of an old, moldering garden. Tokyo's former *daimyo*, entrepreneurial and flower gardens, and its more contemporary designs, models of innovative space management within an urban environment, are vital for the health of the city. Without them, Tokyo would be a poorer place, reduced to airless streets, and in the city's torrid summer months unbearable temperatures and siroccos of dust motes.

BELOW LEFT The main courtyard of Shunka-en, the finest bonsai museum in the capital.
BELOW CENTER The little known Denpo-i in the precincts of Senso-ji.
BELOW Autumn in the grounds of the Nezu Shrine Garden.

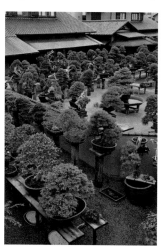
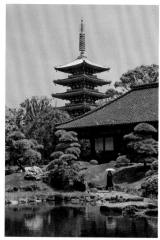
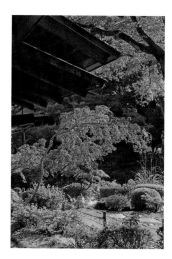

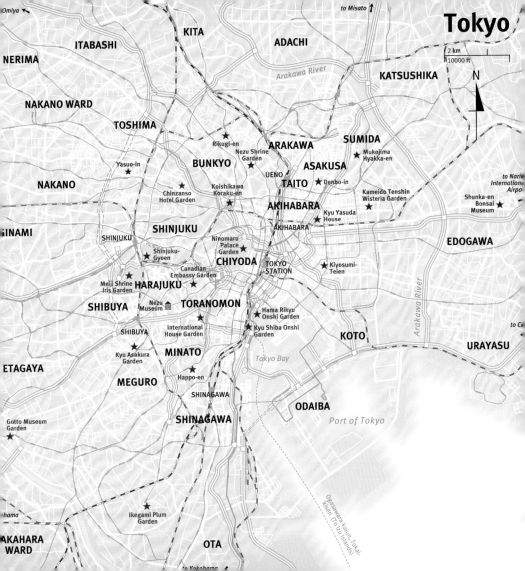

NINOMARU PALACE GARDEN
二の丸庭園

Location: Chiyoda 1-1, Chiyoda-ku. **Hours:** 9.00 a.m.–5.00 p.m. Closed Mondays and Fridays. **Fee:** None

Occupying a site within the environs of Edo Castle, the Shogun's villa and his successor's palace were built here along with a garden and teahouses. The current landscaping is a restoration based

on a sketch of the garden dating from the eighteenth century. The garden is attributed to Enshu Kobori, who is known to have designed only a handful of original gardens. The Ninomaru Garden, in common with many other gardens in Japan credited to Enshu, is likely a stylistic tribute to the master. One of the first steps taken by the Shogun Ieyasu after the castle grounds were laid out, was to create a camellia garden here. Today, the garden is noted for its Kurume azaleas and a central iris garden. Transplanted from the iris garden at Meiji Shrine, eighty-nine variet-

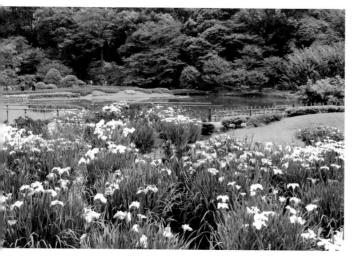

LEFT Part of a pond tentatively attributed to the master garden landscaper Enshu Kobori.

RIGHT The garden is full of easily overlooked details, such as this sunken stone.

LEFT The central stones in Japanese garden waterfalls are distinct for being positioned vertically.

ies of the flower bloom from May to June. Besides the four iris fields, cherry, crepe myrtle and wisteria surround a medium-sized pond. Cow lily, Japanese seedbox, floating-heart and pygmy water lily float on its tranquil surface. Teeming with flowers, trees, shrubs and even birdsong, the garden, astonishingly, is only a short stroll from the capital's roaring commercial centers.

OPPOSITE Also known as the Imperial Palace Garden, its iris pond attracts large numbers of visitors.

KYU SHIBA ONSHI GARDEN
旧芝離宮恩賜庭園

Location: 1-4-1 Kaigan, Minato-ku.
Hours: 9.00 a.m.–5.00 p.m. **Fee:** ¥

Once known as Rakuju-en, this early Edo era landscape design is one of the oldest stroll gardens in the city. Commissioned by Okubo Tadatomo, a senior councilor to the fourth shogun, Ietsuna, the site was constructed on reclaimed land near Tokyo Bay. The Shiba Detached Palace, as it was also called, was one of the city's *shioiri no niwa*, or tidewater gardens, a feature unique to Edo. The largest of the pond islands is Horai-jima, named after the mythic Chinese Isles of the Immortals. Black pines, a symbol of longevity, dot the island. In ancient China, Taoist teachings inveighed monks and other holy people to consume pine needles, resin and cones in order to absorb the energy of the tree. The rear section of the garden

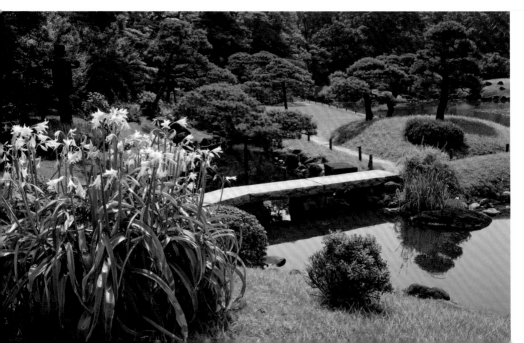

contains a hill named Kyua Dai, constructed for the Meiji emperor so that he could observe the tides washing into the garden, a pleasure that is no longer possible. Today, a grid of railway lines, busy roads and office blocks surround the site on four sides, but once in the garden these intrusions are moderated as our attention shifts from the audio plane to the visual.

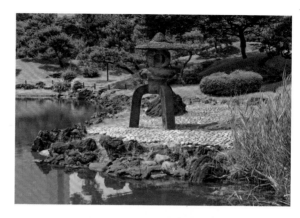

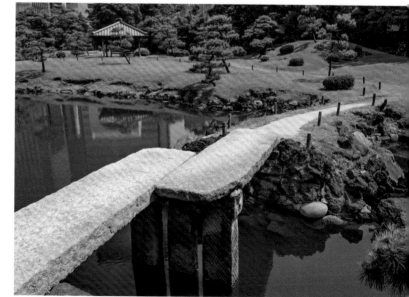

LEFT The profusion of pine trees associates the garden with ocean shorelines, where they are often planted.

ABOVE RIGHT This lantern, standing on a shoreline of pebbles, might be interpreted as a lighthouse.

RIGHT Granite is the preferred material of choice for making stone bridges.

HAMA RIKYU ONSHI GARDEN
浜離宮恩賜庭園

Location: 1-1 Hamarikyu Teien, Chuo 104-0046. **Hours:** 9.00 a.m.–5.00 p.m. **Fee:** ¥

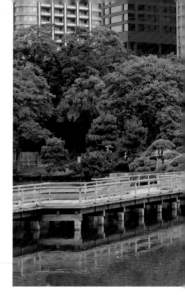

Construction of this garden, which remains largely intact in its essential elements, first began in 1654 on reclaimed marshland facing Tokyo Bay. Housing a residence for the imperial family, a succession of shoguns co-opted the grounds for their own pleasure and personal projects, developing in one instance the grounds for a hawking reserve. Yoshimune, the eighth shogun, created an experimental farm on the grounds, growing new crops and herbs. He is believed to have imported an elephant from Vietnam, which was kept on the grounds. An outstanding black pine close to the entrance of Hama Rikyu has become an object of near pilgrimage for Japanese garden lovers. The tree was planted in 1704 when the garden was remodeled to celebrate the succession of the sixth shogun, Ienobu. In spite of earthquakes, fires, typhoons and air raids, the pine has miraculously survived. The gnarled bark and ancient looking branches of pine trees typically suggest endurance, but also the craggy coastal locations where many pines once grew. These are often represented in compressed form at the edges of stroll garden ponds. The highlight of Hama Rikyu, however, is a large tidal pond, half fresh, half salt water, with a small tea pavilion at its center, and islets connected by wooden bridges. Sluice gates control the ebb and flow of what is the only remaining tidal garden in the capital.

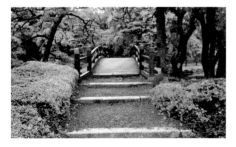

ABOVE Peonies were introduced into Japan in the eighth century and are now strongly associated with gardens.

LEFT Azaleas form an appealing passageway to this bridge.

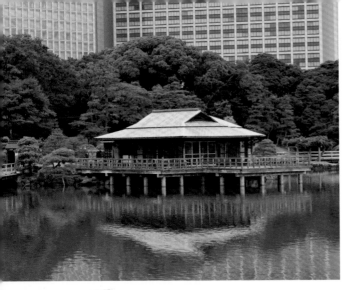

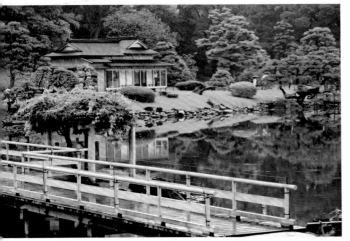

ABOVE CENTER What might once have been a distant view of Mount Fuji is now obstructed by office blocks.

ABOVE Flower fields and picnic areas have turned parts of the garden into the likeness of a park.

LEFT Wooden bridges that zigzag are a common feature of the Japanese garden.

INTERNATIONAL HOUSE GARDEN
国際文化会館

Location: 5-11-16 Roppongi, Minato-ku.
Hours: 9.00 a.m.–5.00 p.m. **Fee:** None

The garden we see today at the International House, a structure influenced by the Modernist movement, was designed by the influential gardener Jihei Ogawa (1860–1933). Commissioned by Koyata Iwasaki as an adjunct to a mansion designed to serve as a building for entertaining foreign

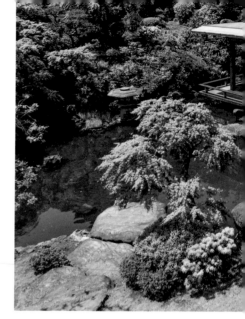

RIGHT Part of the first-floor premises have been skillfully cantilevered over a pond.

BELOW The designs of some Japanese landscapes are best appreciated from slightly elevated ground.

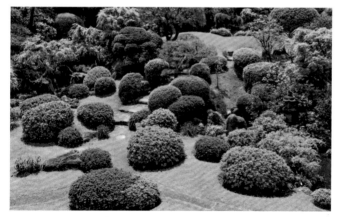

guests, the garden was completed in 1930. Ogawa's gardens are characterized by wide, open spaces that integrate lawns and water. For the student of the Japanese garden, there are many features of interest: a dry river, an ancient looking temple pedestal, two stone figurines in the deeper ever-glade rear of the garden, and time-worn stone statues. The garden strata conform to the classic Japanese approach of dividing landscapes into three portions. In this

RIGHT A Shinto priest and shrine maiden prepare ritual objects for a wedding ceremony.

BELOW It is extremely rare to find a dry landscape garden constructed on a flat roof.

case, the foreground is dominated by the lawn, the mid-section is planted with bushes and shrubs, with the denser background consisting of a tree-studded hill. The pressures on gardens located within areas of prime real estate is nowhere higher than in Tokyo. To their credit, the current custodians of Ogawa's garden and its Modernist addition have made sure it remains dedicated to lifting the spirits of its visitors, not to commercial advancement.

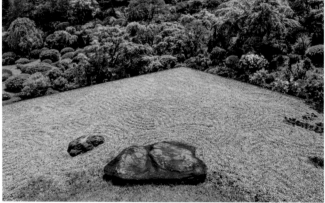

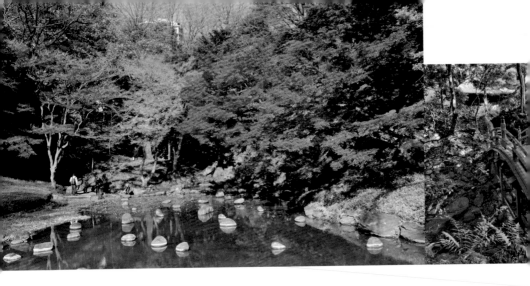

KOISHIKAWA KORAKU-EN
小石川後楽園

Location: 1-6-6 Koraku, Bunkyo-ku. Hours: 9.00 a.m.–5.00 p.m. Fee: ¥

Mercifully, several of Tokyo's Edo era *daimyo* gardens, landscapes built for the nobility, have survived, albeit on a reduced scale. Laid out in 1629, Koishikawa Koraku-en is Tokyo's oldest garden. Commissioned by Tokugawa Yorifusa, founder of the Mito clan, the name Koraku-en ("A Place to Take Pleasure After") has its origins in a Chinese poem by Fan Zhongyan, which reads: "Be the first to take the world's trouble to heart, be the last to enjoy the world's pleasures." The garden's Engetsukyo bridge, an exquisite "full moon" span in the Chinese style, though largely ornamental, may very well be the oldest intact bridge in the city. Observers with a little knowledge of the Chinese visual connotations found in many circuit gardens, will recognize an earthen watercourse passing through the center of the garden's small river. This is a miniaturized refashioning of a celebrated causeway that passes through Hangzhou's West Lake in China. Another Chinese allusion can be found in a small hill near the pond, which represents Mount Lu in Jiangxi province. The original Koishikawa Koraku-en encompassed 63 acres (25.5 hectares). The present

LEFT The brightly painted Tsuten-kyo represents a miniaturized version of a similar maple-viewing bridge in Kyoto.

RIGHT This stone promontory extends from a wooded Horai island.

BELOW Zigzag *yatsu-hashi* bridges are designed to offer eight views, often of iris fields.

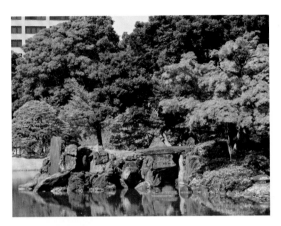

garden covers a much reduced but manageable 17 acres (7 hectares). The highlights of this garden lie in its details, particularly its quality masonry and stone paths, which appear to be entirely original features. The garden's tranquility is compromised somewhat by an adjacent amusement park replete with a huge roller-coaster, but this, to some extent, matches the original function of stroll gardens, which were created for pleasure and diversion. The garden we see today remains a wonderful introduction to Japanese gardens in general and to the stroll garden in particular.

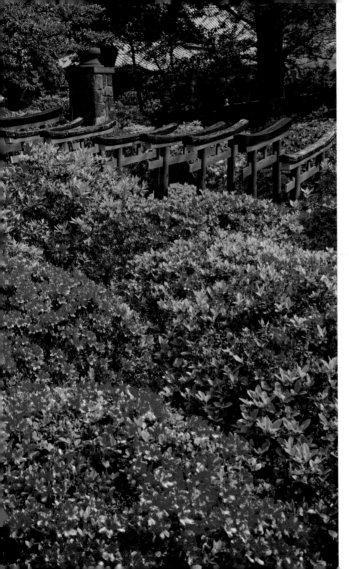

NEZU SHRINE GARDEN
根津神社

Location: 1-28-9 Nezu, Bunkyo-ku.
Hours: Mid-April to early May. **Fee:** ¥

Situated on a graduated slope within the precincts of Nezu Shrine, the Bunkyo Azalea Festival is one of the floral highlights of the city. Arguably the largest concentration of azaleas in the capital, over three thousand bushes occupy the 1.5 acre (0.6 hectare) grounds of the garden. Some one hundred varieties of the flower are on display, including, among the more common Kurume azaleas some rarities such as *hanaguruma* (pinwheel flowers), *Fuji-tsutsuji* (bean-size flowers) and *karafune* (black azalea). Azaleas have been long admired by the residents of Tokyo. Discovering that the local soil and climate were well suited to the cultivation of azaleas, Ito Ihee Sannojo, a nurseryman in the northern Somei district, then located on the rural outskirts of the city,

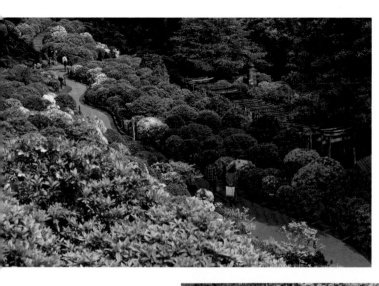

LEFT The azalea garden is honeycombed with pathways, each offering a differing view.

BELOW This section of landscaping is visible from outside the garden.

OPPOSITE A row of *torii* gates, the symbolic entrance to Shinto shrines, complements the tones of the azalea.

began cultivating the plants in the mid-seventeenth century. With affordable cultivars like the azalea, gardening, formerly a preserve of the nobility and samurai class, was taken up by merchant families and commoners, who displayed plants in pots set out along the boundaries and stoops of their tiny homes. Catering to high levels of literacy among all classes of townspeople, combined with a love of horticulture that persists to this day, Sannojo published an illustrated catalog in 1692 listing over three hundred varieties of azalea.

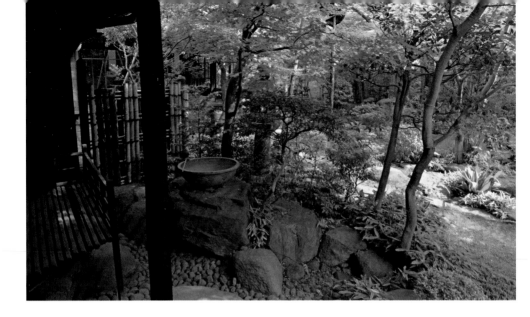

KYU YASUDA HOUSE
旧安田楠雄邸庭園

Location: 5-20-18, Sendagi, Bunkyo-ku. **Hours:** Wednesday and Saturday: 10.30 a.m.–4.00 p.m. **Fee:** ¥

A relatively narrow plot in the old Tokyo quarter of Sendagi gives little indication of the residence's wonderfully space managed, perspective deepening garden. Built in 1919 by entrepreneur Fujita Yoshisaburo, the Taisho era house was sold to banking magnate Yasuda Zenshiro, who maintained interior touches that balance Western style notes with refined Japanese aesthetics. Thus, we have a European influenced drawing room, replete with mantelpiece, hearth, Axminster carpet and chairs furbished in handwoven fabrics, seguing into Japanese chambers with tea ceremony alcoves, latticed paper doors and a sunroom that replicates the shape of a moon-viewing veranda. The rooms act as galleries, while the building itself, designed in a zigzag form, maximizes garden views. The landscaping follows the techniques of the *karesansui*, or dry stone garden, whereby the presence of water

LEFT The garden skillfully blends elements of dry landscape and stroll garden designs.

is inferred in this instance by the creation of a rocky, miniaturized valley. One large stone represents an island situated in rapids. A set of stepping stones provides a means to reach the shore. A dry waterfall further promotes the idea of symbolism over actuality. The original rolled glass is used for the sliding doors separating rooms, wooden decks and garden. The dimpled effect transforms the lush tree and shrub boundaries of the garden into a world of soft green distortions.

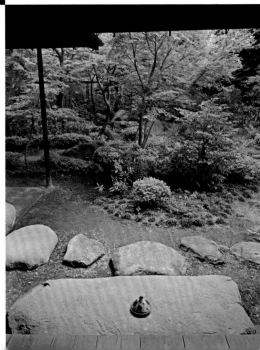

RIKUGI-EN
六義園

Location: 6-chome, 16-3 Honkomagome, Bunkyo-ku. **Hours:** 9.00 a.m.–5.00 p.m. **Fee:** ¥

The world of oriental literature and mythology is strongly felt at Rikugi-en, the intriguingly named "Garden of the Six Principals of Poetry." Construction of this spacious Tokyo stroll garden, considered by many to be the most beautiful of the capital's landscapes, began in 1695 under the supervision of Yoshiyasu Yanagi-sawa, a highly regarded litterateur and art connoisseur who served as chamberlain to Shogun Tsunayoshi Tokugawa. Edo gardens were not made overnight. Designed so that guests could stroll along paths that would reveal fresh perspectives on miniature hills, teahouses, ponds

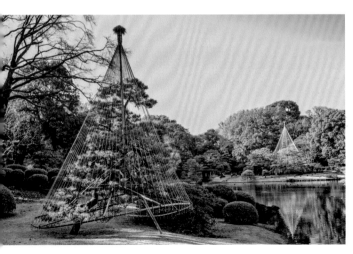

and islands planted with pine, the garden took a full seven years to complete. If visitors to gardens like this today complain at times about commercialization, the imperative to generate revenue from selling trinkets in souvenir stalls, serving powdered green tea confectionery in arbors and pavilions, or the occasional markets which are set up in the entrance grounds of gardens, they should note that quite lavish receptions were once laid on for visiting dignitaries. These events appear to have had an

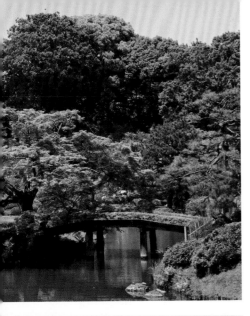

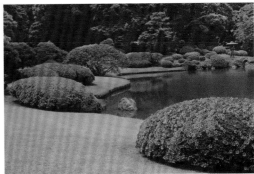

LEFT The rural aspirations of the garden are promoted by having an earth bridge connect to the island.

BELOW The azalea varietals at Rikugi-en bloom slightly later than elsewhere.

LEFT The woodland borders of Rikugi-en provide one of the best garden opportunities for viewing the autumn foliage.

OPPOSITE Bamboo frames called *yuki-tsuri* are designed to prevent snow from weighing down pine branches.

unabashedly mercantile character. Records are surprisingly detailed on the visit in 1701 to Rikugi-en by Keshoin, mother of the fifth Tokugawa shogan, Tsunayoshi. The large entourage of consorts, ladies-in-waiting, footmen, children and retainers, including a priest and physician, were treated to an unstinting generosity that included trays of sweets, saké and fruit, but also inveighed the visitors to shop at stalls proffering papier-mâché dolls, fans, flowers, toys and illustrated books.

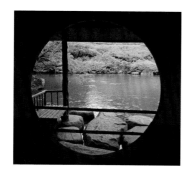

HAPPO-EN

八芳園

Location: Shirokanedai,108-0071, Minato-ku. **Hours:** 10.00 a.m.–8.00 p.m.
Fee: None

Happo-en stands on the former estate of Hikozaemon Okubo, a high-ranking nobleman. In the Meiji era, the garden and villa, built in the early seventeenth century, passed into the hands of an influential politician and industrialist whose reworked vision of the grounds we see today. The pond, a natural stream, the main building of the estate and a functioning teahouse remain. In common with other Tokyo gardens, Happo-en's seasonal almanac is varied, with spring cherry blossoms and azalea, summer rhododendrons and blazing red Chinese maples in autumn. It is best known, however, for its collection of outdoor bonsai. Displayed on sturdy tables along a viewing path, we can compare the scale of the dwarf trees with their fully grown counterparts planted nearby. All of the miniature trees are over one hundred years old, with two extraordinary specimens,

TOP LEFT The moon window of a wooden arbor is perfect for pond viewing.

ABOVE Bamboo covers what was once used as a well.

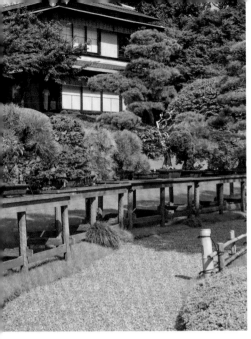

a Yezo spruce and a Chinese juniper, dating back over half a millennia. Another delightful touch to the garden is the Suich-in, an arbor cantilevered over the pond. As privately owned gardens experience increasing pressure to fund and maintain them, there is a trend back to their original functions as entertainment spaces and banqueting areas. Accordingly, Happo-en boasts a fine Japanese restaurant, wedding hall and party facilities. Bridal services include couples posing for commemorative photographs in the garden's scenic grounds.

LEFT The upper reaches of the garden house an extremely valuable collection of bonsai.

BELOW CENTER Ancient bonsai have to be brought indoors when typhoon forecasts appear.

BELOW Arbors are made from a mixture of wood, clay, thatch and shingle made from cypress.

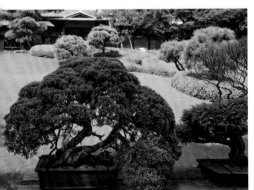

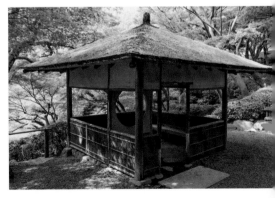

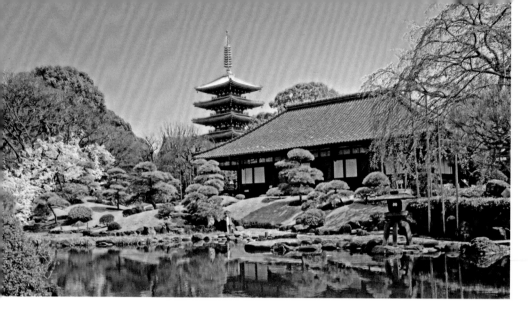

DENPO-IN
伝法院庭園

Location: 2-3-1 Asakusa, Taito 111-0032. **Hours:** 10.00 a.m.–4.00 p.m.
Fee: ¥. **Special Features:** The garden is only open to the public in
spring, from March 13 to May 7.

ABOVE Denpo-in's relatively
large pond helps to expand
space within a confined area.

Secluded behind walls, discreetly
hidden in its own greenery,
Denpo-in is located behind the
busy Nakamise shopping street
that forms an approach to the
great Senso-ji temple. Originally
known as Kannon-in, this circuit
style garden, arranged around a
generous carp pond, occupies
108,000 square feet (10,000 square
meters). The garden is often attrib-
uted to Kobori Enshu, renowned
designer and tea master, but this is
highly improbable, Denpo-in join-
ing other Japanese landscapes
designated as Kobori Enshu style
gardens. Originally the garden of
the head priest of Senso-ji, abbots
connected to the imperial family,
the Shogun and members of the
nobility were the only visitors per-
mitted to enter. The design, with its
stone placements, granite bridges
and artificial hill made from earth

excavated during the digging of the pond, remains largely unchanged since it was created in the early seventeenth century. It's *shidare zakura* ("cascading cherry trees") and azaleas are a strong visitor lure in the spring. Other objects of interest include a pondside temple bell cast in 1387 and an ancient rectangular-shaped stone coffin. In the absence of mountains or distant hills, the temple's five-story pagoda serves as borrowed scenery. A small tea ceremony house adds to the illusion of entering a wooded glade.

ABOVE There are only a handful of cherry trees in the garden but their placement is first rate.

BELOW The garden grounds are carefully inclined to provide diverse perspectives.

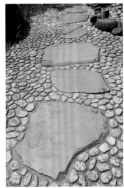

TOP *Sekimori-ishi* act as barrier stones, indicating that certain areas of the garden are closed to visitors.

ABOVE Irregularity, a preference for asymmetry, is a feature of Japanese garden paths.

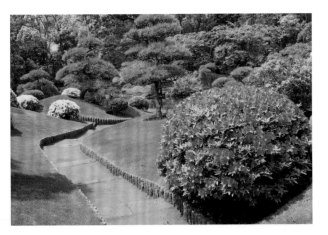

MUKOJIMA HYAKKA-EN
向島百花園

Location: 3-18-3 Higashi-Mukojima, Sumida-ku.
Hours: 9.00 a.m.–5.00 p.m. **Fee:** ¥

A short stroll from the banks of the Sumida and Arakawa rivers, the groundwork for Mukojima Hyakka-en ("Garden of One Hundred Flowers") began in 1804. An area of temples and teahouses much to the taste of the city's literati, the garden was the creation of a retired antique dealer, one Sawara Kiku, whose friends numbered

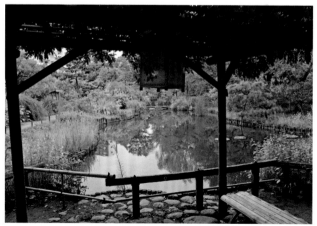

well-known poets, painters and Confucian scholars. Modeled after the Chinese literary garden, Sawara enlisted the help of his friends, who contributed stones engraved with their verse. Created as a riposte to the gardens of the ruling class with their preference for assertive rock formations and large-scale landscapes, plum trees, flowers and herbs were selected in accordance with their symbolic associations in Chinese and Japanese literature. Today's garden is similarly endowed with kudzu vine, valerian, pampas grass, agueweed, a

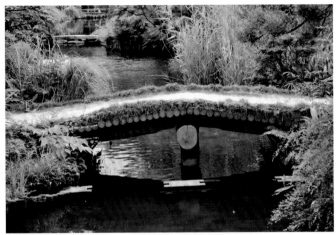

FAR LEFT *Hagi* (bush clover) is a symbol of early autumn in Japan.

LEFT The use of earthen bridges adds a touch of country rusticity to Japanese gardens.

OPPOSITE BELOW This pond arbor provides the most sweeping perspective on the garden.

BELOW A single lotus stands out in a garden otherwise devoted to herbs, trees and shrubs.

LEFT A pulley system for raising water from this well has been left intact.

CENTER LEFT Place your ear against the bamboo pipe of this *suikinkutsu* (water zither) and you can hear an underground stream.

pergola of climbing wisteria and countless other plant species. Bedizened with bush clover in the early days of autumn, a tunnel arbor, more typical of Italian and Northern Renaissance gardens than those of Japan, is the most striking feature of the grounds.

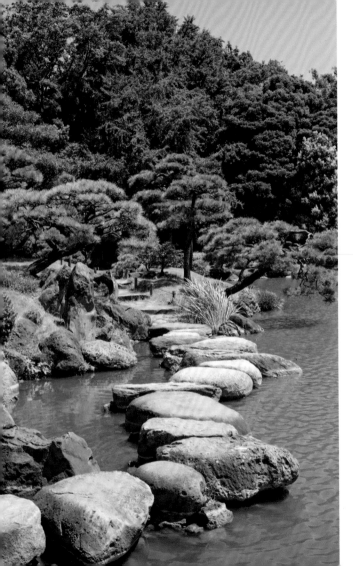

KIYOSUMI-TEIEN
清澄庭園

Location: 3-3-9 Kiyosumi, Koto-ku.
Hours: 9.00 a.m.–5.00 p.m. **Fee:** ¥

Ponds are invariably the central feature of a stroll garden, as they are at Kiyosumi-teien to the east of Tokyo's Sumida River. The stroll garden that Bunzaemon Kinokuniya, a wealthy timber merchant, built here in 1688 was designed around water diverted from the Sumida River, the pond's level changing with the ebb and flow of the tides in Tokyo Bay. Artificial hills were a key feature of stroll gardens like this. Many, created in the likeness of Mount Fuji, were designed to be climbed and to provide a panoramic view of the garden below. The central hill of the Kiyosumi garden, covered in Japanese azaleas, is also known as Mount Azalea. The grounds were acquired in 1878 by Yataro Iwasaki, a member of the wealthy Mitsubishi family, who set about restoring the garden and adding some distinctive features, such as granite bridges and tall stone basins. Among

LEFT Ferns are used to soften a dynamic rock arrangement placed beside the pond.

OPPOSITE Large stones known as *watari-ishi* are used to cross water.

these are a number of stones with interesting striated surfaces and forms. These were selected from far and wide by Iwasaki's brother, Yano-suke, an art specialist, who had them transported to Tokyo in the company's steamships. The result is a garden reflecting the effusive tastes of an entrepreneur and those of a fastidious connoisseur.

ABOVE This large water laver is the first visible object on entering the garden.

LEFT An earth bridge carries visitors to one of the garden's small islands.

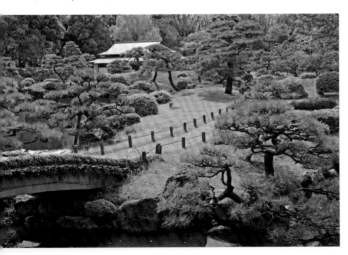

KAMEIDO TENJIN WISTERIA GARDEN
亀戸天神社

Location: 3-6-1 Kameido, Koto-ku.
Hours: All hours. **Fee:** None.

What is likely the largest concentration of wisteria vines in the city, the flower was originally associated with Heian era Kyoto nobility. Pendulant clusters of the flower were planted in the courtyard gardens of the inner palace where the emperor's ladies-in-waiting and consorts resided. Though the setting here is distinctly more urban, the heady fragrance from the lavender and white varietals at Kameido Tenjin, a prominent Tokyo shrine, evoke a similar floral utopia. Built in 1662, the shrine's wisteria garden, best viewed in late April and early May, attracted a great deal of interest among the city's flower loving residents, who would access the shrine by boat from Asakusa or Yanagibashi, disembarking at a canal pier in Kameido. The garden and its reflective pond were enough of a city landmark for the woodblock artist Hiroshige to include an

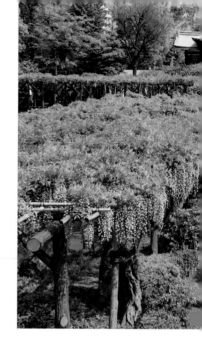

BELOW This stone lantern resembles a type that originated in Sengan-en, a stroll garden in Kagoshima.

LEFT Being a shrine, Kameido Tenjin is open at all hours. Early morning visitors can avoid the inevitable crowds.

RIGHT Lavender pendants luxuriate over a wooden trellis.

BELOW The addition of other blooms such as azalea, add contrast to the masses of wisteria.

ukiyo-e plate depicting the garden in his anthology *One Hundred Views of Edo*. The print, which inspired the design of Claude Monet's Japanese garden in Giverny, depicts foreground clumps of hanging wisteria with the garden's famous Chinese style drum bridge in the background. The *wisteria floribunda*, to give the hanging racemes their botanical name, are endemic to Japan but are rarely seen in northern climes like Hokkaido.

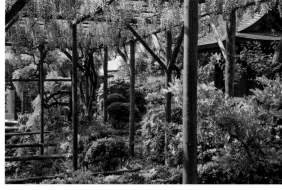

SHUNKA-EN BONSAI MUSEUM
春花園

Location: Nihori 1-29-16, Edogawa-ku.
Hours: 10.00 a.m.–5.00 p.m. Closed Mondays. **Fee:** ¥¥

One of the foremost bonsai centers in Japan, with over 2,000 specimens, the name Shunka-en suggests a garden, and this is the initial impression the visitor receives stepping from the pavement outside the walled enclosure onto black *nachiguro* stones embedded in mortar, a traditional Japanese garden touch signaling the transition between spheres. Shunka-en is the life work of bonsai master Kobayashi Kunio. The offspring of two interesting branches of devotion, his grandfather was a priest, his father a florist. One of the most valued bonsai specimens at Shunka-en is almost 1,500 years old. Rarity by association is also on show, one tree descending down the ages from its original owner, the Shogun Tokugawa Iemitsu. It is a testament to the almost scholarly authority of the museum's bonsai master that

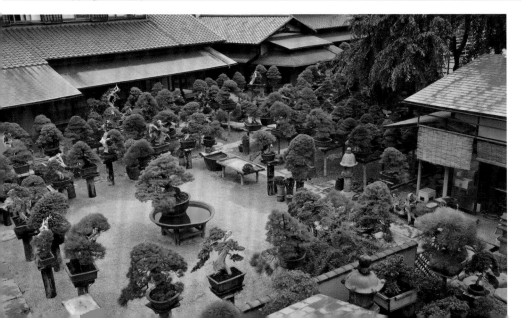

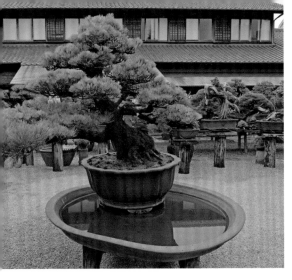

ABOVE Japanese garden elements add interest to the museum's highly presentational character.

RIGHT Algae has been left to form on the surface of a jar, a hint at naturalism.

ABOVE Centrally positioned, this *kuro-matsu* (black pine) bonsai is several hundred years old.

LEFT Two elevated platforms at the center provide fine overviews.

RIGHT This juniper is an arresting mixture of living tree and deadwood.

private owners of rare specimens place their trees at the center for safekeeping, retrieving them for special occasions and ritual events. At Shunka-en we see bonsai in many states of existence and non-existence. The vigorous roots of *ishi-tsuki* trees appear to be overpowering the rocks they cover, while the term *sabakan* refers to bonsai whose trunks are broken and exposed, their dry surfaces like cartilage. The combination of living and withered forms is a dramatization of the Buddhist notion of the impermanence of life.

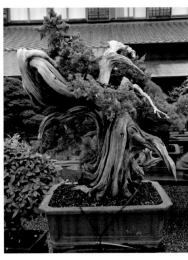

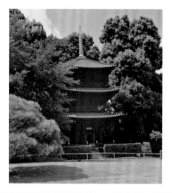

CHINZANSO HOTEL GARDEN
椿山荘庭園

Location: 2-10-8 Sekiguchi, Bunkyo-ku. **Hours:** 9.00 a.m.–10.00 p.m. **Fee:** None

As privately owned gardens in Tokyo experience increasing pressure in funding their maintenance, some are reverting to their original function as pleasure and entertainment venues. This can be seen at the Chinzanso Hotel, whose rather over-ornamented grounds now boast a fine restaurant, wedding hall and party facilities. Bridal services include couples posing for commemorative photographs in its scenic grounds. Despite the contemporary activities, traces of an older garden can still be seen. In the pre-Edo era, the land from which the garden was shaped was known as Tsubakiyama, the "Mountain of Camellias." The *haiku* poet Basho Matsuo lived in a hermitage between the garden's entrance and the Kanda Canal. The private estate of a domain lord, the grounds passed in the Meiji period into the

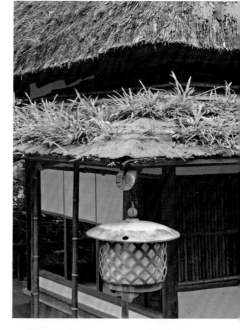

hands of Yamagata Aritomo, a former prime minister with a keen knowledge of art and gardens. He was instrumental in designing and overseeing the construction of the garden himself, turning the land into a stroll garden with a pond, miniature mountains, lawns, azalea bushes, and camellia, cherry and crepe myrtle trees. Historical artifacts, including Buddha and Rakan statuary, stone temple lanterns and a rare three-story pagoda dating from the Muromachi era are positioned throughout the garden. From late May until early July, fireflies, a traditional Japanese symbol of summer beauty, are released into the garden.

ABOVE Among the garden's historical artifacts, the refulgent face of one of the Seven Lucky Gods.

ABOVE RIGHT Wild plants and moss have been allowed to grow freely on the thatch of a teahouse.

RIGHT A solid water basin inscribed with large Chinese *kanji* characters.

OPPOSITE Corded *shimenawa* ropes and *gohei* hanging papers signify good fortune in the Shinto religion.

YAKUO-IN
薬王院

Location: 4-8-2 Shimo-Ochiai,
Shinjuku-ku. **Hours:** All hours.
Fee: None

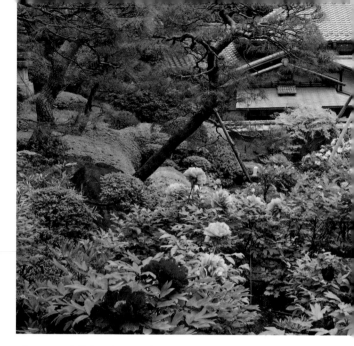

A temple flower garden in a quiet residential quarter of Tokyo, the discerning few who know Yakuo-in descend on its grounds in mid-April to view a luxuriant display of pink, red and white peonies. The site of a shogunal hunting reserve in the eighteenth and nineteenth centuries, the flowers have their own history and progeny, having been cultivated from seedlings extracted from the celebrated peonies at the prestigious temple of Hase-dera. The approach to the temple is lined with peonies but the main concentration of flowers is found on a slope that can be viewed from an ascending set of stone steps. Introduced from China in the eighth century, the peony has inspired poets, playwrights, tattoo artists, woodblock printers, kimono designers and painters, who covered sliding doors and folding screens with their brilliance. The *haiku* poet Buson captured the exuberance of the flower when he wrote:

> *On the point of blooming*
> *And exhaling a rainbow*
> *The peony.*

The flowers are at their most radiant during the early morning.

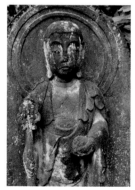

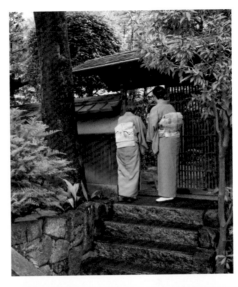

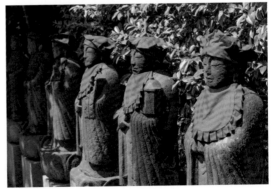

ABOVE The south-facing hillside contains the main concentration of peonies as well as Yakuo-in's main hall, reconstructed after the war.

LEFT Examples of ancient Buddhist statuary can be found in the upper reaches of the garden.

ABOVE RIGHT A small but private and exclusive teahouse is situated at the entrance to the garden.

RIGHT A row of Jizo statues, a Buddhist deity assigned as protector of travelers and children, in the upper part of the garden.

SHINJUKU-GYOEN
新宿御苑

Location: 11 Naito-machi, Shinjuku-ku.
Hours: 9.00 a.m.–4.30 p.m. Closed
Mondays. **Fee:** ¥

The property of Lord Naito Kiyo-
nari, the original garden, complet-
ed in 1772, was converted into an
experimental center for agriculture
before passing into the hands
of the imperial family who land-
scaped the site in 1906, creating a
set of gardens reflecting Japanese
and Western styles. The garden
might be accused of resembling
a municipal park but its open mar-
gins, blending sinuously with the
rest of the grounds, hint at a supe-
rior design aesthetic. The garden is
the finest spot in the city to view

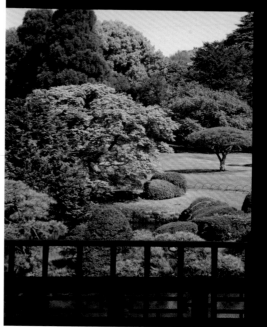

displays of chrysanthemum from
late October. Tents and bamboo
pavilions housing displays of flow-
ers are decorated with red and
white cloth and purple banners,
creating a brocade effect from a
distance. During the chrysanthe-

mum festival, the name of each
flower is written so that viewers
can discern the sometimes finite
differences between, say, swell-
pedaled, deep-flowered, tube or
pin quill-pedaled varieties. The
poet James Kircup visited the

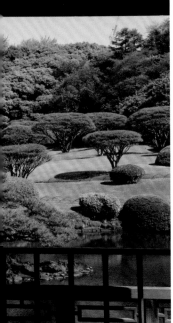

LEFT This type of cherry blossom is the larger, double-petal variety.

BELOW A quiet but flora-rich corner of the Japanese garden.

LEFT Sweeping views from the Taiwanese Pavilion.

OPPOSITE TOP The garden is a haven for weekend artists.

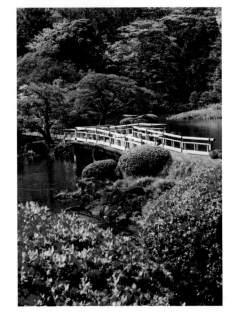

garden in the 1960s, noting one of the festival's Mount Fuji representations, its "snow-white 'cloud' of traditional formality, shaped like a long French loaf, suspended its dead-white, airy, colossal blooms just below the cratered peak."

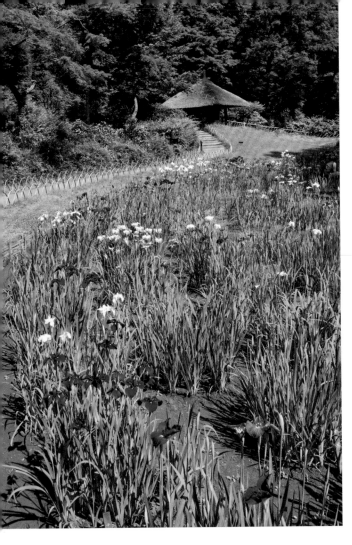

MEIJI SHRINE IRIS GARDEN
明治神宮内苑

Location: 1-1 Yoyogi-Kamizono-cho, Shibuya-ku. **Hours:** 9.00 a.m.–4.30 p.m.; 8.30 a.m.–4.30 p.m. in the iris season. **Fee:** ¥

Listed as a perennial herb, the Japanese iris blooms in early to mid-June during the humid rainy season. A water flower, it thrives beside brooks, in shallow ponds and marshy earth, or in disused ricefields. In the Meiji Shrine garden, the iris beds run along the center of a shallow dale. The 1,500 flowers that grace this damp meadow are descended from Edo varieties brought from the Horikiri Shobu-en, another celebrated and much-visited Tokyo iris garden east of the Arakawa River. A teahouse, gazebo and azalea garden add interest to grounds planted with bush clover, Japanese globeflower and maples. In the wooded extremity of the garden, a well, sunken in a pool of cool water, supplies the south pond where

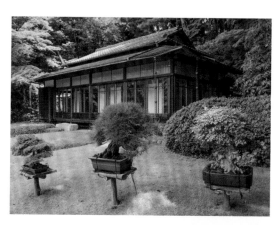

RIGHT The purple *hanashobu* is the classic Japanese iris.

BELOW A natural spring with pure water in the woodland, known as Kiyomasa's Well.

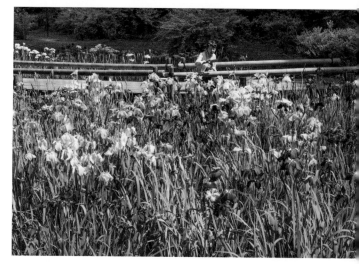

BELOW The sequence of narrow iris beds runs for 656 feet (200 meters).

ABOVE An elegant teahouse not open to the general public.

OPPOSITE The main iris fields run through a wooded valley, an almost soundproof zone.

water lilies bloom at the same time as the irises. The garden was planted on the orders of the Meiji Emperor as a gift to his wife, the Empress Haruko. She is said to have spent long hours enjoying the peace of this garden in the final years of her life.

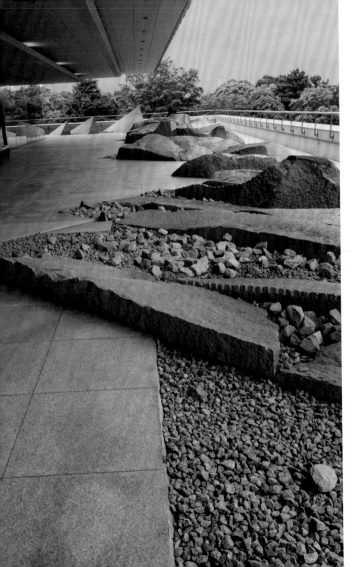

CANADIAN EMBASSY GARDEN
カナダ大使館の庭

Location: 3-38 Akasaka, 7-chome, Minato-ku. **Hours:** 9.00 a.m.–4.30 p.m. **Fee:** None

In his 1991 masterpiece, Zen priest and prolific garden designer Shunmyo Masuno used stones from the Hiroshima region to represent the geological character of the ancient, glacially worn bedrock that forms the Canadian Shield. The symbolism is meant to embody the principle of harmony through friendship and interaction between the two countries, while the primal ruggedness of the Canadian terrain is suggested in the rough cutting of the stone in which lines of holes into which wedges were hammered to split the rocks have deliberately been left exposed. The stark monotone elements of the garden have been developed by using geometrically precise floor tiles to connect the landscape to the glass and con-

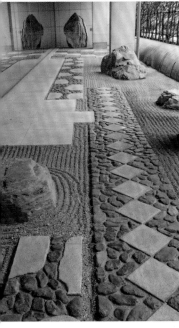

LEFT *Nobedan* are straight stone paths, this one with a classic diamond pattern.

RIGHT The garden is characterized by precision forms.

BELOW Used by the Inuit people, the central pillar is an *inukshuk*, a symbolic marker.

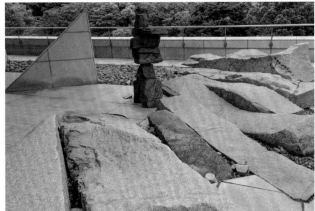

crete of the modern building. The dynamic aridity of rock is complemented by a more intimate, more introspective Japanese stone garden on the enclosed south side of the building and a raised pool representing the Pacific Ocean. To stand on a granite spit above this sheet of water built into the side

portion of the garden and gaze over the treetops of the nearby Akasaka Palace grounds is to feel a pleasant sense of corporeal detachment—of being suspended in space between city and sky.

OPPOSITE The larger rocks were hollowed out in order not to be too heavy for the elevated floor.

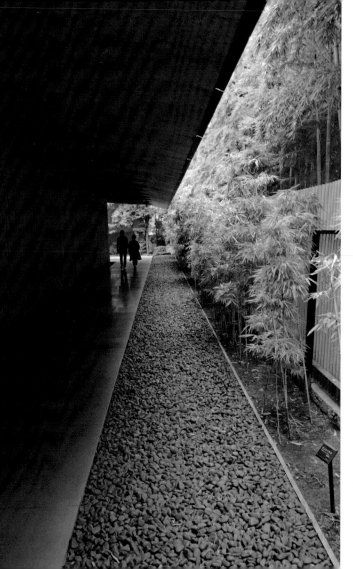

NEZU MUSEUM
根津美術館

Location: Minami-Aoyama, 6-chome 5-1, Minato-ku. **Hours:** 10.00 p.m.–5.00 p.m. **Fee:** ¥¥¥

An area of hills and green dales, the land on which this garden is built was purchased in 1906 by the industrialist and entrepreneur Nezu Kaichiro. The original museum, garden and teahouses perished in the air raids of World War II but painstaking efforts ensued and today's garden has been restored in harmony with many of its initial design intentions. Innovations have also been added, including the creation of more barrier-free paths so that everyone can access a garden that also functions as a healing retreat. In May, the museum exhibits Ogata Korin's famous "Irises" folding screen painting. Complementing art, irises bloom in one of the garden's two interconnecting ponds. The museum's collection of priceless Japanese and Asian art includes a number of ancient Buddhist statues, steles

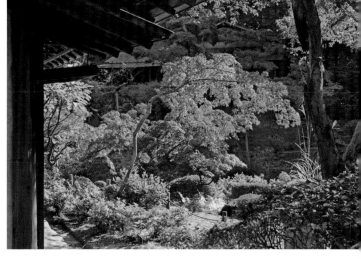

and friezes. The religious contents are replicated in the garden itself, with a fascinating collection of art objects placed at the side of paths, beneath trees or embedded in deeper foliage. Here we may chance upon a Korean stone lantern from the Choson dynasty, a

seated Buddha dating from the twelfth century, a Ming era Bodhisatva, a moon-shaped stone boat once placed in front of a tomb or a beautifully engraved Amitabha triad. Such treasures transform an accomplished garden design into a place of sanctity.

ABOVE LEFT A latticed window (*shitaji mado*) attached to a roofed waiting bench.

ABOVE A beautiful interplay of light and shade.

LEFT Contrasting with the garden's high art statuary, a simple stone water basin.

RIGHT A five-sided stone water basin with carved Buddhist reliefs.

OPPOSITE The long entrance passage to the museum and garden calms visitors.

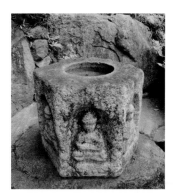

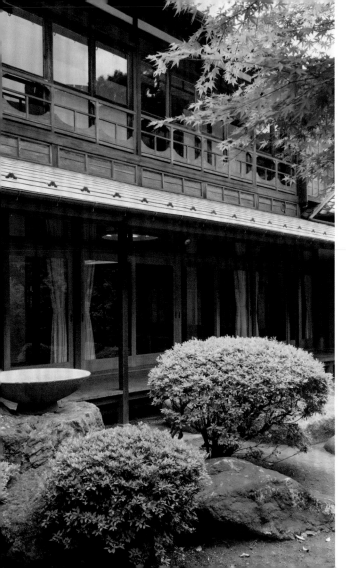

KYU-ASAKURA GARDEN
旧朝倉家住宅

Location: 29-20 Sarugakucho, Shibuya-ku. **Hours:** 10.00 a.m.–6.00 p.m. **Fee:** ¥

Commissioned in 1919 by Torajiro Asakura, a prosperous businessman and chairman of the Metropolitan Assembly, a conspicuously large *kutsu-nugi-ishi*, or shoe-removing stone, hints at the wealth and touches of hubris that characterize the gardens of this period made for a new order of entrepreneurs, industrialists and politicians. Tall water laver basins, known as *chozubachi*, were also symbols of affluence, and along with imposing pedestal-style stone lanterns show a similar fascination with the gargantuan. Moderating any unseemly touches of pride is the landscape itself, with much of the rear garden built on a bluff. Undulating paths run beneath a thick canopy of trees, and large rocks and roof tiles embedded beside paths add rustic

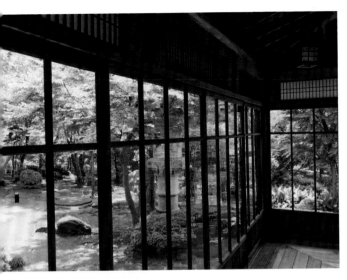

LEFT *Engawa* passageways are a feature of more affluent residencies.

touches that evoke the aesthetics of the tea garden but also an interest in Western style naturalism. The pathways meandering through the grounds are set at different levels in the wooded dell, creating a sense of spatial depth. Space flows here in much the same way as light—fluidly, following its own contours and circulations. The density of the foliage and the garden's well-placed stones promote a sensation of detachment from the urban domain. This, in turn, engenders a mood of refined introspection.

ABOVE When opened, circular windows, known as *enso*, provide a creative framing of the garden.

OPPOSITE The well-preserved two-story villa offers some different perspectives on the garden.

TOP A rather plain water basin made more interesting with adjacent plantings.

ABOVE Sunken tiles and roof finials add interest to the woodland floor.

IKEGAMI PLUM GARDEN
池上梅園

Location: Ikegami, Ota-ku. **Hours:** 9.00 a.m.–4.30 p.m. Best in February and early March. **Fee:** ¥

The history of the "plum" as more than just a tree originates in China. No Chinese literary garden was complete without a plum tree. Introduced to Japan from continental Asia in the seventh century, it was taken up, as in China, by the nobility and literati. If the cherry tree and its delicate blossoms represent the youthfulness of spring, the plum tree stands for a withered-looking but stubbornly insistent and enduring old age. Over three hundred trees, representing thirty different varieties, are planted along the flat entrance area of the garden and on picturesquely designed tiers connected by pathways over a graduated slope below a plateau upon which stands the mightily impressive complex of Honmon-ji temple. Two well-crafted teahouses are situated within the garden,

adding an air of elegance to grounds that were originally the home of the painter Shinsui Ito. Gardens like this prove the point that Tokyo may appear, at least on first acquaintance, to be a concrete jungle, but in its fondness for historical gardens it is a city that continues to reflect the changing seasons.

OPPOSITE *Yuki-tsuri* frames prevent snow from bending pine branches but these days there is little snowfall in the Tokyo area.

LEFT Plum trees have been cultivated on a graduated hill.

BELOW Plum blossoms are one of the highlights of the winter horticultural calendar.

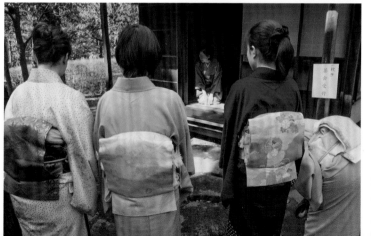

LEFT The garden is well known for its teahouses and tea ceremony events.

BELOW Bamboo pipes used for an old *suikinkutsu* (water zither).

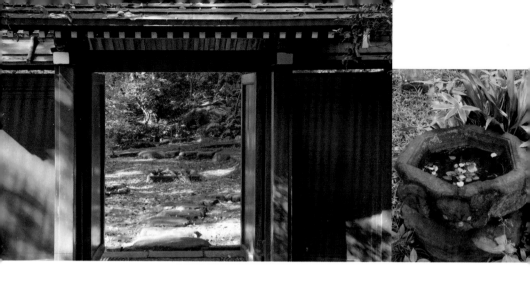

GOTOH MUSEUM GARDEN
五島美術館

Location: 3-9-25 Kaminoge, Setagaya-ku. **Hours:** 10.00 a.m.–5.00 p.m. Closed Mondays. **Fee:** ¥¥

The taste responsible for the collection of Japanese and Chinese fine art displayed inside the museum is replicated in the extraordinary number of Buddhist themed statuary in its garden. The presence of these stone images turns the landscape into an open-air museum. Located along the terraced banks of the Kokubunji Cliff, a natural landscape facing the Tama River, this stroll garden, commissioned in the early twentieth century by Keita Gotoh, a wealthy entrepreneur, is approached across a well-maintained lawn. A dramatic shift takes place between this open, airy section of the garden when descending a path from the azalea border into woodland. A canopy of maples, deliberately evoking the elegance of Heian era gardens, creates a private world insulated from exterior sounds. Blending the Western naturalism popular at one time with English garden designers and Japanese aesthetics, the impression strolling through the dense verdure is of wandering in the hills or mountains. It is one more example of the cleansing sensation it is possible to experience when visiting gardens in the world's largest metropolis.

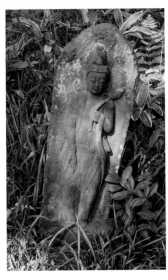

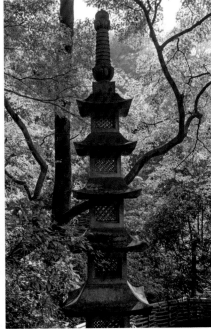

FAR LEFT With a light covering of moss and mildew, a well-carved Buddhist figure.

LEFT A stone pagoda promotes verticality to this section of the garden.

OPPOSITE LEFT A red lacquered gate adds a dash of color to the inner garden.

OPPOSITE RIGHT The top of this water basin is an interesting polygon of hexagon sides.

ABOVE Visitors have placed coins as offerings before this Buddhist statue.

LEFT One of the pleasures of this garden is that it is not over-maintained.

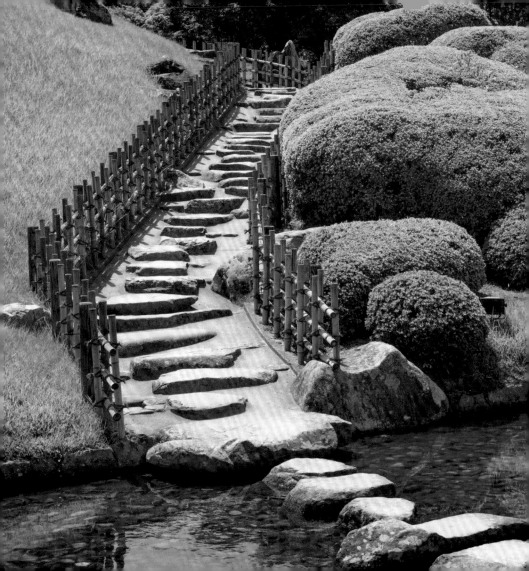

Part Three
Regional Gardens

Japan is a big country. Scale, of course, is relative. Coming from Britain as I do, a nation whose land mass would fit comfortably, and with room to spare, into Japan's main island of Honshu, this is easy to affirm. A visitor from China or Russia, on the other hand, would likely characterize Japan as a rather small country. What everyone can agree on, though, is that it is a long country. Stretching from the sub-Arctic reaches of its northern island of Hokkaido through the temperate zone of its central girth, the islands of southern Kyushu and Okinawa lay firmly in the subtropics. The flora of the gardens in these vastly different geographical

zones reflect climatic conditions as much as cultural differences and preferences.

The assertion one often hears in Japan, that the country enjoys four distinct seasons, is an imperfect generalization. Hokkaido, for example, experiences an unusually long winter and manages to avoid the humid early summer rainy season that saturates the rest of the country. Okinawa hardly has four seasons in the conventional sense.

Many of the gardens selected for this section of the book are attached to temples, noble estates or the villas of prosperous business clans. These were located in small provincial towns that are now counted as cities. As these remote rural locales acquired larger populations and more wealth, more urbane practices, including garden design, were adapted from established centers like Edo, Kyoto, Kanazawa and Osaka, where

extraordinarily high levels of culture flourished. Among the items regarded as symbols of refinement and prestige were gardens.

During the Edo era, the Law of Alternative Residence, a measure aimed at depleting the coffers of potentially seditious clans, required the nobility and a considerable number of their retainers to maintain two estates, one in Edo, the other in their home province. Exposure to landscape designs en route between these two residences would no doubt have inspired the commissioning of regional gardens. Despite strict restrictions on the movement of common citizens, the authorities permitted private and group pilgrimages to remote religious sites. In an age when travel permits were hard to come by, pilgrimages were often ruses for those who could not obtain the necessary papers to make pleasurable excursions.

LEFT Stone steps ascend to the artificial hill, Yuishinsan (Sole Heart Mountain), at Koraku-en Garden, Okayama.

The pilgrimage experience, ranging from journeys of enlightenment, the promoting of good health and the expiating of sins were also opportunities for the acquisition of ideas and knowledge. They would undoubtedly have provided further windows on garden design.

While it is still possible to catch the aroma of Zen in Kyoto's silent worlds of murmured sutras, burning incense and stocking feet gliding over ancient polished wood, the recent advent of mass tourism has dispelled some of that magic. Although you are unlikely to see monks picturesquely lined up in the full lotus position before cones of sand, a more ancient ambiance, untroubled by commercial imperatives persists in the temple gardens of remoter locations.

It is interesting to ponder the irony that, in comparison with the great gardens of England and France, whose trees, plantings and horticultural elements have been subject to constant change and decay, an overwhelming number of Japanese gardens, particularly the dry landscape variety, mirroring a philosophy keenly aware of impermanence, have survived intact.

BELOW, LEFT TO RIGHT A section of the large inner courtyard garden of the Tamozawa Imperial Villa. *Saru suberi* (crepe myrtle) in the courtyard of Seigan-ji. Strong rock arrangements at Kongobun-ji.

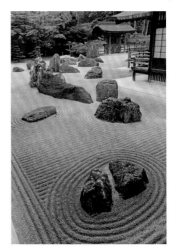

Japan

250 km
100 miles

N

Hokkaido

Asahikawa

Sapporo

Hakodate
Kyu-Iwafune-shi Garden

Aomori

Akita
Morioka

Motsu-ji
Shinjo

Yamagata
Sendai

Niigata
Oyaku-en
Fukushima

Tamogawa
Imperial
Villa

Nagano
Nikko
Utsunomiya

Kanazawa
Kenroku-en
Toyama
Maebashi
Omiya Bonsai Mura

Nomura-ke
Kozen-ji
Kofu
TOKYO

Fukui
Tesso-en
Shinsen-kyo
Sankei-en

Seigan-ji
Nagoya
Yokohama

Adachi Museum Garden
Ryotan-ji
Meigetsu-in

Matsue
Tottori
Genkyu-en
Kiun-kaku

Shojuraiko-ji, Sanzen-in, Jikko-in, Hosen-in
Ohara
Shizuoka

Raikyu-ji
Himeji
Kobe
Zuiko-in
Hamamatsu

Shukkei-en
Okayama
Kyoto
Nara
Issui-en, Yoshiki-en, Nigiwai-no-ie

Hiroshima
Soraku-en
Fukuchi-in

Joei-ji
Takamatsu
Osaka
Keitaku-en

Yamaguchi
Souraiken
Ritsurin-Koen
Kongobun-ji

Kitakyushu
Mori Residence
Garden
Wakayama

Fukuoka
Matsuyama
Shikoku

Saga
Oita
Kochi

Nagasaki
Suizen-ji Joju-en
Kumamoto

Kyushu

Miyasaki
Sengan-en

Kagoshima

Gardens of Chiran

Sea of Japan

H o n s h u

PACIFIC OCEAN

Kagoshima

Yaku-shima I.

Okinawa Islands

Amami

Amami Oshima I.

Okinawa-honto

Shikina-en
Hanging Bonsai
Garden

Naha

PACIFIC OCEAN

N

100 km
100 miles

Miyara Dunchi
Ishigaki I.

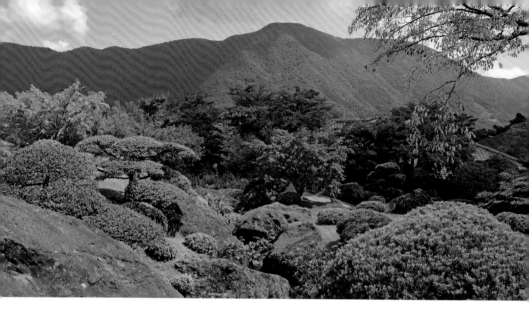

HAKONE
SHINSEN-KYO
神仙郷

Location: 250-0408 1300, Gora, Hakone-machi.
Hours: 9.30 a.m.–4.30 p.m. Closed Thursdays. **Fee:** ¥¥

Completed in 1953, Shinsen-kyo draws its inspiration from the surrounding landscape, a lava strata formed by volcanic activity. Located on the grounds of the Hakone Museum of Art, the institution's owner, Mokichi Okada, employed highly skilled gardeners to complete the landscaping which he oversaw himself. A strong believer in the idea that art, including gardens, should be accessible to everyone, Okada, in choosing trees, plants, grasses and arrangements of rocks, was quoted as saying he created the design as if he

were "drawing a painting using natural materials." Entering the main gate, you pass along a stone path above a scaled-down recreation of a moss-covered valley set in a mountain recess, a highly skillful transitional effect that places you in the realm of the quasi-natural world of the master landscape gardener. Divided into a garden with 130 species of moss, a pond arrangement, a bush clover passage and a bamboo garden, each section segues seamlessly into the next. The largest garden section is Sekiraku-en. Set on a slope, the garden, replete with

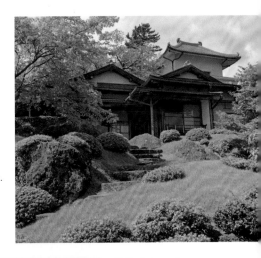

OPPOSITE The garden provides an unimpeded *shakkei*, or "borrowed view," of distant mountains.

RIGHT The faintly Chinese style gabled roof of the Hakone Art Museum appears above the garden.

LEFT Lush clumps of moss grow beneath tree canopies that protect them from excess sunlight.

FAR LEFT The garden designers maintain that bamboo should be planted in odd numbers.

a teahouse called Kanzan-tei, is notable for its dynamic rocks expressive of the surrounding geological conditions. A fine garden, Shinsen-kyo manages to both soothe and stimulate the senses.

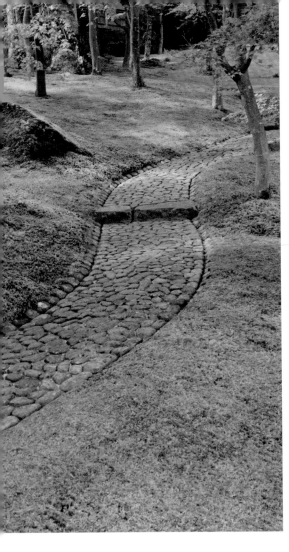

ABOVE Geometric lines and careful design styling blend in this corner of the garden.

LEFT The garden's curving stone paths replicate its winding brooks and streams.

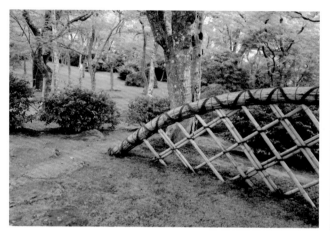

ABOVE *Koetsuji*, or "sleeve fences," are used to elegantly partition garden sections.

BELOW In slightly elevated Hakone, maple leaves change color a little earlier.

BELOW RIGHT *Hagi* (bush clover) habitually come into bloom in late September.

ABOVE Water-dividing stones are positioned to divert flows and add visual diversity to streams.

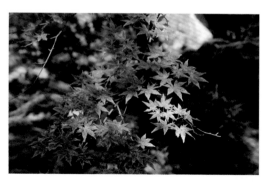

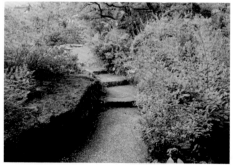

YOKOHAMA
SANKEI-EN
三溪園

Location: 58-1, Honmokusannotani, Naka-ku. **Hours:** 9.00 a.m.–5.00 p.m. **Fee:** ¥¥

Construction of Sankei-en, the "Garden in the Third Valley," began in 1900. Six years later, it was opened to the public. Its creator, Hara Sankei, was not only an astute businessman but also something of a philanthropist, stating that although it was his property "scenic beauty should belong to no one; it is in the realm of the Creator." Keenly involved in the arts and literature of his time, the garden reflects his broad cultural interests and tastes. Several historical buildings and structures have been moved into the garden, creating a space akin to an architectural theme park. Highlights among these structures are a magnificent three-story pagoda dating from 1457, a rustic teahouse relocated from Nara, a Zen Buddhist sanctum from Kamakura and a rural residence that once stood in the village of Shirakawa-go. Paths lead from the main entrance gate past

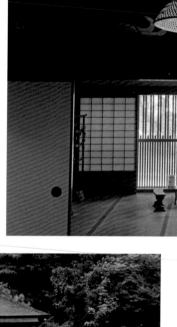

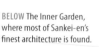
BELOW The Inner Garden, where most of Sankei-en's finest architecture is found.

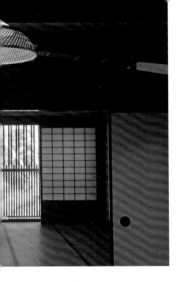

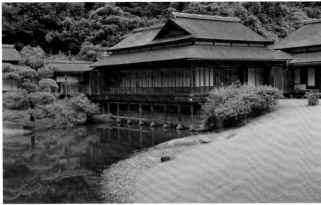

ABOVE Exquisite lattice doors and windows are a feature of the garden's most exquisite structures.

BELOW Sensitive, seasonally matched flower arrangements are still maintained.

lotus and water lily ponds to these sights. Another path, leading to the Inner Garden, offers a further assemblage of historic buildings, including the Rinshunkaku, a villa that once stood on the Kinokawa River in Wakayama City. When the structure was reconstructed on its present site, Sankei had the three sections of the building arranged into the shape of geese in flight. This well-ventilated garden, standing on a buff above the Pacific Ocean, reminds us how a landscape can be co-opted as a stage for exhibiting a broad range of personal cultural passions.

ABOVE Because of damage during World War II, much restoration work has been done on buildings.

BELOW Teahouses in Japanese gardens have always been synonymous with refinement and good taste.

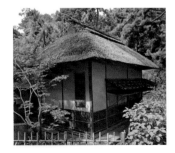

NIKKO
TAMOZAWA IMPERIAL VILLA
田母沢御用邸

Location: 8-27 Honcho, Nikko 321-1434.
Hours: 9.00 a.m.–5.00 p.m. Closed Tuesdays. Fee: ¥

Generous rainfall, humid summers and shady ground cover explain the depth and luxuriance of moss in the Nikko area. Built in 1899 as an imperial residence, the gardens of this grand villa evoke a number of historical landscape touches, creating a digest of over a thousand years of Japanese landscape design. A reference, for example, to the ancient Heian era can be found in the garden's *yarimizu*, or shallow winding stream. Pleasurable literary events were held on their banks, in which court nobles composed seasonal poems while intercepting small cups of saké as they floated past. The period's *naka-niwa* (inner gardens) are thought to be the forerunners of the later Edo period *tsubo-niwa*, the tiny courtyard gardens favored by merchants. Large portions of the garden are designed to be seen

RIGHT A huge courtyard garden at the center of the main villa.

BELOW The villa has some unusually large, quadrangular-shaped inner gardens.

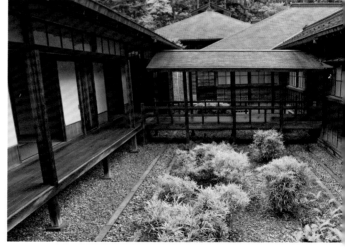

from inside the villa, its windows providing perfectly framed views. Once the visitor has taken in the broad sweep of the gardens, it is the details that begin to emerge. Despite its elegant gardens, high level of traditional craftsmanship and designation as an Important National Cultural Property, only a handful of visitors grace the site. Overshadowed by the better publicized Nikko attractions, the villa and gardens, with their deep instinct for beauty and balance, were only opened to the public in 2000, a possible explanation for their relative obscurity.

ABOVE Sliding doors look onto the more naturalistic outer gardens.

BELOW This dry landscape garden contrasts with the villa's moss gardens.

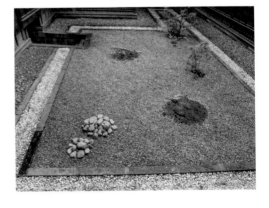

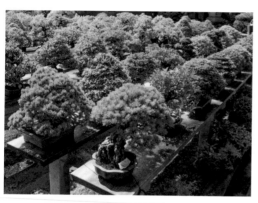

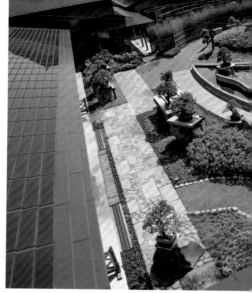

OMIYA
OMIYA BONSAI MURA
大宮盆栽村

Location: Bonsai-cho, Kita-ku, Saitama. **Hours:** Nurseries: 9.00 a.m.–5.00 p.m. Some are closed on Thursdays. Omiya Bonsai Museum: 9.00 a.m.–4.30 p.m. Closed on Thursdays. **Fee:** Omiya Bonsai Art Museum: ¥¥¥. No fee for most of the nurseries.

ABOVE LEFT Each bonsai has to be meticulously pruned and maintained.

ABOVE The second-floor café provides the best overall view of the museum's main courtyard.

When the cataclysmic Great Kanto Earthquake of 1923 struck the capital, bonsai growers in the old district of Sendagi decided to relocate to Omiya, known for its rich, loamy soil. Today's dozen or so nurseries fit snugly into the garden suburb that boasts the world's largest diversity of miniature tree species.

Entering the nurseries at Bonsai Mura reveals varieties ranging from quince trees to junipers, pine and small crab apple trees, their sour fruit red and enticing though inedible. The display areas are complemented by Japanese garden touches, such as traditional entrance gates, stone paths, grass

growing between the granite sections and wooden structures with inner galleries, all pointing to a rustic garden aesthetic. Although it is rewarding to simply stumble into nurseries as you come across them, visitors should make a point of seeking out the Omiya Bonsai Art Museum for an organized view

RIGHT An example of *sabakan*, where a section of the tree is either dead or exposed.

BELOW Potting a small bonsai sample.

RIGHT Bonsai are watered in the early morning or when the sun begins to set.

of the history and development of the subject. The specimens here are of extraordinary value and rarity. Understanding the spirit of the tree, an embodiment of harmony, unity, beauty and balance, is a process the modern world is in much need of, an art well worth cultivating.

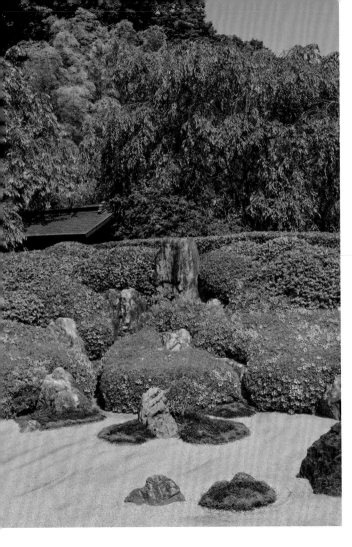

KAMAKURA
MEIGETSU-IN
紫陽花寺

Location: 189 Yamanouchi, Kamakura-shi.
Hours: 9.00 a.m.–4.00 p.m.; 8.30 a.m.–5.00 p.m. during the hydrangea season.
Fee: ¥

Also known as the Ajisai-dera or "Hydrangea Temple," Meigetsu-in's eponymous flower is at its best when the weather in Kamakura is at its worse—the humid, wet days of the rainy season. The majority of blooms are of the blue *Hime Ajisai* or "Princess Hydrangea" variety. To the right of an ascending path of Kamakura stone, where dense clumps of hydrangea bushes are planted, towering bamboo trees grow in the shadow of a cliff, the floor of the grove littered with ceramic roof tiles, finials, statue fragments and friezes depicting religious figures. The upper level of the grounds features a well-formed stone garden with a single upright rock surrounded by stone clusters, representing Mount Sumeru, the gravitational center of the

Buddhist cosmology. An irrigated field of irises to the rear of the temple come into bloom at the same time as the hydrangeas. The stone rabbit statues placed in the gravel of a nearby dry landscape garden may seem a touch kitsch but the figures have significance. The temple's name, meaning "Bright Moon Hermitage," connects in Japanese minds with a folkloric account of a rabbit pounding rice cakes on the moon.

LEFT A small extra fee is required to enter the rear garden during the iris season.

RIGHT The temple is best known in the rainy season for its blossoming hydrangeas.

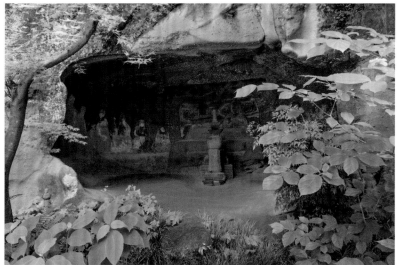

LEFT The eastern hills of Kamakura are honeycombed with caves, many containing Buddhist images.

OPPOSITE Compared with the temple and its ancient grottoes, this dry landscape garden is a relatively recent design.

ATAMI
KIUN-KAKU
起雲閣

Location: 4-2 Showa-cho, Atami. **Hours:** 9.00 a.m.–5.00 p.m.
Closed on Wednesdays. **Fee:** ¥

Located in the hot spring resort of Atami, Kiun-kaku is a fine example of the type of garden commissioned in the Taisho period by wealthy business figures, an empowered nouveau riche with an interest in Western styles of gardening but with an abiding nostalgia for late Edo period aristocratic gardens and the early Meiji era landscapes of their youth. There always seems to be something to look at in the grounds of Kiun-kaku, with azaleas, wisteria, Japanese quince and fragrant olive among its flowering shrubs and bushes. The harmony between garden and home, interior and exterior, is achieved with some

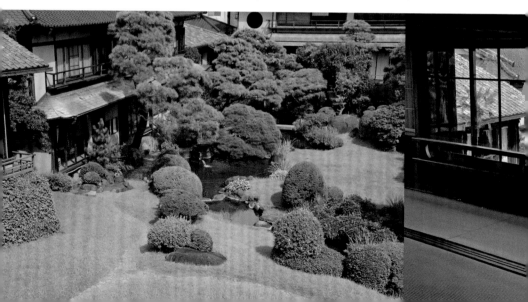

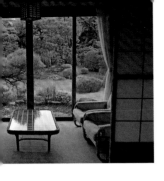

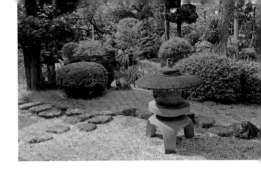

interesting materials and design touches. Instead of the customary expanse of *tatami* mats, here we have small colored floor tiles, lending a neo-Moorish atmosphere to one room. Somehow, where you would expect opposition, symbiosis is achieved. When the residence served as a high-end guest house, celebrated writers like Dazai Osamu, Shiga Naoya and Tanizaki Junichiro stayed here. A meticulously conceived work, the designer skillfully took into account the natural landscape that forms this well-ventilated plot. To design gardens like this, fully exploiting a sloping terrain, you have to be both planner and field technician.

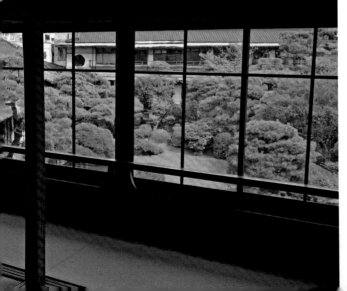

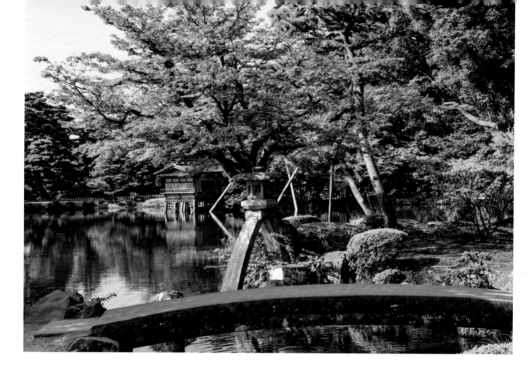

KANAZAWA
KENROKU-EN
兼六園

Location: Kenroku-machi, Kanazawa.
Hours: 7.00 a.m.–6 p.m. **Fee:** ¥

The influence of the tea ceremony and tea devotion on architecture is evident at Kenroku-en, a classic circuit garden, one that is counted among Japan's Three Most Beautiful Gardens. Such ranking may be a flawed system but it is a fine garden, a master design that embodies the six components from which its name is composed: solemnity, vastness, matchless planning, venerability, beauty of form and the coolness that comes from running water. Implanted in the garden's deftly laid out structure are several teahouses, among them the Yugao-tei, a small thatched hut that faithfully follows traditional edicts of space. Typically, such structures attempt to reproduce on a more modest scale the vernacular architecture of *minka*, the grand

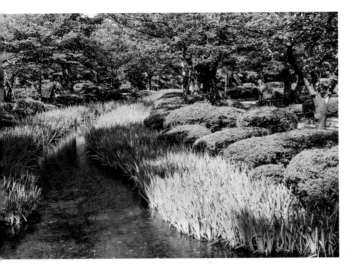

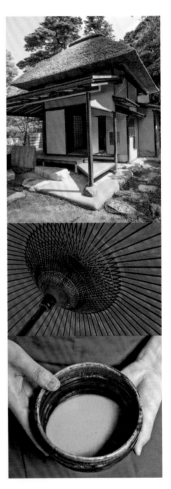

LEFT The celebrated Kotoji, a stone lantern whose shape derives from the bridge of a *koto*, a classic Japanese instrument.

ABOVE Cherry blossoms reflect on this stream in early spring, while irises bloom a little later.

thatched farmhouses of rural Japan. In their diminished form, they try to suggest the isolation of a hermit's forest hut. In his classic *Book of Tea*, the Meiji era art critic Okakura Kakuzo wrote, "Teaism is a cult founded on the adoration of the beautiful among the sordid facts of everyday existence." In Japan's contemporary urban setting, the statement has acquired renewed meaning.

TOP RIGHT One of numerous teahouses found throughout the garden.

CENTER RIGHT A classic red-lacquered Japanese umbrella used as an ornament outside a teahouse.

RIGHT Kanazawa is known for its tea culture and the sweets that complement powdered green *matcha* tea.

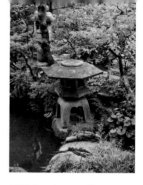

KANAZAWA
NOMURA-KE
野村家屋敷跡

Location: 1-3-32 Nagamachi, Kanazawa. **Hours:** 8.30 a.m.–5.30 p.m.
Closed December 26–27. **Fee:** ¥

ABOVE Stone lanterns add verticality to a garden defined by a horizontal sheet of water.
BELOW A flowering sprig adds color to raw stone.

Nomura House and its Edo era private garden are picturesquely tucked into Kanazawa's old quarter of Nagamachi. Loosely based on the style of the great landscape designer Kobori Enshu, the garden is a rather brilliant exercise in compression, everything in its right place. Should you come here in the winter, you will see that its stone lanterns are wrapped in straw, a wattle coat that keeps them from splitting during the bitterly cold winter months. A stream runs through the garden from a waterfall. As the water slows, it gathers in a small pool below the two main viewing rooms and wooden porches. Sections of the

garden are visible from the five principal rooms of the home and the deep *engawa* porch that runs between the drawing room and a carp-filled pond. It's a skillful fusion of intermediate space, a small triumph in the harmonizing of the man-made and deftly designed replications of nature. The garden is the ideal place to refresh the senses, and if you should wish partake of a bowl of jade-green tea, reflecting, as you sip the astringent brew, on the slow passage of time.

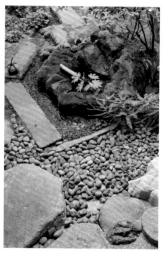

ABOVE Complex lines and forms in a small corner of the garden.

RIGHT This reception room, with its fine views, was transported from an old residence in the south of Ishikawa prefecture.

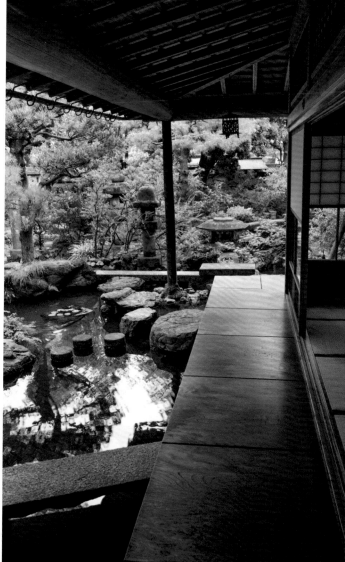

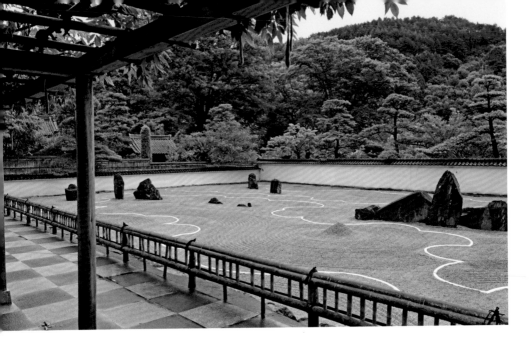

KISO FUKUSHIMA
KOZEN-JI
興禅寺

Location: 5659 Fukushima, Kiso-mach.
Hours: 9.00 a.m.–5.00 p.m. Fee: ¥¥

ABOVE The garden's location in a valley served by a local train may explain its relatively low visitor numbers.

Sinuous banks of tightly clipped azalea bushes interspersed with rock clusters run along the path to the entrance to Shigemori Mirei's highly contemporary garden at Kozen-ji temple. The lushness of the causeway stands in stark contrast to the bare expanse of his inner dry landscape garden. Even on a gloomy day the garden emits a radiance, its full exposure to the sky capturing small traces of light.

Said to be inspired by the sea of clouds that often cover the valley here, glimpses of the surrounding countryside and its forested hills add further contrast to a vision of nature in both its raw and contrived forms. Concrete chords wiggle across the gravel like white pythons, or in another interpretation, icy rivers passing through a landscape of dark, slightly forbidding rock arrangements. It is easy

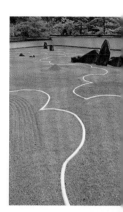

LEFT Fluid forms made from azalea bushes facilitate the approach to the main garden.

RIGHT The white, cord-like lines help to promote depth of field.

to miss an Edo era garden to the rear of Shigemori's modernist design, a landscape skillfully composed and much improved by age. Weathered stone lanterns and bridges, wash basins, and moss-covered rocks transport us back to an age of gardening defined by certitudes, a confidence in how to execute a mature landscape.

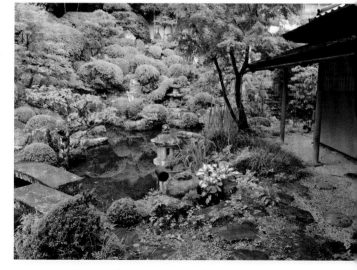

RIGHT Nothing appears to be written about this highly accomplished but little known rear garden.

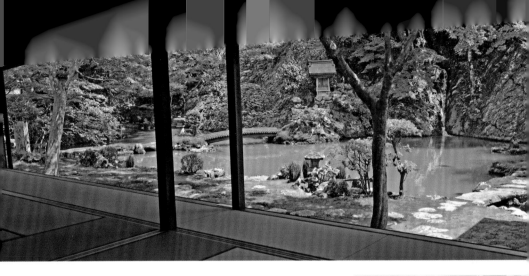

GUJO HACHIMAN
TESSO-EN
てっ草園

Location: Shimadani 339, Hachiman-cho, Gujo-shi. **Hours:** 9.00 a.m.–5.00 p.m. **Fee:** ¥

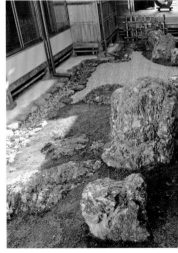

Few people visit this wonderful garden, one of the best kept secrets of the mountain town of Gujo Hachiman in Gifu prefecture. Part of the sixteenth century Zen temple of Jionzen-ji, Tesso-en was created by the temple's first head priest, Hanzan. It is relatively rare with older gardens to be able to definitively accredit a garden design in this way. Classified as a stroll pond garden, its design lines echo Muromachi era landscape principals. Integral to the design of the temple, the garden, best viewed from a seated position in the large *tatami*-floored main room, is ideal for meditation. The soothing resonance of the garden's natural waterfall, set in a cliff face

LEFT Although man-made, the designer has appropriated existing natural forms.

RIGHT Elegant as they are, it is almost obligatory to include a water basin in a Japanese garden.

BELOW Compared to the languorous main garden, its dry landscape is conspicuously assertive.

BELOW RIGHT Under the shade of a canopy of trees, moss is able to flourish.

surrounded by woodland, is complemented by the calming regularity of a *suikin kutsu*, an upturned earthen jar with a hole, which is positioned under a stone basin. When water from the basin passes through the hole, it produces a gentle splashing sound. Water is a dominant theme in the garden, with a pond surrounded by maple trees and ancient stone lanterns and crossed by weathered granite bridges. The water theme continues even in the powerful courtyard

garden at the rear of the temple, a dry landscape arrangement containing rocks representing a crane and turtle afloat in a symbolic sea of gravel.

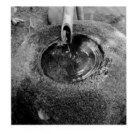

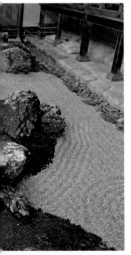

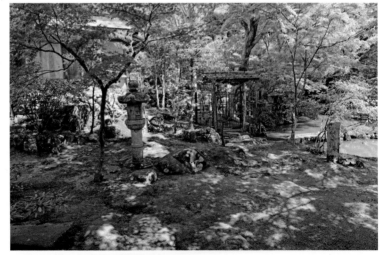

HIKONE
GENKYU-EN
玄宮園

Location: 3-40 Konkicho, Hikone.
Hours: 8.30 a.m.–5.00 p.m. **Fee:** ¥

LEFT Powdered green tea and a local sample of *wagashi* (Japanese confectionery) are served at a small extra cost.

Also known as Genyu-Rakuraku-en, the pond and garden of this 10 acre (2 hectare) feudal era circuit garden were constructed by the fourth lord, Ii Naoki, in 1677. The garden was named after Chinese emperor Xuan Song's Tang era detached palace. What differentiates Japanese gardens from the Chinese templates that influenced their designs, however, are the specific tastes, preferences and aesthetics of the Japanese themselves. In common with many pond gardens, a path circles the water while gentle sloping banks on the other side of the path have ancient trees and rock arrangements. In the garden's commanding rock forms, some observers have detected the stylistic aesthetics of the earlier Momoyama period. Timber bridges span the large pond, which has four islands. A

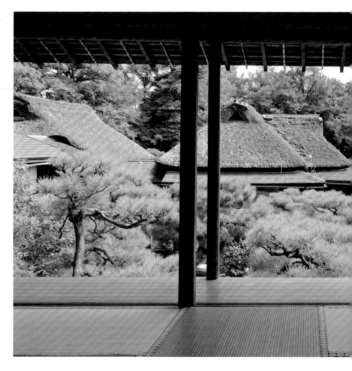

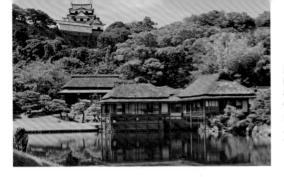

LEFT Verticality is established in the form of an upright rock at the side of the pond and the distant form of Hikone Castle.

RIGHT A naturalistic flower arrangement adds elegance to the corner of a teahouse.

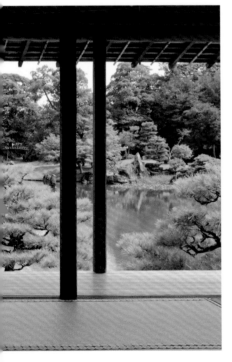

set of interlinked teahouses on the west side offer matchless views across the water. The main keep of Hikone Castle, one of only twelve original fortresses remaining in Japan, towers above the garden, providing the focus for a dynamic "borrowed view." An audio as well as visual experience, the time-keeping bell of Hikone Castle and the chirping of cicadas and crickets in the summer and autumn add to its soundtrack.

LEFT Open to the public, this teahouse may have the garden's finest view.

RIGHT Fortified by masonry similar to castle walls, the wooden bridge acquires the character of sculpture.

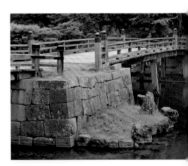

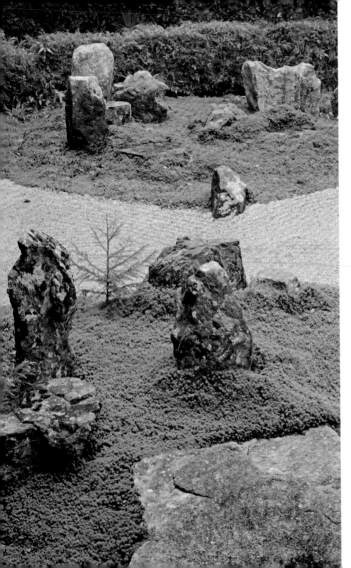

HIKONE
RYOTAN-JI
龍潭寺

Location: 1104, Furusawa-cho, Hikone 522-0007. **Hours:** 9.00 a.m.–5.00 p.m. Fee: ¥

Tucked up against a wooded slope on the edges of Hikone, the temple of Ryotan-ji is, arguably, the town's most underrated cultural asset. A light dusting of moss, more like powdered green tea than the spongy moss variety found in Kyoto gardens, covers the approach steps to the temple, reminding you how few visitors pass this way. As you walk along the corridors of the main temple building, Buddhist statuary, scrolls and partially faded painted screens come into view, creating the impression of walking through a muted gallery. More artistry is evident in the temple's two superb gardens. The flat plane of the Hojo South Garden, a dry landscape surrounded by temple buildings and hedges, though small, creates an infinity of space

by the skillful placement of moss and rock islands. On a bed of raked gravel, a large stone at the center of the arrangement represents Fudaraku Mountain, spiritual home of Kannon, the goddess of mercy. On the other side of the temple, the serenely quiet Shoin East Garden, with its pond, stone turtle island, dry waterfall and hill of clipped bushes and rocks, makes clever use of a natural gully as "borrowed scenery," animating a natural scene into a man-made garden drama.

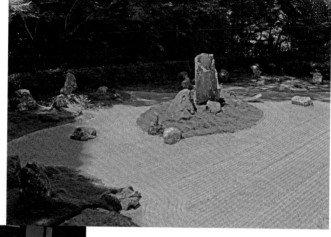

ABOVE This corner of the dry garden is bordered by natural woodland and low hedges.

BELOW The foot of a steep hillside has been co-opted to turn natural landforms into garden art.

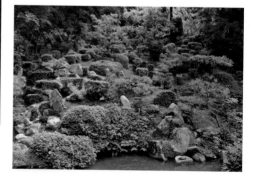

OPPOSITE Three separate moss and rock islands float majestically in a sea of gravel.

ABOVE *Shoji*, sliding paper doors, allow muted light to enter the rooms of the temple.

MAEBARA
SEIGAN-JI
青岸寺

Location: Maebara-shi, Maebara, 669.
Hours: 9.00 a.m.–5.00 p.m. **Fee:** ¥

Located at the rear of a small town in the Ohmi region of Lake Biwa, the bold, assertive rock placings of the dry landscape at Seigan-ji temple endorse the impression of a garden created by people with unshakeable religious beliefs. The entrance path to the temple is overhung by an unusually large crepe myrtle tree, whose flowers swell into glorious dark pink blooms in high summer. Instead of using gravel or sand to represent water, the garden employs moss. A stone bridge crosses this expanse of symbolic water. Symbolism is exploited to great effect in other garden elements, including a *kare-ike* (dried pond), a *kare-taki* (dried waterfall) and a cluster of stones representing the legendary Mount Horai. The classic crane and turtle island float in the center of the garden's depiction of a lake or sea. Built in 1678, the greenery of the

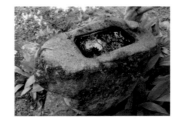

ABOVE A freestanding *tsukubai* (water basin) without surrounding stones or other additions.

slope behind the garden and the aridity of its rocks form a starkly impressive contrast. An unusual *furi-ido* style water basin and a stone lantern that blends Japanese and Western sensibilities add to the interest of a garden that was designed to evoke the mood and ambience of Togenkyo, the mythological Chinese paradise or Utopia.

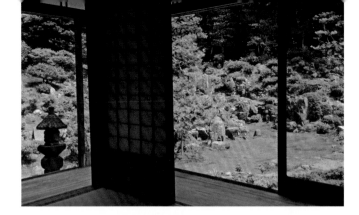

RIGHT The L-shaped temple building provides differing views of the garden.

BELOW With few visitors, Seigan-ji has retained its hidden, reclusive character.

OPPOSITE BELOW The crepe myrtle (*saru suberi*) tree comes into full bloom in high summer.

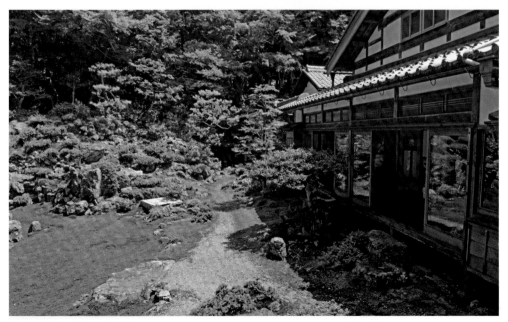

MOUNT KOYA
FUKUCHI-IN
福智院

Location: 657 Koya-san, Ito-gun, Wakayama prefecture. **Hours:** All hours.
Special Features: The entrance garden is visible to the general public.
To view the other two gardens you have to be an overnight guest at the inn.

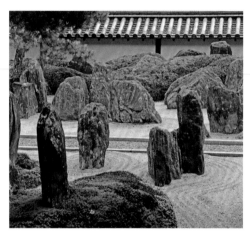

ABOVE Look carefully and you can make out the shape of a turtle, an auspicious symbol.

LEFT In Shigemori Mirei gardens, rocks seem to erupt from the earth.

The writer Donald Richie spoke of a "descending balm" experienced by visitors to Koya-san, one of Japan's most sacred mountains. The soothing ambiance is palpable at Fukuchi-in, a *shukubo*, or temple lodging, and its three gardens. Commissioned by its head priest to design a pond, courtyard and entrance garden, Shigemori Mirei's work was completed in 1974. As you enter the temple grounds, an outer dry landscape garden with the forceful, upright rocks favored by the designer is visible, the rear section of the garden divided into bordered squares, each with a different colored gravel. According to garden writer Christian Tschumi, the grid pattern "represents Buddhist solemnity." The pond garden to the rear, best observed from a spacious lobby, contains the familiar crane and tortoise island, symbols of longevity. A billowing mass of azalea bushes, forming a sinuous backdrop, fills out the rear of the garden. An adjacent arrangement, known as Yusen-tei, the "Ascent to Paradise Garden," depicts in moss and gravel the winding progress of a river. Whether your garden tastes run to the modern or purist, at Fukuchi-in Shigemori Mirei created a work that was both contemporary and implacably Japanese.

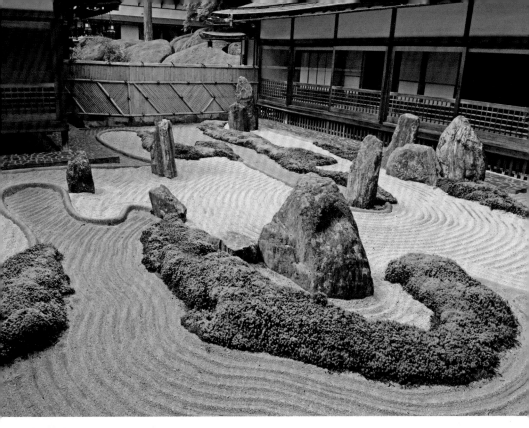

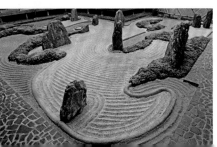

LEFT Shigemori's juxtaposition of styles and materials creates interesting interplays of form.

ABOVE Separated from the pond garden by a bamboo fence, the sense of a winding river is created in two contrasting colors of gravel.

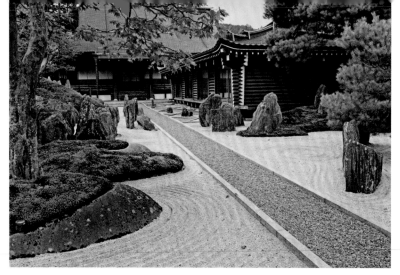

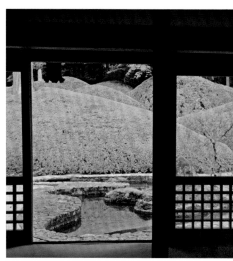

BELOW Meticulously clipped topiary at the rear of the pond garden creates deeper perspective.

ABOVE This straight gravel path leads directly to the Hojo, the temple's main structure.

BELOW The materials are typical enough but the colors and tones are not.

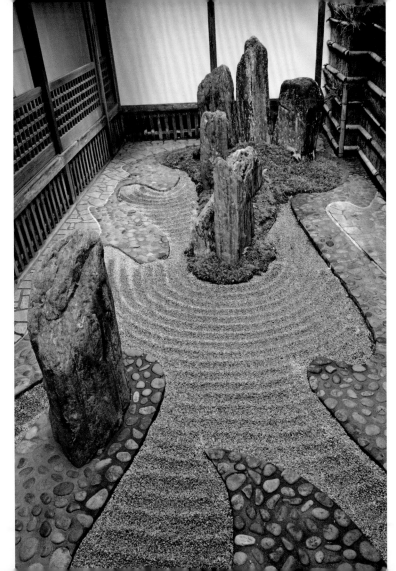

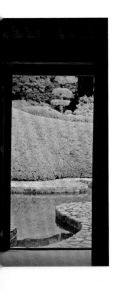

RIGHT This narrow stone garden off the main courtyard arrangement is often overlooked.

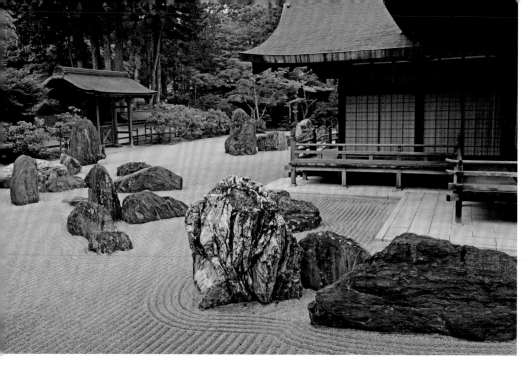

MOUNT KOYA
KONGOBUN-JI
金剛峯寺

Location: 132 Koyasan, Koya-cho, Ito-gun.
Hours: 8.30 a.m.–5.00 p.m. Fee: ¥

Banryutei, as this massive stone garden is known, adjoins Kongobun-ji, a Shingon sect temple dating from 816, though the current reconstruction was built in 1863. The garden consists of no fewer than 140 granite stones extracted from Shikoku Island, then set in white sand taken from the Kyoto region. The garden's entire surface area is a generous 25,000 square feet (2,340 square meters). A modern design, completed in 1984, the resulting composition symbolizes two dragons in an ocean of cloud, their role to protect the sanctuary and the nearby tomb of Kobo Daishi, the founder of Shingon Buddhism. Exposed wooden corridors and decks provide ample viewing points, the structures extending to a rear pavilion with

RIGHT A parallel walkway makes it possible to access the entire length of this long and narrow dry landscape garden.

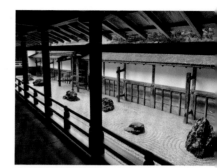

LEFT The generous expanse of gravel around the temple's main structures permits the placement of several rock groupings.

BELOW Walkway pillars inadvertently create several viewing frames.

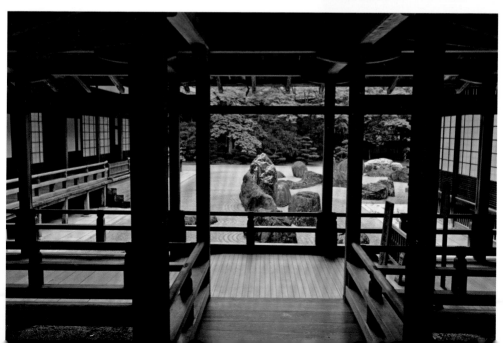

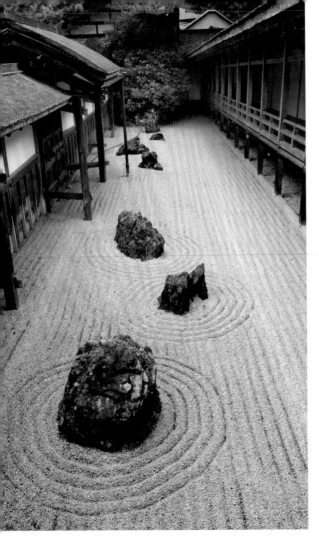

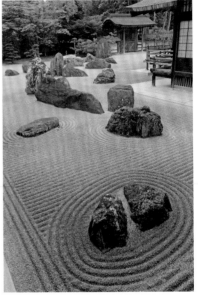

LEFT Elevated decks provide a commanding view of this stone garden.

ABOVE As part of Zen training, leaves are removed and gravel raked early each morning.

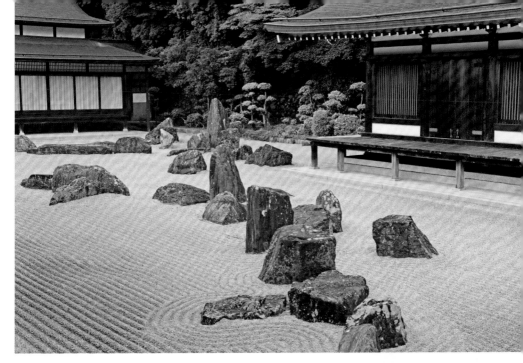

another stone arrangement. Some people may find the garden of Kongobun-ji, the largest stone landscape in Japan, overstated, its rocks lumpy and indelicate. Look a little closer, though, and you will see carefully co-ordinated site lines and form in what at first appears to be over-assertion. The scale may be overwhelming but the design is compelling.

ABOVE After the 1868 Meiji Restoration, Kongobu-ji emerged as the most prominent temple on Koya-san.

RIGHT Frames, pillars and wooden rails add rather than detract from this garden perspective.

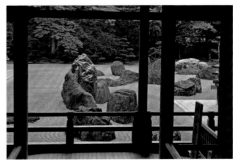

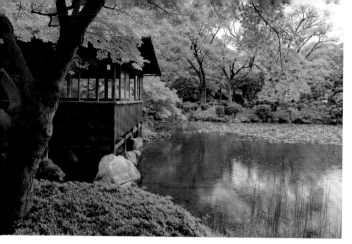

OSAKA
KEITAKU-EN
慶沢園

Location: 1-108 Chausuyama-cho, Tennoji-ku, Osaka. **Hours:** 9.30 a.m.–5.00 p.m.
Fee: ¥

Some of the finer principals associated with Japanese aesthetics survive at Keitaku-en, a stroll garden in the busy Osaka district of Tennoji. The existence of the garden is surprising given the damage inflicted on Osaka by air raids in World War II and the post-war construction industry. Created by Jihei Ogawa, one of the foremost garden designers of the early to mid-twentieth century, the landscaping was done for the wealthy Sumitomo family as part of their main Osaka residence. Situated within Tennoji Park, the garden was donated to Osaka City during the Taisho era, along with the main residence. A *chisen-kaiyu-shiki* style garden, the site has several features in common with classic Japanese landscaping, including distinctive rocks, pavilions, a tea-house and gazebo, stone lanterns and well-appointed bridges. There are over two hundred plant and tree species, including iris, azalea, Japanese apricot, maple, Japanese blue oak, hackberry, cherry and camphor. Thickets of cycads, or Sago palms, hint at warmer, southern climes. In the summer months, the pond is covered in water lilies. In a gardening technique known as *sawatari*, stepping stones traverse brooks flowing into the pond, allowing visitors to experience the flow of water beneath their feet. With precious little greenery in the commercial and industrial city of Osaka, Keitaku-en is a blessing.

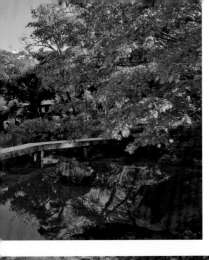

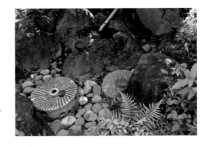

FAR LEFT In common with many teahouses, this cantilevered structure provides one of the best views of the garden.

LEFT A simple granite bridge that is both functional and aesthetically pleasing.

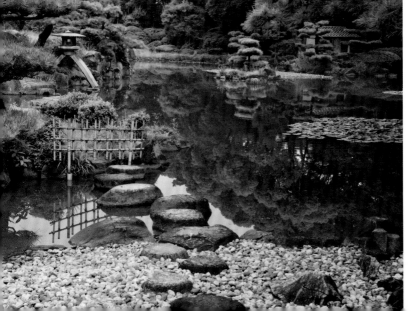

ABOVE Millstones are occasionally used in gardens, serving as interesting *mitate mono*, or requisitioned objects.

LEFT Stepping stones, a *koto-ji* style stone lantern and an arbor form a precise triangle in an otherwise asymmetric design.

KOBE
SORAKU-EN
相楽園

Location: 5-3-1 Nakayamate-dori, Chuo-ku, Kobe. **Hours:** 9.00 a.m.–5.00 p.m. Closed Thursdays. **Fee:** ¥

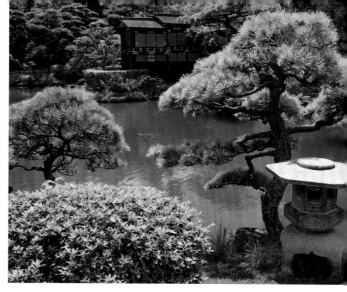

On January 17, 1995, as the city of Kobe was struck by one of the country's worst earthquakes in living memory, the rocks, artificial hills and root systems of Soraku-en, a Meiji period circuit garden, held firm. Arguably, the most outstanding feature of Soraku-en, a classic Japanese stroll garden with a gourd-shaped pond and a number of artificial hills, is the *kawa-goza-bune*, an ornate boathouse dating from the seventeenth century. In what must have been a magnificent social event, it was once used to host guests at floating parties. Circuit gardens like this are at their most successful when they provide a fluid succession of predetermined, framed images. Thus, visitors move from the edge of the pond where pine trees dominate,

up squat, grass-covered hills planted with azaleas, across the stepping stones of a stream to groupings of camphor trees. Individual rocks, including granite and blue Iyo stone, complement the garden's stone bridges, which are made of fieldstone. If the deceleration of speed and time is essential to the experience of the Japanese garden, Soraku-en embodies glacially slow changes in natural elements, modified by the temporal hand of gardeners who maintain, and through that supervision, subtly alter the grounds.

LEFT Pine trees, associated with seashores, are often planted beside garden ponds.

BELOW LEFT Water overflows from this unusually shaped basin.

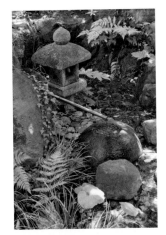

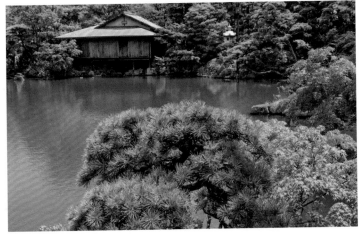

ABOVE LEFT The classic tableau of stone lantern, water basin and selected rocks.

ABOVE Soraku-en has one of the richest concentrations of garden cycads in Japan.

LEFT Pines remain green throughout the year but most of the trees at Soraku-en are deciduous.

SHIMANE
ADACHI MUSEUM GARDEN
足立美術館

Location: 320 Furukawa-cho, Yasugi.
Hours: April–September: 9.00 a.m.–5.30 p.m. January–March and October–December: 9.00 a.m.–5.00 p.m. **Fee:** ¥¥¥
Special Features: There are free shuttle buses to the garden from JR Yasugi Station. Foreign visitors are charged half the entrance fee on production of ID.

The Adachi Museum of Art's impressive collection of paintings and ceramics is almost at risk of being upstaged by its superlative landscaped gardens. Completed in 1970, the garden is the work of Nakane Kinsaku, a powerful force in modern landscaping. The grounds are divided into four main zones: Dry Landscape Garden, White Gravel and Pine Garden, Moss Garden and Pond Garden. Far from being a modest exercise in miniaturization, the gardens cover a staggering 463,000 square feet (43,000 square meters). Embedded in this digest of Japanese garden

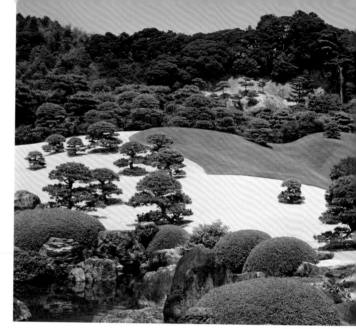

ABOVE The garden represents a collaboration between a wealthy entrepreneur and art collector and a celebrated landscape designer.

LEFT Designed to alter the rhythm and pace of walking, paths like this use irregular sized stones.

RIGHT Plum blossoms seen from inside Juryu-an, a teahouse.

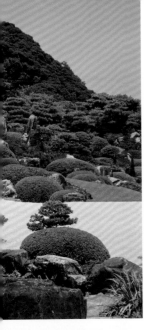

forms are a number of traditional teahouses. The Juryu-an is a replica of a teahouse in the Katsura Rikyu garden in Kyoto. Here, for a price as exalted as its cultural antecedent, visitors can sample powdered green tea made from water boiled in a golden teapot. There is nothing random about the elements of this well-contoured space. A distant waterfall, just beyond the garden boundary, creates a visual focus that unifies the design, the managed compression of space artfully concealing a busy road just beyond the line of pines. Observed from inside the building, wall openings

are flanked by works from the museum's collection, creating an extraordinarily seamless integration of art, architecture and landscape.

ABOVE Plum branches silhouetted against a classic circular window.

LEFT An elevated arbor provides an open view of this section of the garden.

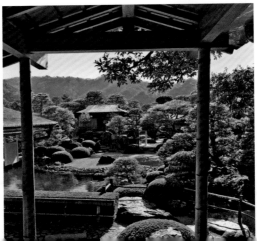

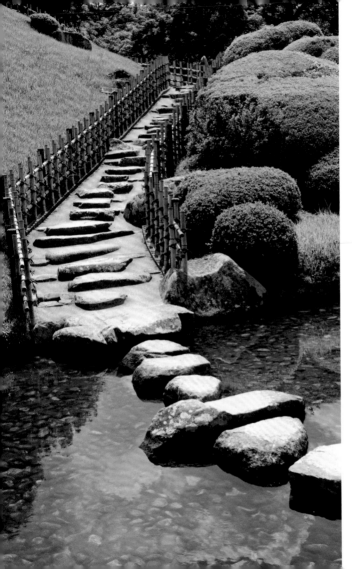

OKAYAMA
KORAKU·EN
後楽園

Location: Korakuen, 1-5, Kita-ku.
Hours: March 20–September 30:
7.30 a.m.–6.00 p.m. October 1–March 19:
8.00 a.m.–5.00 p.m. **Fee:** ¥

It may be a flawed system but
Koraku-en is ranked as one of
the three finest gardens in Japan.
Nobody would argue that it is a
major work of Japanese landscape
art. The current design, completed
in 1700, was begun under the
supervision of Ikeda Tsunamasa,
lord of Okayama province. If the
garden has a centerpiece, it must
be Mount Yuishin, an ascendable
hill created, like so many of these
stroll garden forms, in the likeness
of Mount Fuji. Azaleas are planted
on its slopes and fine views of the
garden are available from its mod-
est summit. The garden has unu-
sually wide expanses of lawn, a
fashion adopted in the Edo era,
a broad pond with three islets
known as Sawa-no-ike, and size-
able yin and yang stones. Sited on
the north bank of the Asahi River,

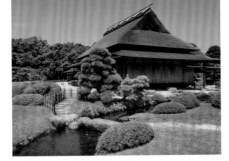

RIGHT A grand teahouse near the entrance to the garden.

RIGHT A grand teahouse near the entrance to the garden.

ABOVE Japanese gardens provide the perfect photo-ops for newlywed couples.

LEFT *Yatsu-hashi* are wooden plank bridges that zigzag through iris gardens.

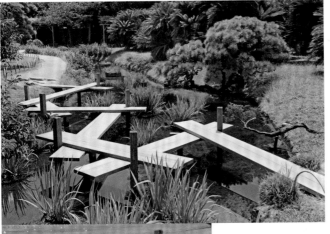

LEFT A small but highly distinctive stone lantern accentuates the curve of the stream.

OPPOSITE A combination of stepping stones and water lead to the man-made Yuishinsan ("Sole Heart Mountain").

the dark stories of Okayama Castle stand just beyond the garden perimeters, forming an impressive "borrowed view." Groves of plum, cherry, pine and maple and a miniature tea plantation fill out the open spaces of the garden. A zigzag *yatsuhashi* bridge runs above an iris field close to an open pavilion, known as Ryuten, where poetry events were once held.

BICHU-TAKAHASHI
RAIKYU-JI
頼久寺

Location: 18 Raikyu-ji-cho, 716-0016, Takahashi.
Hours: 9.00 a.m.–5.00 p.m. Fee: ¥

LEFT Carefully clipped topiary beautifully framed by a circular *enso* window.

BELOW Cool interiors like this are perfect for garden viewing.

The designer attribution, generally supported by the garden establishment in Japan, is to Kobori Enshu, making it one of only a few authentic gardens created by this master. Constructed in 1609, the garden, attached to a Rinzai sect temple, is a model of equipoise and good taste. The azalea topiary, one of two main focal points, represents waves crashing onto a symbolic gravel beach. This has been formed in sections, with an enclosing bank of camellias. Look behind them and there are narrow, earthen walkways, access for the gardeners to trim the hedges. The details in such gardens are always fascinating. Our eyes turn naturally to a cluster of rocks wrapped in low, flowing topiary. This is a classic arrangement in which the island form is made to represent a crane and turtle, symbols of good health and longevity.

The garden's main path, an intriguing blend of shapes and surfaces, mixes natural and hewn stone. The "borrowed scenery" of Mount Atago confers depth and extended perspective to the garden. A black stone placed in the foreground replicates the outline and slope of the mountain. Some viewers see in the stone triad and long, curving stepping stones a similarity between this garden and Kobori Enshu's design for Konshi-in, a Kyoto temple.

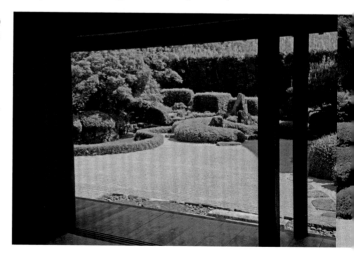

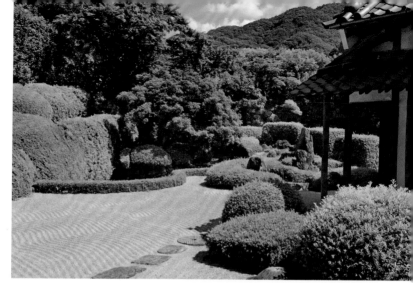

RIGHT The garden's carefully conceived curves complement the natural contouring of the background.

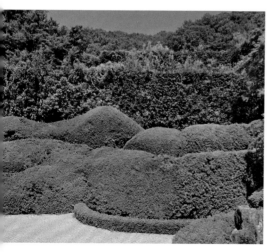

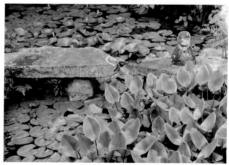

LEFT The billowing form of the topiary is a typical Kobori Enshu touch.

ABOVE A small rear garden is a wonderland of water plants and weathered stone.

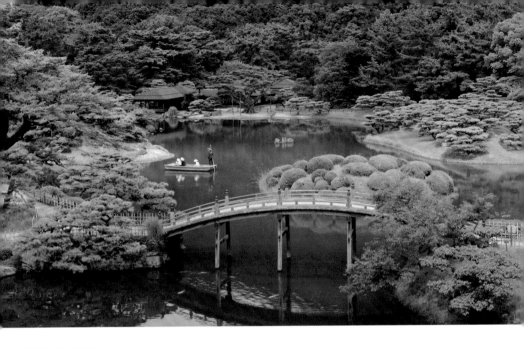

TAKAMATSU
RITSURIN-KOEN
栗林公園

Location: 1-20-16 Ritsurin-cho, Takamatsu-shi. **Hours:** Seasonally varying opening times, from 5.30 p.m.–7.00 p.m. **Fee:** ¥

Spread out gloriously below the slopes of Shiunsan ("Purple Cloud Mountain"), which functions as a classic example of *shakkei*, or the "borrowed view" technique, it took several generations of the feudal Matsudaira clan to complete the garden in 1745. One of the finest stroll gardens in Japan, six interconnecting ponds, a large number of artificial hills and numerous islets supporting intriguing figurative rock formations create a complete web of land, water and symbolism. Noted for a large number of black and red pines, its cubic *hako-zukuri*, or '"box-making" topiary, is striking. Although almost any perspective on the

LEFT The garden's large pond dates from the Momoyama era when a feudal lord, Takatoshi Ikoma, established a residence here.

RIGHT Latticed squares created within the circular design of the window.

BELOW The Kikugetsu-tei teahouse was originally constructed in 164, before the main garden was built.

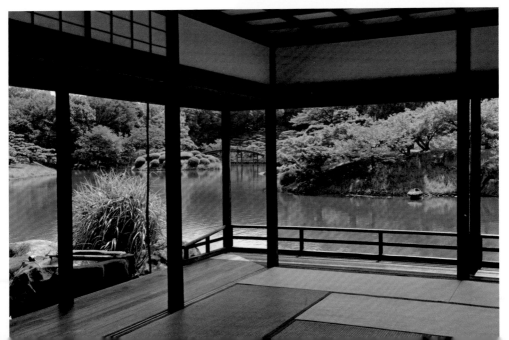

BELOW Flat-bottomed barges are yet another way to view the garden.

RIGHT View from a corridor beside the teahouse of Kikugetsu-tei.

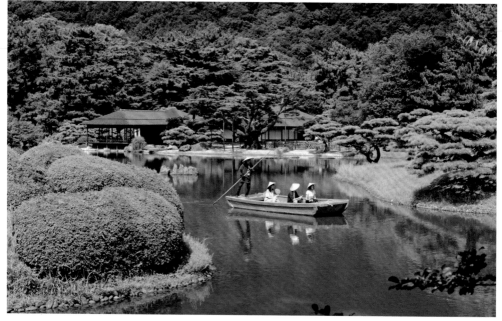

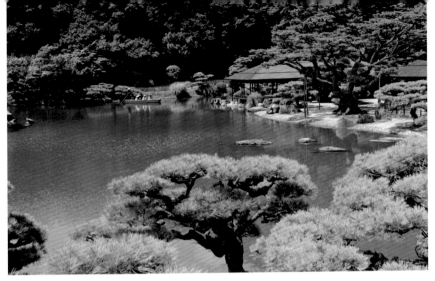

garden yields gratifying views, two particular observation spots stand out. The elegantly curving Engetsu-kyo Bridge provides a slightly elevated view along the South Pond to the second observation gallery, the Kikugetsu-tei ("Moon Scooping Pavilion"). A teahouse built on the edge of the South Pond, its interior focusing on a large *tatami* mat room, provides magnificently appointed views. In 1953, the 133 acre (54 hectare) garden was designated as a Special Place of Scenic Beauty but its magisterial design, the manipulation of space and attention to detail, elevate it above the merely beautiful.

ABOVE Ritsurin Park is known for its profusion of pine trees, some clipped into creative shapes and forms.

RIGHT Tea bowl and flower display in the spacious Kikugetsu-tei teahouse.

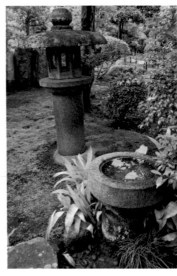

ONOMICHI
SOURAIKEN
爽頼軒庭園

Location: 6-6, 2-chome, Kubo Onomichi-shi.
Hours: 10.00 a.m.–4.00 p.m. **Fee:** ¥

As you wander along weathered stepping stones past mottled rock formations, stone wells, rustic teahouses, clumps of evergreen bushes and a canopy of trees that create an almost subterranean green world, the sense is of a well-worn, long-established garden. Come here in the humid summer months and the sound of cicadas and rustling bamboo, sealed within the clay walls that surround the garden, create the impression of a timeless sound chamber. It comes as a surprise then, to learn that Souraiken, located in the Inland Sea town of Onomichi, though built on the grounds of an older family residence, a second home once owned by the prosperous Hashimoto family, actually dates from this century. Inspired by the tea garden ascetic, its paths deliberately reducing the speed at which we pass through the grounds, allowing us to take in the details and its mossy hillocks and weathered rocks, suggest a depth and antiquity beyond the garden's real age. It is truly heartening to see a contemporary Japanese garden like this, to know there are still people in possession of the traditional skills and aesthetic sensibility required to create a landscape of this quality in the current age.

FAR LEFT Hemp palm, an evergreen, partially conceals an ancient stone lantern.

CENTER LEFT Many Japanese garden elements are contained within this small corner.

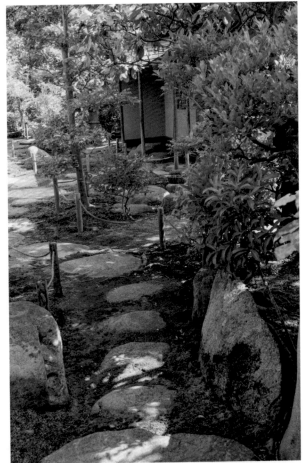

ABOVE Older elements like this water basin have been introduced to create a more weathered mood in this contemporary garden.

RIGHT Stepping stones are designed to reduce walking speed and promote an appreciation of garden details.

HIROSHIMA
SHUKKEI-EN
縮景園

Location: 2-11 Kaminobori-cho, Naka-ku, Hiroshima.
Hours: 9.00 a.m.–6.00 p.m. **Fee:** ¥

The location of Shukkei-en, close to ground zero during the nuclear attack on Hiroshima during World Wat II, resulted in extensive damage to the garden. After painstaking reconstruction, it was reopened to the public in 1951. If old pre-war photos are anything to go by, the restoration appears to be a remark-ably faithful one. A typical Japanese stroll or circuit garden, the site was first created in 1620, purportedly by the tea master Ueda Soko. The name Shukkei-en, also known as Izumi-tei, translates as "Compressed Scenery Garden," an apt description for the series of valley, forest and mountain cameos skillfully inte-

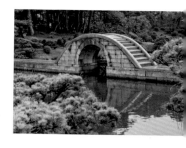

ABOVE This Chinese style bridge, Koko-kyo, is the focal point of the garden.

BELOW LEFT A spacious garden, Shukkei-en occupies roughly 10 acres (4 hectares).

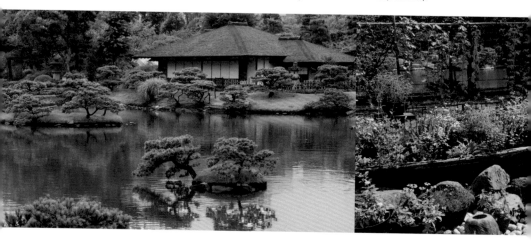

grated into the grounds. Like today, the original garden contained a number of teahouses, stone lanterns and miniaturized scenes, forming a cultural digest of China and Japan. Perhaps the strongest Chinese reference is the Takuei Pond, with its many islets, including the clear outline of a turtle and crane island. The water is transected by a bridge, the Koko-kyo, modeled on the causeway at Hi Hu, the West Lake in Hangzhou, China. A green and bucolic spot, Shukkei-en is more than just a garden, it is a symbol of rebirth and hope.

RIGHT A wooden vessel has been ingeniously converted into a planter.

BELOW Authentic teahouses like this are extremely small and are made from modest materials.

BELOW CENTER Seasonal flowers are regularly changed in this unusual display container.

BELOW A *sorihashi* or bow bridge with a curved design intended to reinforce the structure.

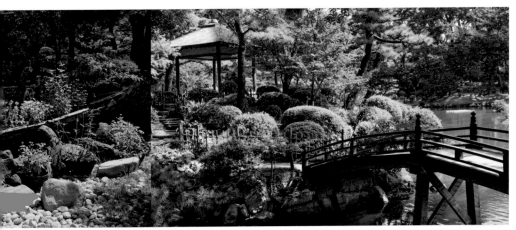

YAMAGUCHI CITY
JOEI-JI
常栄寺

Location: 2001-1 Miyanoshimo, Yamaguchi City.
Hours: 8.00 a.m.–5.00 p.m. **Fee:** ¥

Replete with lush hills, it is fitting that among the cultural assets of Yamaguchi City is one of Japan's most exquisite dry landscape gardens, the work of an extraordinary man. Poet, Zen monk, calligrapher, landscape painter and garden designer, if there was ever a Renaissance figure in the Japanese arts it must be Sesshu Toyo (1420–1506). Returning by trading ship from China, Sesshu was asked to design a traditional Japanese garden in the grounds of Joei-ji temple. The result is a dynamic synergy, with a series of islands, seas, mountains, ravines, straight-sided and flat-topped rocks, replicating the visual vocabulary of Sesshu's own monochrome paintings. One stone clearly represents Mount Fuji, others an auspicious turtle and crane islet and a dry

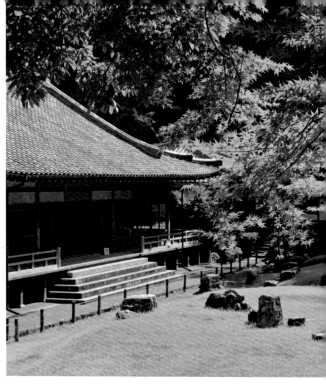

ABOVE The main garden in summer is a study in green.

LEFT A rugged section of earthen embankment hints at an ascent into a more elevated zone.

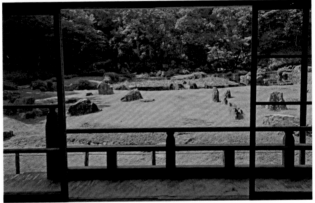

LEFT A hillside planted with trees provides a three-sided frame for the garden.

waterfall descending a small gully. The raised path through the woodland perimeter provides glimpses of a pond shaped into two opposing peninsulas, each connected by an earth-covered bridge. Reflecting on the garden, Donald Richie observed, "the impression is of a vast open universe rather than a particular

ABOVE The temple's main viewing room provides a full vista of Sesshu's painterly vision.

panorama." This idea of scale and intent, of a design that draws its viewers in to spiritually replenish them, seems just right for a garden that is open to all and sundry.

HOFU
MORI RESIDENCE GARDEN
毛利氏庭園

Location: 1-5-1, Tatara, Hofu-shi. **Hours:** 9.00 a.m.–5.00 p.m. **Fee:** ¥

After conceding the Chofu fiefdom to the new forces of the Meiji emperor, Mori Motonori had this garden and villa built for his family and retainers. Constructed on a number of different levels, the design is notable for a large pond, which, with its steep embankments, feels a little like a reservoir. A rock-strewn ravine forms an inlet into the pond. Over 250 tree species are planted in the garden, including the *nioi zakura*, an ancient type of cherry. The views from the grand central villa and connected structures are less impressive than the reverse perspective of the residence from the garden. With plenty of weeds and other invasive plants, this is a garden that is not over-maintained. The design is not without its shortcomings, including

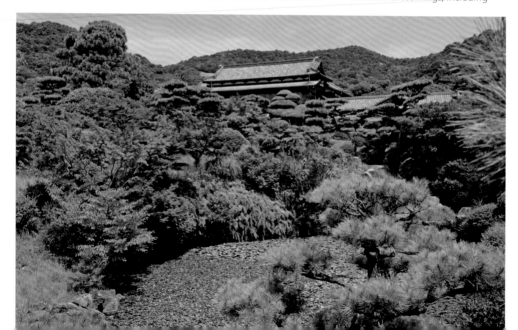

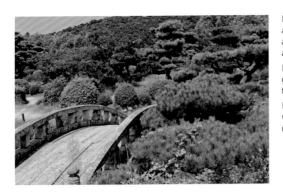

LEFT The granite floor and railings of this bridge are precisely carved to accommodate the curvature.

RIGHT A quiet corner of the garden where water lilies float in a tiny pond.

BELOW The fine old Mori villa now serves as a museum.

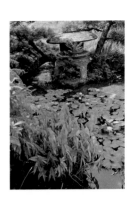

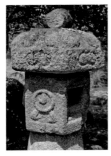

ABOVE In common with other garden ornaments here, this stone lantern has a bold and assertive character.

LEFT This spacious garden has been designated as a Cultural Asset by the Yamaguchi prefectural government.

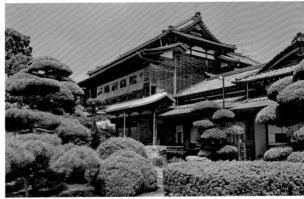

some over-zealous elements, such as a giant concrete lantern, an oddly oversized stone pagoda and, moored at the edge of the pond, a fiberglass tub that a century ago would have been a wooden dugout. The garden's strength lies in its well-judged requisitioning of natural landscape and its well-appointed and integrated features.

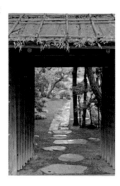

KUMAMOTO
SUIZEN-JI JOJU-EN
水前寺成趣園

Location: 8-1 Suizenjikoen, Chuo-ku.
Hours: March–October: 7.30 a.m.–6.00
p.m. Nov–Feb: 8.30 a.m.–5.00 p.m. **Fee:** ¥

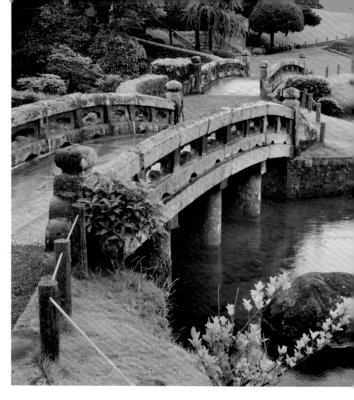

The predominant characteristics of Suizen-ji joju-en might be summed up as sophistication of design combined with a sense of novelty and entertainment. A fine example of the circuit garden, the landscape was commissioned by the powerful Hosokawa family in 1632 to serve as the setting for a detached villa. Suizenji, with its central spring-fed pond, is a classic Japanese stroll garden, the image of its miniature grass-covered Mount Fuji epitomizing the form. Other representational features include a pond shaped to reflect the outline of Biwako, a large lake close to Kyoto, the 53 stages of the Tokaido, an Edo era route that ran from Kyoto to present-day Tokyo, a small green tea plantation and an authentically restored 400-year-old teahouse. Its well-appointed main room serves powdered green tea to guests who sit on *tatami* mats in a serene setting with exquisite views. Despite the accomplished beauty of its landscaping, tour groups, souvenir shops and highly ornamental design features suggest a space that is as much about

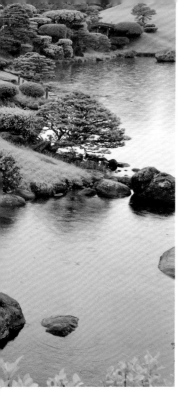

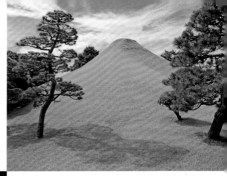

LEFT With many visual diversions, the garden was opened as a public park as early as 1879.

ABOVE Perspective on the iconic Mount Fuji hill is promoted by planting pines that get smaller as they ascend to the summit.

BELOW Superb landscaping has created a valley within the garden.

recreational pursuits as it is about garden art. After a major earthquake struck Kumamoto in April 2016, a large granite gate and a number of stone lanterns collapsed in the garden and the water in the pond dried up. The water has since re-appeared and the garden, like the city, has been carefully restored.

ABOVE A view from the rear of the teahouse to the main garden.

OPPOSITE TOP LEFT Entrance gates are often the first sense the visitor has of the natural materials used within the garden.

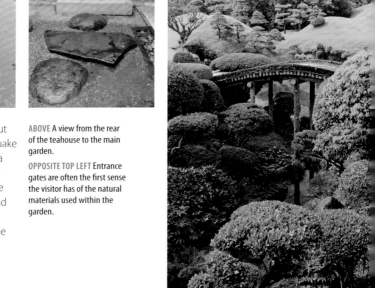

KAGOSHIMA
SENGAN-EN
仙巌園

Location: 9700-1 Yoshino-cho, Kagoshima. **Hours:** 8.30 a.m.–5.30 p.m. **Fee:** ¥¥¥

Vaporous clouds billow testily from Sakurajima's sliced head, the volcano's wind-borne ash settling on to the grounds of Sengan-en. The Shimazu family built a detached villa here, the main residence constructed in 1658. A nearby gazebo was a gift from Okinawa. Decorated with colorful Chinese tiles, the Bogakuro, as it is known, a dark stained wood pavilion, was used to host representatives from the islands. A highly distinctive visual aspect of the garden are its stone lanterns. The famous Lion Stone Lantern is on the right of the entrance to the inner garden. This huge piece was designed by head gardener Oda Kisanji in 1884. Cultural levels were raised at Sengan-an with one of its inner gardens, the Kyokusai. This design is said to have been commissioned by the

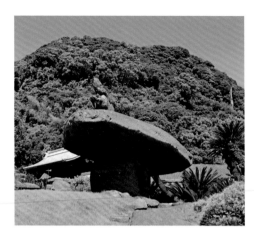

LEFT The famous Lion Stone Lantern is too large to have been much emulated in other gardens.

BELOW The looming head of Sakurajima, a live volcano, is visible from this gazebo.

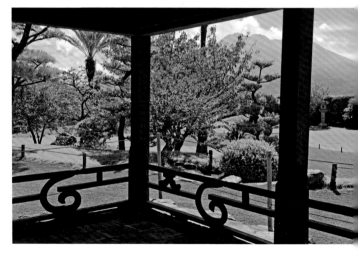

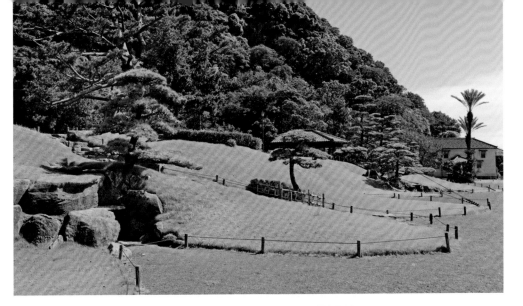

21st Lord Yoshitaka in 1702 but not fully excavated until 1959 when it was rediscovered. Guests at poem writing parties would sit along the winding stream as a cup of saké was floated down on a piece of board. They were expected to complete their poem and then drink from the vessel. The style of garden derives, like so many court-inspired designs and customs, from ancient China, but its broad promenades, groves of bamboo and sun-soaked open spaces suggest a pleasure garden in a southern clime.

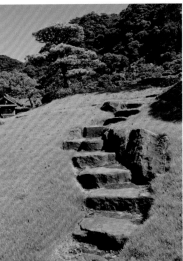

ABOVE Extensively restored between 1830 and 1844, Sengan-en has become one of Kagoshima's major attractions.

LEFT Stone steps help to contour a grassy embankment that represents an intermediate zone between wooded hillside and sea.

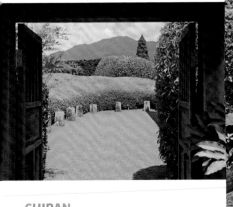

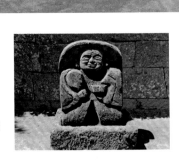

CHIRAN
GARDENS OF CHIRAN
知覧武家屋敷群

Location: Chiran-cho, 6198, Minami Kyushu-shi.
Hours: 9.00 a.m.–5.00 p.m. **Fee:** ¥. A set of
entrance tickets for all seven gardens
can be bought from stores in the village.

Besides its walled lanes, one-story samurai villas and undulating tea plantations, Chiran in southern Kagoshima is best known for a series of seven miniature Edo period gardens. There are three basic garden forms at Chiran. The first is the borrowed landscape type.

Background scenery, such as mountains, forests and hills, is used as part of the garden. This makes the arrangement look larger than it really is. The miniature hill garden is another type. In this style of garden, a central pond is understood to be the sea. Rocks symbolize

mountains and waterfalls. The *kare-sansui*, or dry landscape garden, is the third type. The sea here is represented by sand or gravel which is

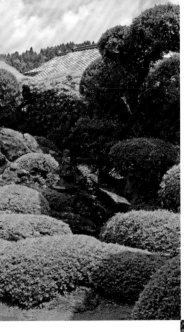

FAR LEFT The entrance to the Hirayama Residence, one of several gardens in this verdant part of Kyushu.

LEFT A stone pagoda gives scale to a composition probably designed to symbolize a gigantic mountainous landscape.

OPPOSITE BELOW A sharply chiseled statue that may represent a mendicant monk.

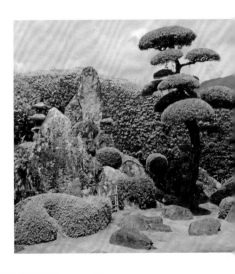

ABOVE Tall trees like this juniper lend flanking support to the main arrangement of rocks and stones.

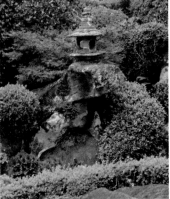

raked into patterns around a number of carefully selected rocks that represent mountains or islands. In a sense, all the gardens at Chiran are of the borrowed view type, requisitioning a tiled roof or the top of a stone lantern beyond the garden wall as a component. The fact that there is very little written about these gardens allows you the freedom to form original rather than borrowed thoughts and views on their designs.

LEFT Originally designed for use in Buddhist temples as containers for votive candles, stone lanterns are now seen as ornamental objects.

KIN-CHO
HANGING BONSAI GARDEN

Location: 4272-1 Kin-cho. **Hours:** 9.00 a.m.–6.00 p.m. **Fee:** ¥¥

The Limestone Cave, Bonsai Garden and Cafe Gold Hall are one of those places that have to be seen to be believed. A fine example of how a personal passion can lead to a fully developed garden project, businessman Matsuzo Gibo conceived the idea of cultivating and protecting Okinawa's bonsai trees in the 1960s. Pressed against a limestone cliff on a slightly elevated road in the main entertainment area of Kin-cho on the eastern seaboard of Okinawa main island, the entrance to the restaurant and bar

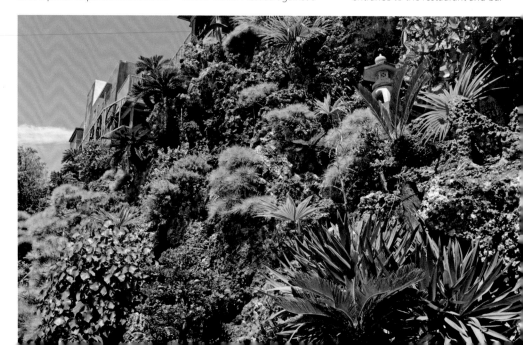

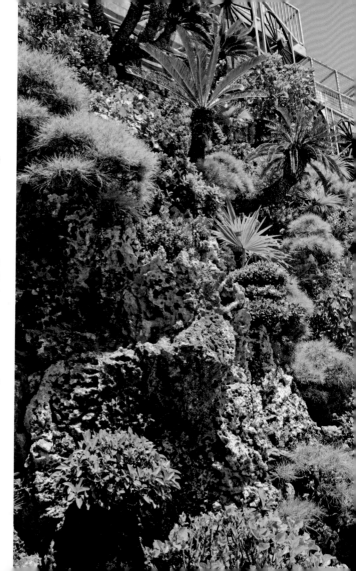

LEFT An engorged Chinese statue of the Buddha adds to the theme park character of the garden.

leads to a passage descending into a complex of limestone caves and chambers. The hanging bonsai garden that greets visitors is an extraordinary sight, the ancient, crustal rock face imbuing the trees with an impression of great age and maturity, the cliff on which the trees have gained a firm anchorage creating a sense of soaring verticality. Adding to the rambunctious congestion, the cliff is pitted with miniature waterfalls, cycads, birds' nest ferns and a number of folkloric figures from the Japanese and Okinawan pantheon: raccoons, *shisha* lion-dog statues, phoenixes, mythological goddesses and corpulent Chinese-style Buddhas.

LEFT Considerable skill has gone into planting such a steep limestone cliff.

RIGHT Viewing the garden from the lower paths highlights its extraordinary verticality.

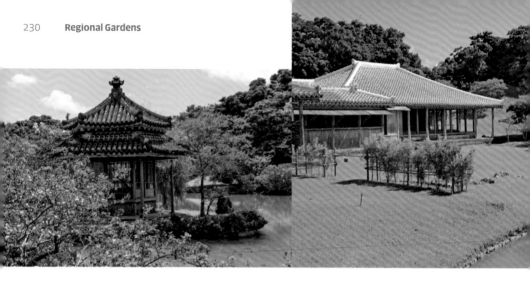

NAHA
SHIKINA-EN
識名園

Location: 421-7 Maaji, Naha. **Hours:** 9.00 a.m.–5.30 p.m. Closed Wednesdays. **Fee:** ¥

ABOVE LEFT Crepe myrtle blooming before the garden's hexagonal pergola.

ABOVE Severely damaged during the Battle of Okinawa in 1945, the garden has since been fully restored.

Assertively Okinawan but with unmistakable Chinese influences, the formal grounds of the royal garden of Shikina-en, completed in 1799, served as the second residence for the royal family in the days when Okinawa was a sovereign state known as the kingdom of Ryukyu. Its red-tiled detached villa was used to host Chinese envoys attending coronations. Much of Shikina-en, declared a Unesco World Heritage Site in 2000, resembles a flourishing botanical garden, an arboretum of tropical specimens like banyan, clumps of birds' nest ferns, cycads, and even a grove of banana trees. The choice of stones, reflecting the Chinese love of pitted rocks with sharp surfaces, blowholes and hollows, is very different from those found in Japanese gardens. The elegant Rokkaku-do, a hexagonal design, closely emulates the waterside pavilions seen in Chinese landscapes. Strolling its expansive grounds we might be excused for thinking we are in the Chinese landscape world of the Humble Administrator's Garden or the Garden of

Cultivation in Suzhou. Any direct or overwhelming resemblance to the literati gardens of China dissolves, however, when one reflects on the absence in Okinawa of any figures akin to the scholar-philosophers of the Middle Kingdom.

BELOW The ghostly aerials of a complex ficus, a tree similar to the banyan.

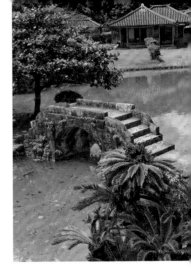

ABOVE A fine Chinese style bridge made from limestone.

BELOW The red and yellow bracts of the heliconia are strongly associated with the tropics.

ISHIGAKI
MIYARA DUNCHI
宮良殿内

Location: 1780, Okawa, Ishigaki.
Hours: 9.00 a.m.–5.00 p.m. Closed Tuesdays.
Fee: ¥

Miyara Dunchi might well have been built by a Chinese wizard or an eccentric Daoist so fabulist are the garden's rock clusters. One could easily imagine the Western Jin dynasty poet Pan Yue idling away his time in contemplation of the garden's craggy landscapes. Built in 1819 by the magistrate for Okinawa's Yaeyama Islands, one Miyara Peichin Toen, the garden's adjoining residence is the oldest extant example of a samurai-style villa in Okinawa. The stone clusters of this small sub-tropical garden may resemble Chinese rockeries, rock piles representing the Isles of the Immortals in their wrinkled and perforated forms, but in place of the lotuses, chrysanthemums and willow trees of the Chinese garden are fallen bougainvillea and hibiscus petals, a barrier of typhoon-resistant *fukugi* trees and the ghostly roots of the ficus tree. To some degree, the garden reflects the Okinawan character. The sun-lit openness of its compressed landscapes and the absence of introspection and complex Buddhist or Taoist concepts in its design mirror a people little given to metaphysics.

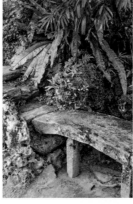

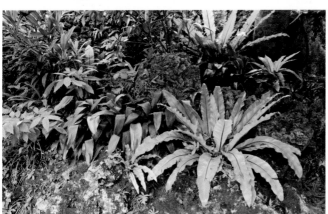

OPPOSITE The salt-encrusted shutters of the villa match the attractive discoloration of the surrounding rocks.

ABOVE LEFT The petals of bougainvillea floating on the surface of a water laver.

ABOVE CENTER Over time, the surface of this small granite bridge has blended in with the tones of the garden's mountain and coral rocks.

ABOVE The surface of this stone lantern has also come to resemble that of the garden's rocks.

LEFT Birds' nest ferns have the capacity to grow in dry crevices.

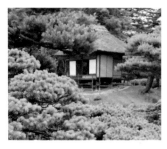

AIZU WAKAMATSU
OYAKU-EN
御薬園

Location: 8-1 Hanaharumachi, 965-0804.
Hours: 8.30 a.m.–5.00 p.m. **Fee:** ¥

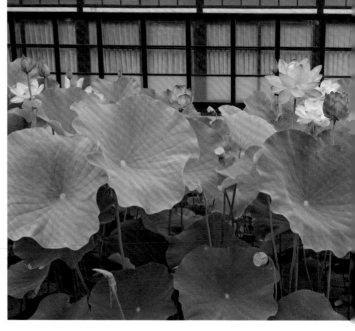

Forming part of the estate of a former lord of Aizu province, the seventeenth century Oyaku-en ("Garden of Medicine"), is a relatively unsung highlight of the city, but the grounds, representing an interesting digest of landscape elements and personal tastes, merit greater visitor patronage. The circuit design suggests the themes of the Edo period stroll garden, and there is even a classic *kokoro*, or heart-shaped pond, to endorse the impression. On the other hand, leafy arbors, the use of dark green plantings and dewy stepping stones hint at the aesthetics of the tea garden. The most unconventional feature for a formal landscape of this period, though, is a large corner of the grounds set aside as a medicinal herb garden. Among the rows of ginseng, gentian, angelica, lycoris and four hundred or so other medicinal plants is a rectangular lotus pond, adding floral interest. The garden shop sells herbs and flavored teas. It also serves *matcha* (powdered green tea), a healthy restorative. Arguably, the best place to sample green tea served with a delicate Japanese sweet is the traditional teahouse, known as Ochayagoten, facing the pond. The rustic elegance of this teahouse, with its framed view of the garden, is nothing short of picture perfect.

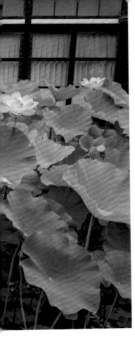

ABOVE In keeping with the theme of health, an acerbic but flavorsome bowl of green tea.

ABOVE LEFT A Hobbit-sized teahouse lurks behind the branches of a magnificent pine tree.

ABOVE Synonymous with Buddhism, the lotus is Japan's most sacred flower.

ABOVE Flowers are always arranged at Ochayagoten alongside hanging scrolls.

LEFT The main garden glimpsed from inside the Ochayagoten teahouse.

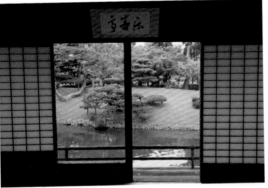

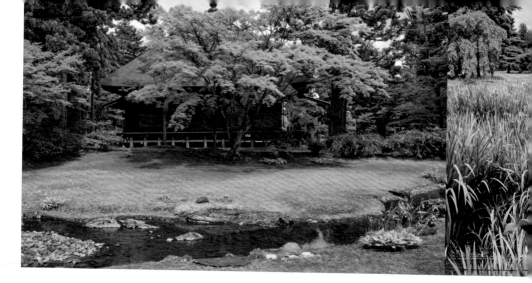

HIRAIZUMI
MOTSU-JI 毛越寺

Location: Aza Osawa, Hiraizumi, Nishiiwai-gun. **Hours:** 8.30 a.m.–5.00 p.m. **Fee:** ¥

The first impression of Motsu-ji is of open parkland, an expansive leisure space. Closer examination reveals details that were incorporated into the garden with the express purpose of satisfying the pleasures and delights of a privileged class of nobles and court attendants. The only intact Heian period garden in Japan, this Jodo, or Paradise garden, commissioned by a clan leader of the powerful

Fujiwara family, occupies the same grounds as Motsu-ji temple. The pond, known as Oizumi-ga-ike, is said to represent the Buddhist Pure Land. Guests would float on the surface of the pond in wooden barges, admiring differing perspectives on the garden, including two islands, one of which is made in the form of a comma-shaped bead (*magatama*). In May, the *kyokusui-no-en* ("banquet beside the wind-

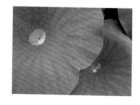

ing stream") re-enacts a poetry contest where participants dressed in Heian period costumes pick up cups of saké as these are floated down a meandering stream, com-

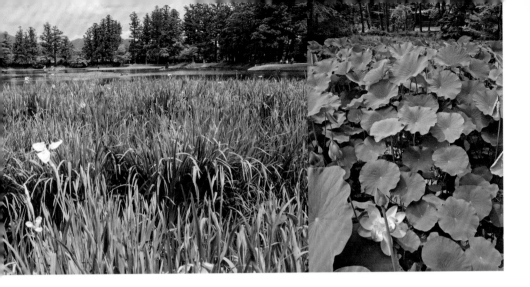

pose a poem and then send it on its way. A design based on diagrams of mandalas, this Unesco World Heritage Site combines sacred concepts with more playful, recreational urges. The great *haiku* poet Matsuo Basho, contemplating foundation ruins in the temple and garden grounds on a visit here in 1689, was struck by the impermanence of glory, writing:

> *The summer grasses*
> *All that is left*
> *Of ancient warriors' dreams.*

ABOVE FAR LEFT *Yarimizu* are winding streams strongly associated with Heian era gardens.

ABOVE CENTER It is not clear when the iris field dates from, but it may be a later addition.

ABOVE RIGHT Rising from the mud to celestial heights, the lotus is a symbol of enlightenment.

OPPOSITE BELOW Water droplets on lotus leaves. In some temples, saké is served and drunk from lotus leaves.

ABOVE A meditating Buddha casts a calm spell over the garden.

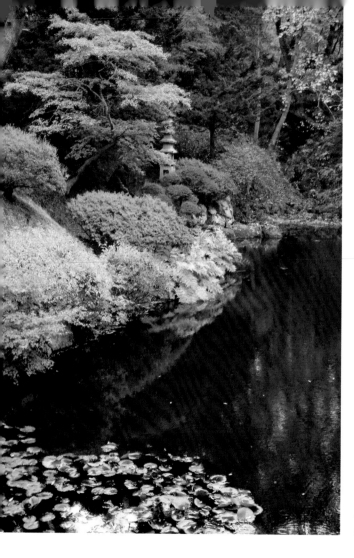

HAKODATE
KYU-IWAFUNE-SHI GARDEN
香雪園

Location: 56 Miharashi-cho.
Hours: All hours. **Fee:** None

Also known as Kosetsu-en, the entire parkland in which this Meiji era garden is located, part of an estate once owned by the influential Iwafune clan, covers over 32 acres (13 hectares). Kosetsu-en is the only garden in the northern island of Hokkaido to be designated as a National Cultural Property. Open to the public, who can stroll at will, the division between park and garden is not immediately apparent. Elements within the park itself, such as *yuki-tsuri*, wigwam-shaped cord arrangements meant to prevent snow from settling on trees and bushes, and shallow streams with carefully managed stone arrangements on their banks, hint at a Japanese garden sensibility. It is not until you descend a stone path alongside a low bamboo fence, entering beneath a traditional wooden gate that you complete the passage from the

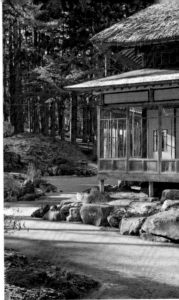

naturalistic to the formal. Japanese garden elements soon assert themselves in an earth bridge crossing part of a small pond, dynamic rock clusters and a stone lantern. A thatched villa sits beside the pond, its design a blend of rural northern architecture and the refinements enjoyed by the Iwafune family who were affluent kimono merchants. Old monochrome photographs of the parkland displayed in a wooden building within the park grounds show a garden and landscape little altered from today.

ABOVE LEFT Spacious lawns are the first park-like section of the garden visitors set eyes on.

ABOVE The villa's pond freezes over in the early months of winter.

LEFT Rice straw mats called *komomake* are used here to protect trees from Hokkaido's severe winters.

OPPOSITE Not quite seasonally in step with mainland Japan, autumn comes early to Hakodate.

This book is dedicated to my brother Graham and sister-in-law Olivia

Published by Tuttle Publishing, an imprint of Periplus Editions (HK) Ltd

www.tuttlepublishing.com

Copyright © 2019 Stephen Mansfield

ISBN: 978-4-8053-1456-2

Distributed by

North America, Latin America & Europe
Tuttle Publishing
364 Innovation Drive, North Clarendon,
VT 05759-9436 U.S.A.
Tel: 1 (802) 773-8930; Fax: 1 (802) 773-6993
info@tuttlepublishing.com
www.tuttlepublishing.com

Japan
Tuttle Publishing
Yaekari Building 3rd Floor
5-4-12 Osaki Shinagawa-ku
Tokyo 141-0032
Tel: (81) 3 5437-0171; Fax: (81) 3 5437-0755
sales@tuttle.co.jp; www.tuttle.co.jp

Asia Pacific
Berkeley Books Pte. Ltd.
3 Kallang Sector, #04-01
Singapore 349278
Tel: (65) 67412178, Fax: (65) 67412179
inquiries@periplus.com.sg; www.periplus.com

22 21 20 19 10 9 8 7 6 5 4 3 2 1

Printed in China 1901CM

TUTTLE PUBLISHING· is a registered trademark of Tuttle Publishing, a division of Periplus Editions (HK) Ltd.

ABOUT TUTTLE
"Books to Span the East and West"

Our core mission at Tuttle Publishing is to create books which bring people together one page at a time. Tuttle was founded in 1832 in the small New England town of Rutland, Vermont (USA). Our fundamental values remain as strong today as they were then—to publish best-in-class books informing the English-speaking world about the countries and peoples of Asia. The world has become a smaller place today and Asia's economic, cultural and political influence has expanded, yet the need for meaningful dialogue and information about this diverse region has never been greater. Since 1948, Tuttle has been a leader in publishing books on the cultures, arts, cuisines, languages and literatures of Asia. Our authors and photographers have won numerous awards and Tuttle has published thousands of books on subjects ranging from martial arts to paper crafts. We welcome you to explore the wealth of information available on Asia at **www.tuttlepublishing.com**.

PHOTO CREDITS

All photos © Stephen Mansfield except following:
Front Cover © toshi/japanphotolibrary.jp; **pp 22 below left** © Sean Pavone/Shutterstock.com; **23 above** © Lubica Jelenova/Shutterstock.com; **23 below left, 122/3 above middle** © Filip Fuxa/Shutterstock.com; **24/25 above middle** © superjoseph/Shutterstock.com; **25 below** © Blanscape/Shutterstock.com; **39 above** © Phuong D. Nguyen/Shutterstock.com; **40 below** © SeanPavonePhoto/istockphoto.com; **41 top** © Pabkov/Shutterstock.com **41 middle** © pattarastock/Shutterstock.com; **41 bottom** © Narongsak Nagadhana/Shutterstock.com; **44 below** © Phattana Stock/Shutterstock.com **45 below left, 90 below** © Fang ChunKai/Shutterstock.com; **45 below middle** © Eramiya/Shutterstock.com; **63 above, 122 above left** © Tupungato/Shutterstock.com; **63 below right** © CO Leong/Shutterstock.com; **76 below** © coward_lion/istockphoto.com; **77 above** © cowardlion/Shutterstock.com; **77 below right, 200 above left** © Pumidol/Shutterstock.com; **91 below** © Liyi Lee/Dreamstime.com; **100/101 bottom** © masayan/japanphotolibrary.jp; **101 above left** © shikema/Shutterstock.com; **114 below** © a_text/japanphotolibrary.jp; **118 below, 119 below** © Yasemin Olgunoz Berber/Shutterstock.com; **119 above right** © つきのさばく/japanphotolibrary.jp; **123 above right** © kawamura_lucy/Shutterstock.com; **123 below** © seaonweb/Shutterstock.com; **128 below, 129 below** © Takashi Images/Shutterstock.com; **132** © Deborah Cheshire/Dreamstime.com; **134 above right** © T.Kai/japanphotolibrary.jp; **135 above** © 源/japanphotolibrary.jp; **137 right** © MaratYakhin/Shutterstock.com; **200/201 above middle** © まだまだひよこ/japanphotolibrary.jp; **238** © Nori/japanphotolibrary.jp; **239 above left** © リリッシュ/japanphotolibrary.jp